Galen Rowell
The Art of Adventure

COLLINS PUBLISHERS

Copyright © 1989 Collins Publishers, Inc., San Francisco.

First published in 1989.

All rights reserved. No part of this publication may be reproduced,
stored in a retrieval system, or transmitted in any form or by any
means, electronic, mechanical, photocopying, recording or otherwise,
without prior written permission of the publisher.

ISBN 0-00-215324-6

Printed and bound in Japan

Library of Congress Cataloging-in-Publication Data

Rowell, Galen A. The art of adventure.

1. Travel photography. 2. Rowell, Galen A. I. Title.

TR790.R69 1989 770'.92'4 89-555

First printing: March 1989 10 9 8 7 6 5 4 3 2 1

To Barbara, my wife, inspiration and partner
in many adventures.

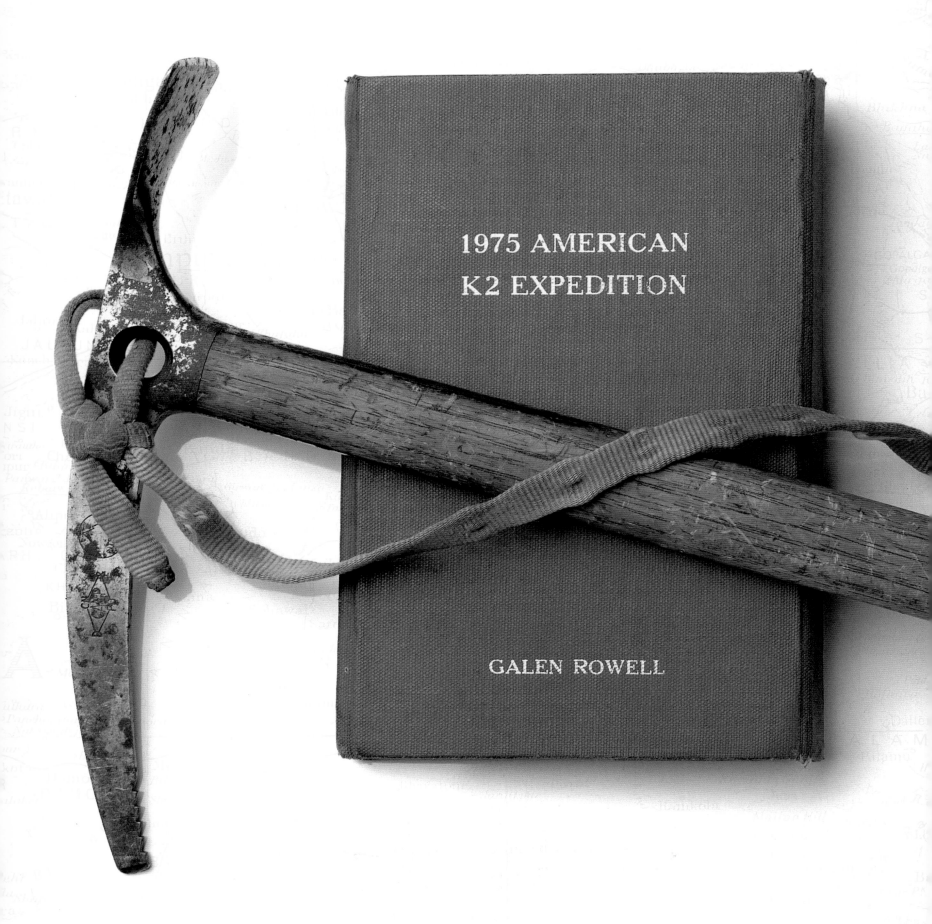

1975 AMERICAN
K2 EXPEDITION

GALEN ROWELL

T here comes a time—it is the beginning of manhood or womanhood—when one realizes that adventure is as humdrum as routine unless one assimilates it, unless one relates it to a central core which grows within and gives it contour and significance. Raw experience is empty, just as empty as the forecastle of a whaler, as in the chamber of a counting-house; it is not what one does, but in a manifold sense, what one realizes, that keeps existence from being vain and trivial. Mankind moves about in worlds not realized. Ages hence people may realize more keenly what has happened today than our contemporaries do. It is the artist, the knower, the sayer, who realizes human experience, who takes the raw lump of ore we find in nature, smelts it, refines it, assays it, and stamps it into coins that can pass from hand to hand and make every man who touches them the richer."—Lewis Mumford

While thumbing through his late father's files, Galen Rowell found this quote, typewritten on a yellowed piece of paper. He remembers that his father read it to him when, as a young child, he first evinced an adventurous spirit.

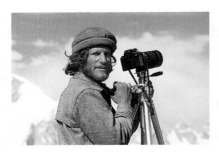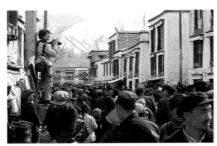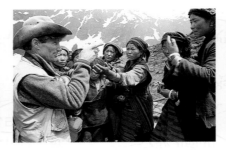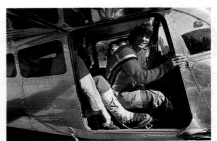

A great traveler, Galen Rowell is also a generous one. He returns from the world's far edges with splendid gifts—frames of film saturated with light and color, faraway places and high adventure. Like the 18th century sketch-artists who accompanied Captain Cook to the South Sea islands, he shows us remote places and peoples with a faculty that transcends mere illustration.

When Galen asked me to write an introduction to this book, I suggested that one of his many famous admirers might do a better job. Unlike Galen, I have no perceptible talent with a camera nor any suggestion of physical courage. For the last decade, our peculiar mission here at Collins Publishers has been to bring together a group of photographers to capture whole countries on film in a single day. During the course of this odyssey, we have been privileged to work with some of the world's greatest shooters. Again and again, we have been amazed by their sheer talent. Like Galen, they are masters of light, color and composition and what Cartier-Bresson called, "the decisive moment." They make the ordinary extraordinary.

After editing a dozen books and perhaps a million pictures taken by the pre-eminent lensmen of our time, we still wonder: What makes a good photographer great; what genetic quirk or germ of experience forms the piercing eye?

I remember walking across Red Square late one night with Eddie Adams, Pulitzer Prize winner and widely regarded as "the photojournalist's photojournalist." Between furtive glances at our KGB tail, I asked him why some people can see a great picture before it is committed to film and others could not. Eddie, never known as a loquacious man, said he didn't know. Then he casually pointed at the half-moon rising beside a Kremlin tower. The tower was topped with an illuminated red star. It was perfect, just the right moment, and of course, I hadn't seen it at all.

So is all of this great photography business unexplainable because we have no lexicon? Is it like one explanation of early childhood—plainly remembered, but unexpressible now because we had no vocabulary then?

There is a case for that. At Collins, we work with photographs all day long nearly every

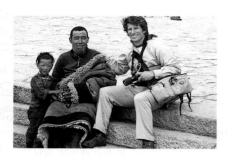 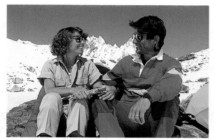 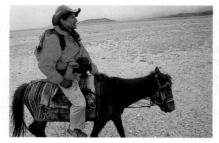 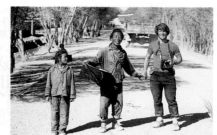

day, and a lot of what we do involves separating good pictures from bad ones. When we come across a bad picture, we can normally tell you why it is bad, and when we find a good one, we can frequently offer a comment on that, too. But on those very rare occasions when we find a truly great picture, that one in ten thousand rolls, we are nearly always at a loss for words. Why is this one frame of film so great? We cannot tell you, but we know it is. And we know it as instinctively as we know the Grand Canyon is magnificent or the Taj Mahal sublime.

When we first saw the work of Galen Rowell, we were at a loss for words. The breadth of his experience, the magnitude of his physical courage, his deeply held concern for the environment—these were no match for the ineffable beauty of his pictures. His pictures took your breath away, transported you to faraway places, made you feel like a child again, snuggled in bed, reading Kon-Tiki.

Here also was that rara avis, a photographer who could write articulately about his work. A brave adventurer whose mad exploits had decidedly philosophical underpinnings. But when I asked him about his photography,

how he made a rectangle of Kodachrome evanescent, why he dangled off thousand-foot cliffs to get "just the right shot," Galen recalled his own boyhood.

Every evening before he went to sleep, Galen's father, a professor of philosophy at Berkeley, would read adventure stories to him: John Muir's narratives from the Sierra and the Far North, Carl Akeley's African chronicles, William Beebe's reports from the seven seas. As Galen listened, his father's voice became faint, the room dimmed, and he became lost in the tale. As his mind wandered, it composed magnificent pictures—pictures of storied peaks and mountain kingdoms, the Hindu-kush and the lush African savannah. Pictures much grander than the grainy little black-and-white illustrations on the page.

When he grew up, Galen went out to find the pictures he had already constructed in his head. And strangely, wonderfully, he did.

In the process, he met challenges of heroic proportions, and not ordinary, run-of-the-mill heroic, either. Galen became the elemental type who conquers mountains and fords dangerous

streams, who tries to save the land and the animals, who walks 12 miles down Mt. McKinley though sorely wounded. In short, Galen became the outgrowth of his own imagination— the real-life version of a bold adventurer who usually lives only in the imagination of a 12-year-old boy.

This book of Galen's adventures is illustrated with his camerawork. In some ways, it is a mid-career retrospective of a great photographer's greatest pictures. A youthful 49-year-old, Galen is now America's pre-eminent adventurer-photographer.

Can we explain why Galen Rowell makes these great pictures? Sort of. We know that he has hunted his childhood dreams with rare talent, fortitude and steely determination. We know that like Ansel Adams before him, he not only says something well, but actually has something to say. Can we tell you why his pictures are great? Probably not, but we're certain they are.

—David Cohen, Editor

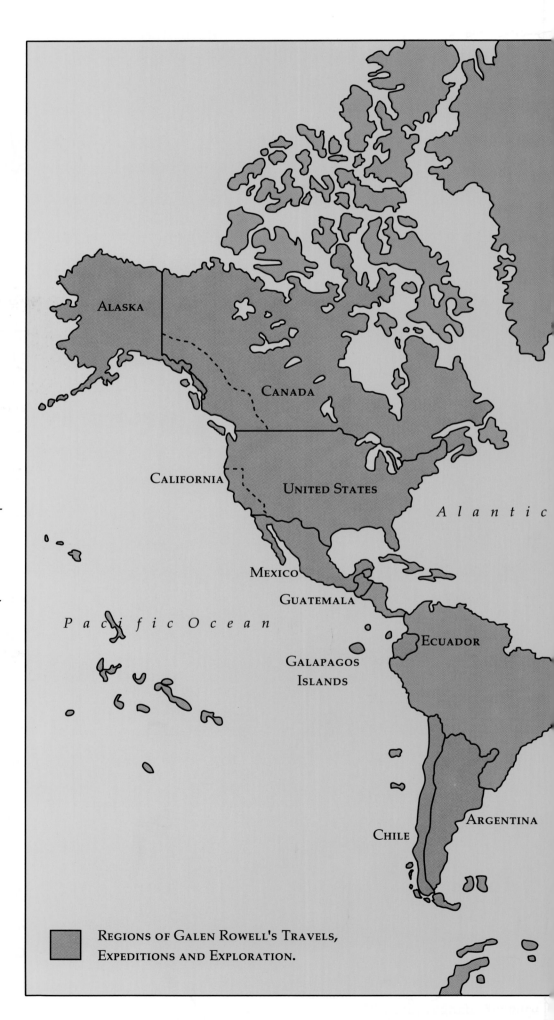

REGIONS OF GALEN ROWELL'S TRAVELS,
EXPEDITIONS AND EXPLORATION.

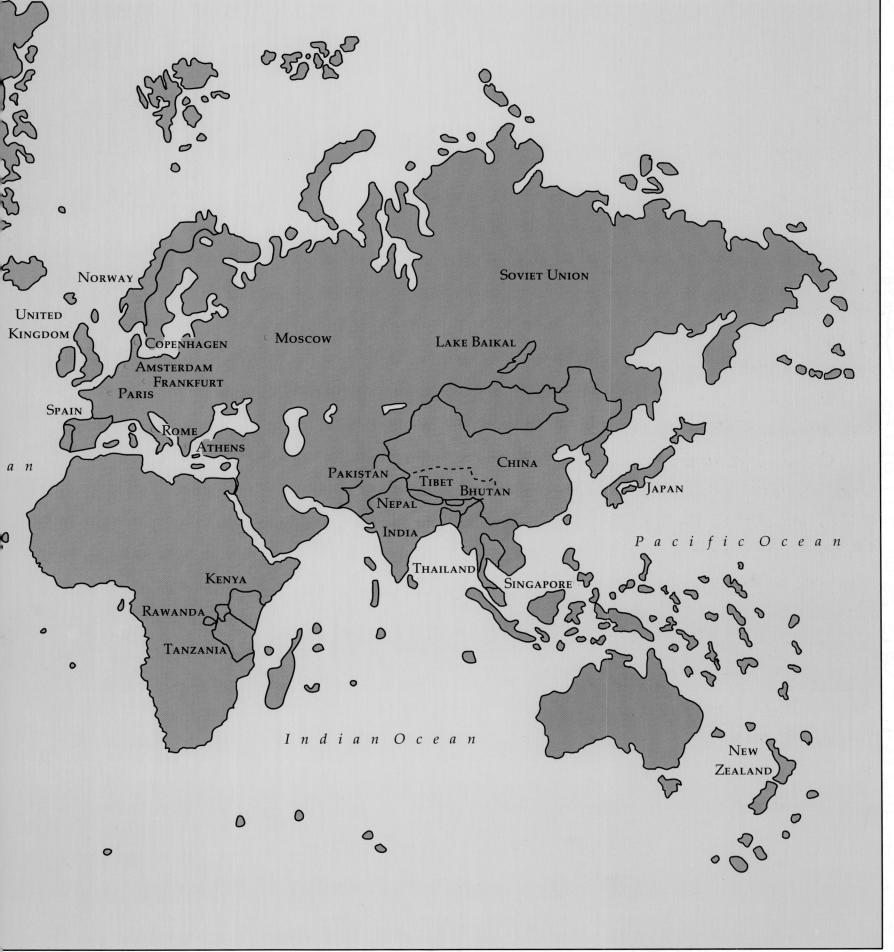

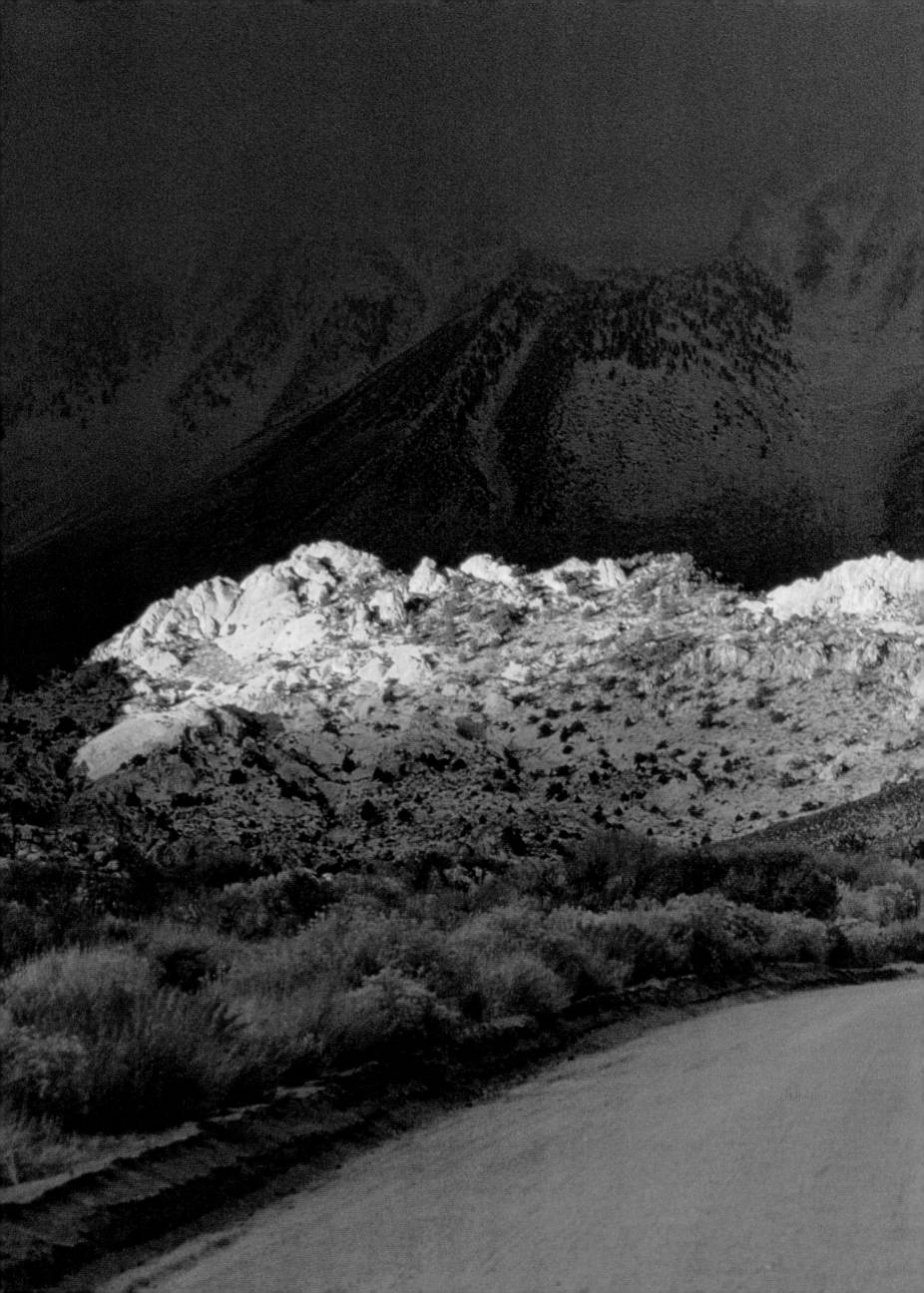

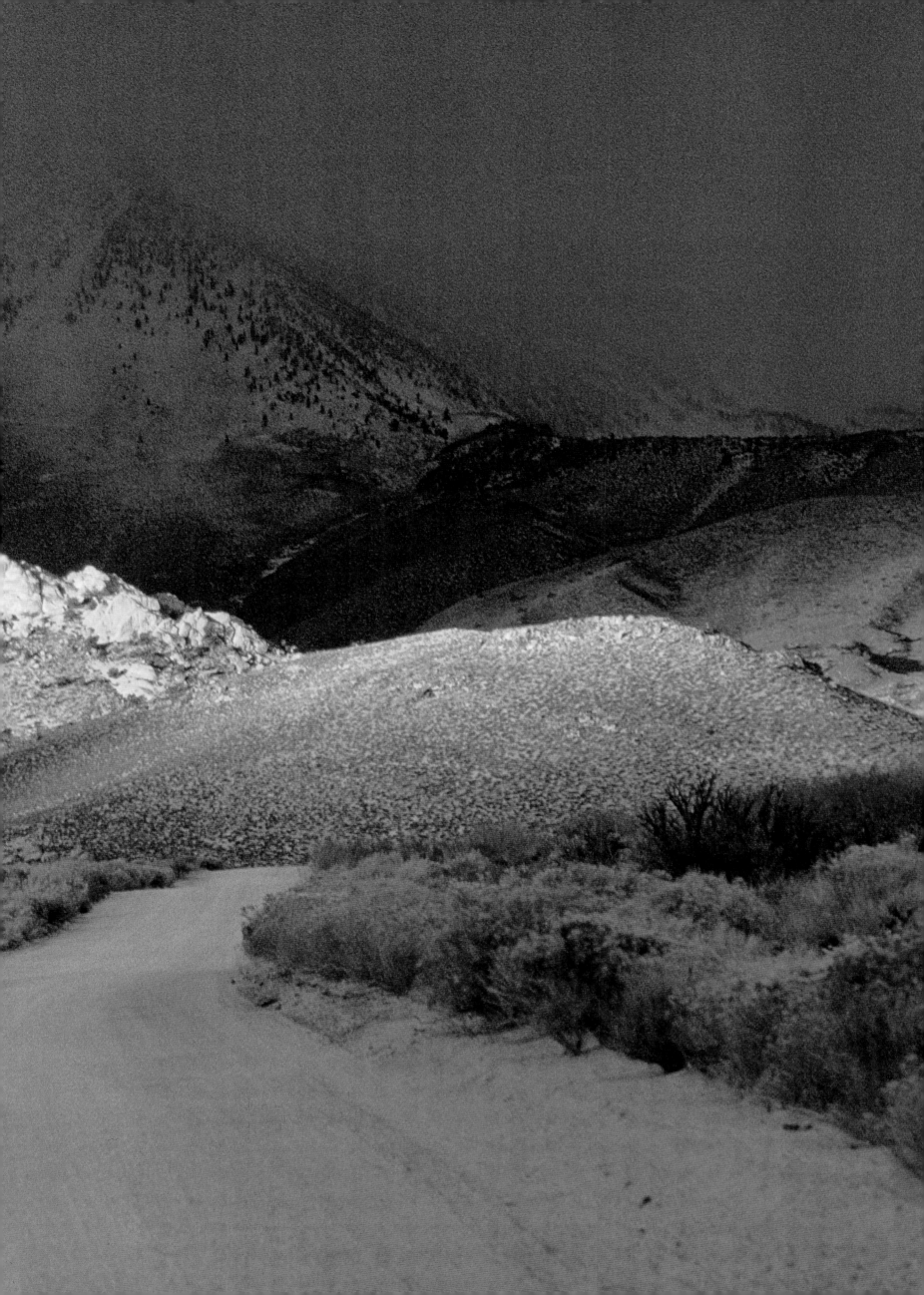

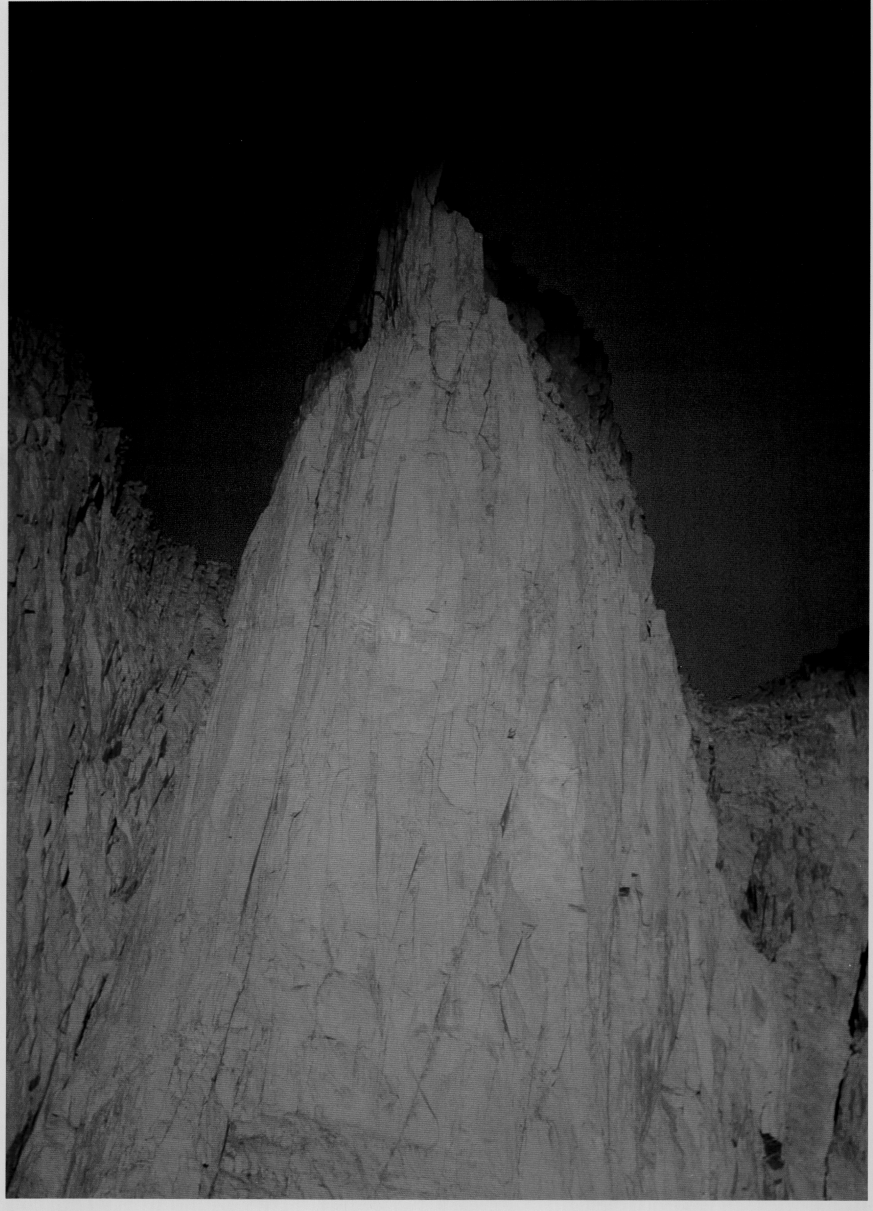

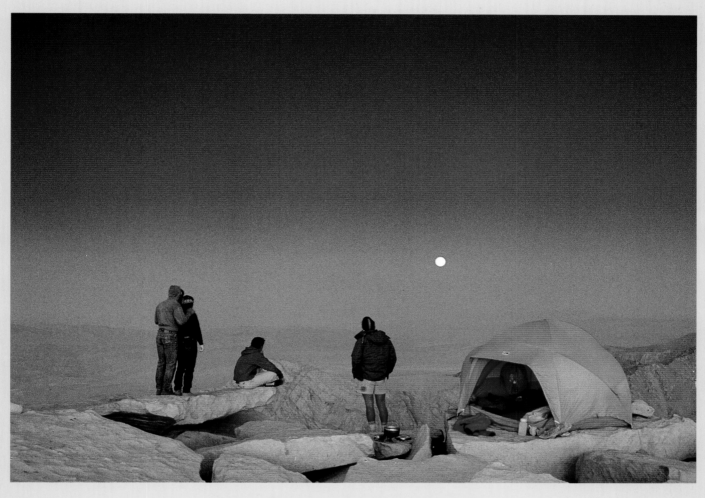

Moonrise From The Summit Of Mt. Whitney

Here, four climbers share the satisfaction of a calm night atop the highest
point in the 48 contiguous states. "I'm trying to
communicate my view of the world," Galen Rowell says, "by sharing
those high moments when what I see and what I
feel are a single experience." (1987) Left: Granite turns to gold on
Keeler Needle, a 14,000-foot spire flanking Mt. Whitney
in the Sierra Nevada. (1976)

◆

The Arid Great Basin Meets The Snowy Sierra

Preceding page: Photographer Galen Rowell pitched camp near the road
hoping for a clear sunrise and some scarlet alpenglow
on the mountains. Instead, he woke up to a startling sight: blue, cloudy
peaks and a desert floor burnished gold by a fugitive
beam of low sunlight. (1971)

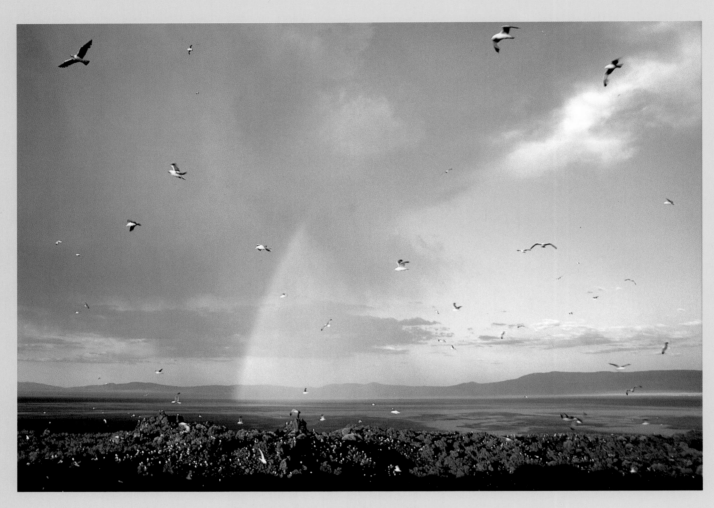

CALIFORNIA GULLS NEST ON NEGIT ISLAND
*in Mono Lake, 300 miles from the Pacific coast. Only five years after
this picture was taken, the gulls abandoned their largest breeding
colony. Water diversion to thirsty Los Angeles lowered the lake's water
level, turning the island into a peninsula accessible to
coyotes and other predators. (1974)*

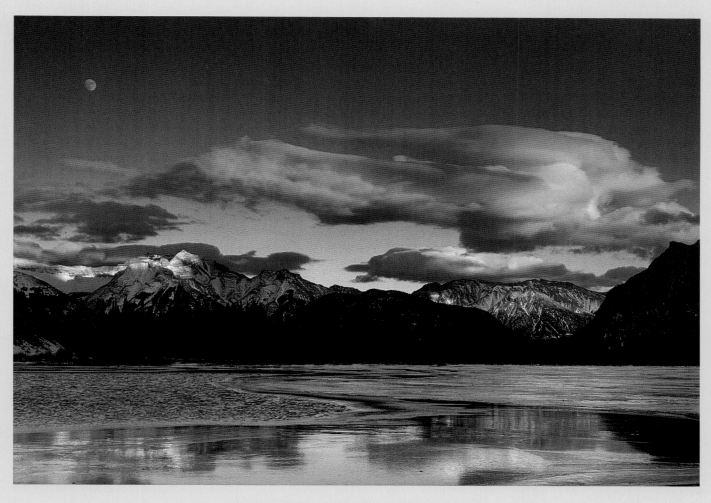

VERMILLION LAKES, CANADIAN ROCKIES, 1980
*"At first I thought about a long telephoto shot of just the mountains,
moon and clouds, but I knew that what I really liked about the scene was
the juxtaposition of the landscape with the patterns on the lake."*
—Galen Rowell *in* Mountain Light

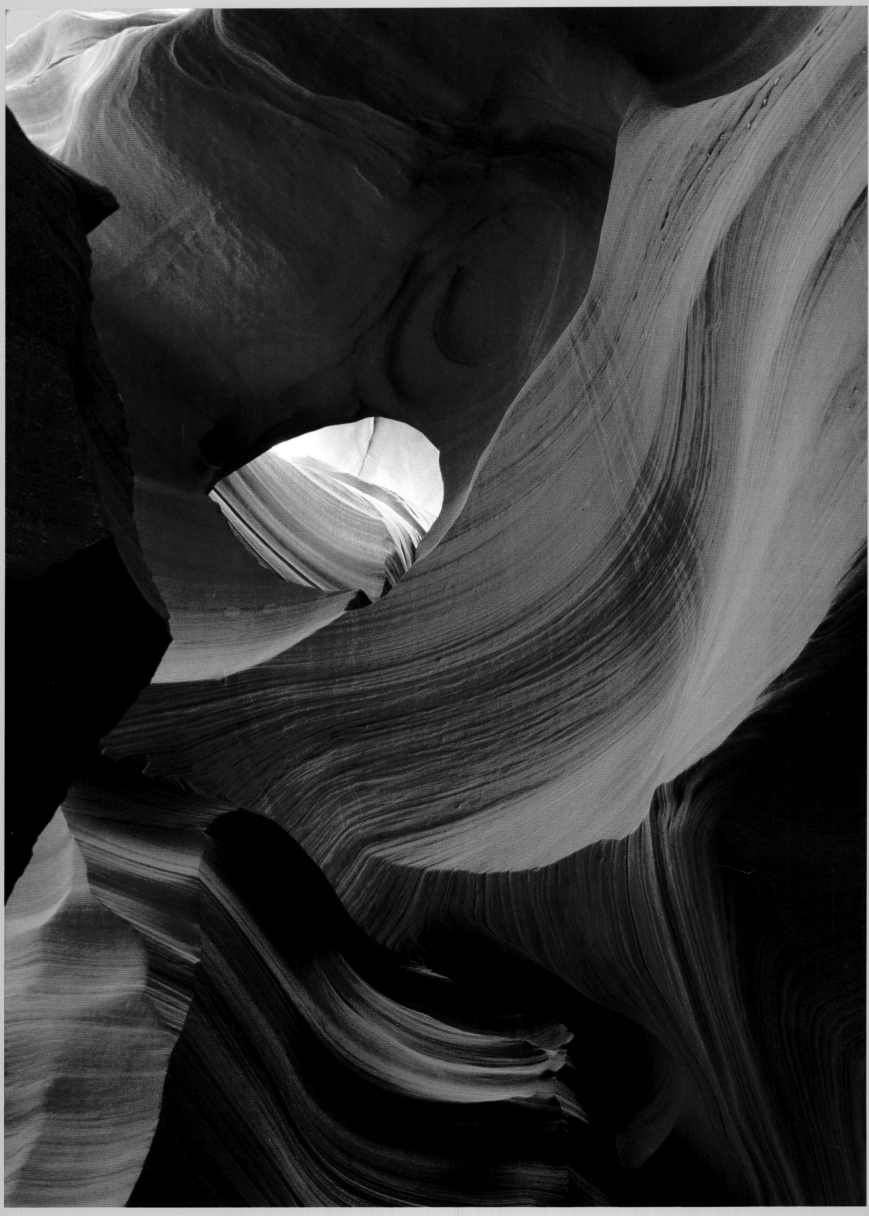

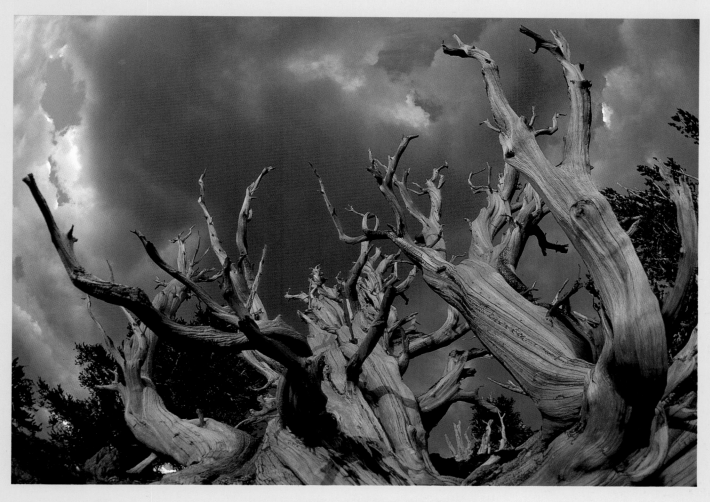

Like A Challenge To The Stormy Sky,
a dead bristlecone pine hugs the earth high in the windy White
Mountains of eastern California. Bristlecones are
the oldest living things on earth. A live tree nearby set seed in
2600 B.C. during the time of the pharaohs. (1988)

◆

A Slot Canyon In Arizona Blushes
under a cascade of midday sunlight. Galen lowered himself on a rope
to follow the light into this voluptuous sandstone chamber.
"The possibilities of integrating light with landscapes are infinite," Galen
says, "and it is the photographer's task to choose moments that
best express the meaning of the subject." (1985)

ALPENGLOW TOUCHES THE SIERRA NEVADA
Below: The ever-receding waters of Mono Lake leave behind
little towers of accreted minerals. (1988)

◆

ASPEN GLADE AND GRANITE
near Lake Sabrina, California. Following page: In overcast
conditions, Galen often turns his camera on closer,
more intimate landscapes. In the soft, even light, Galen says,
"I look for the colors of flowers and meadows
to come alive.." (1974)

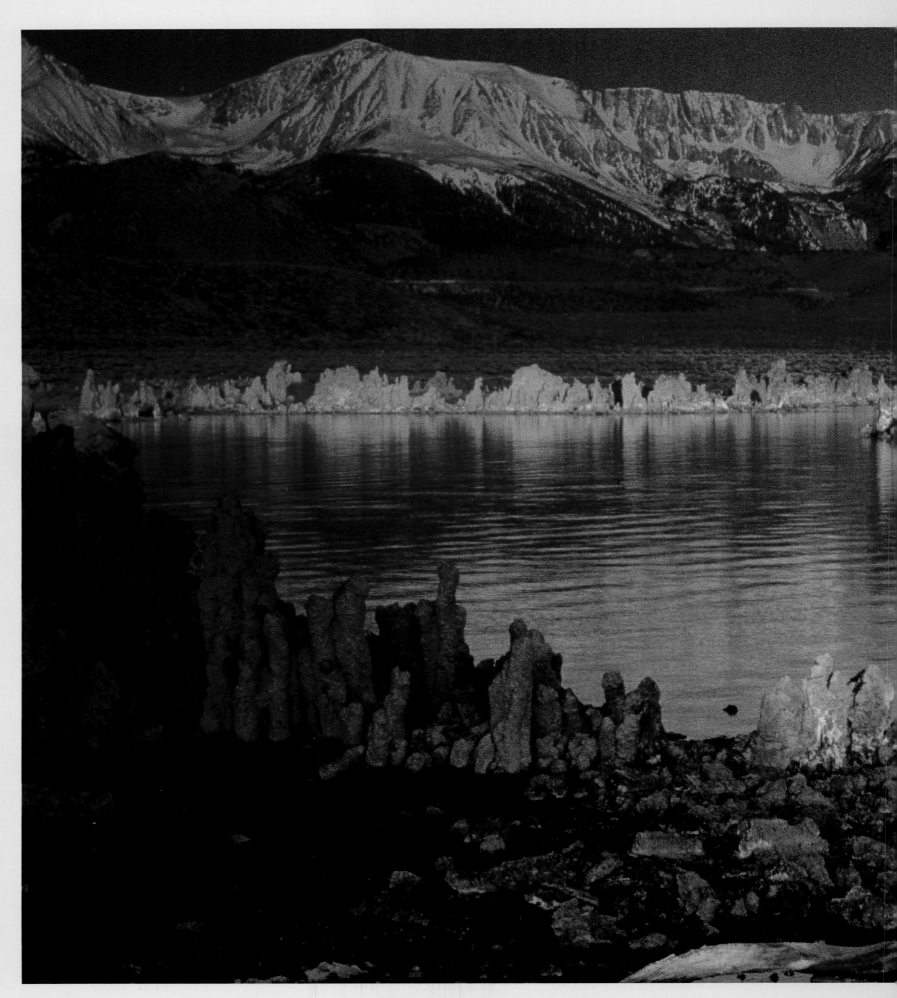

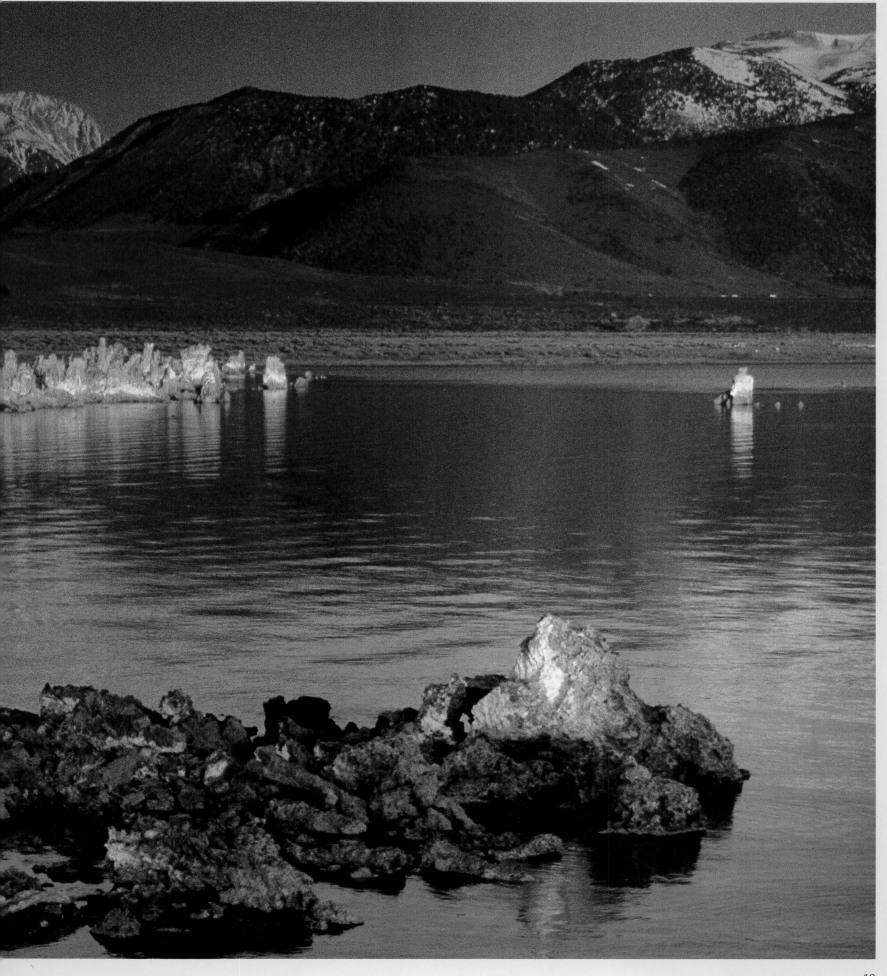

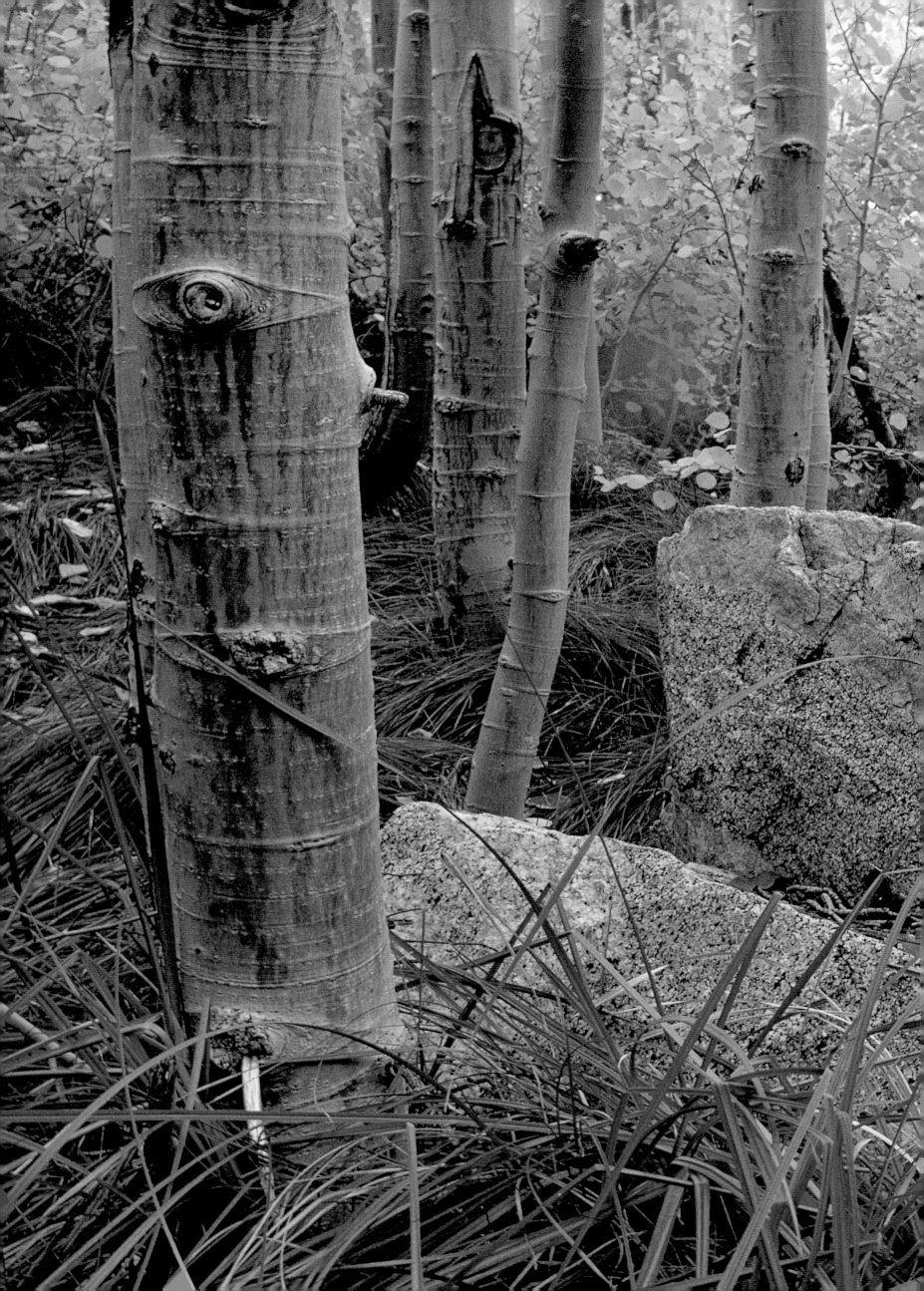

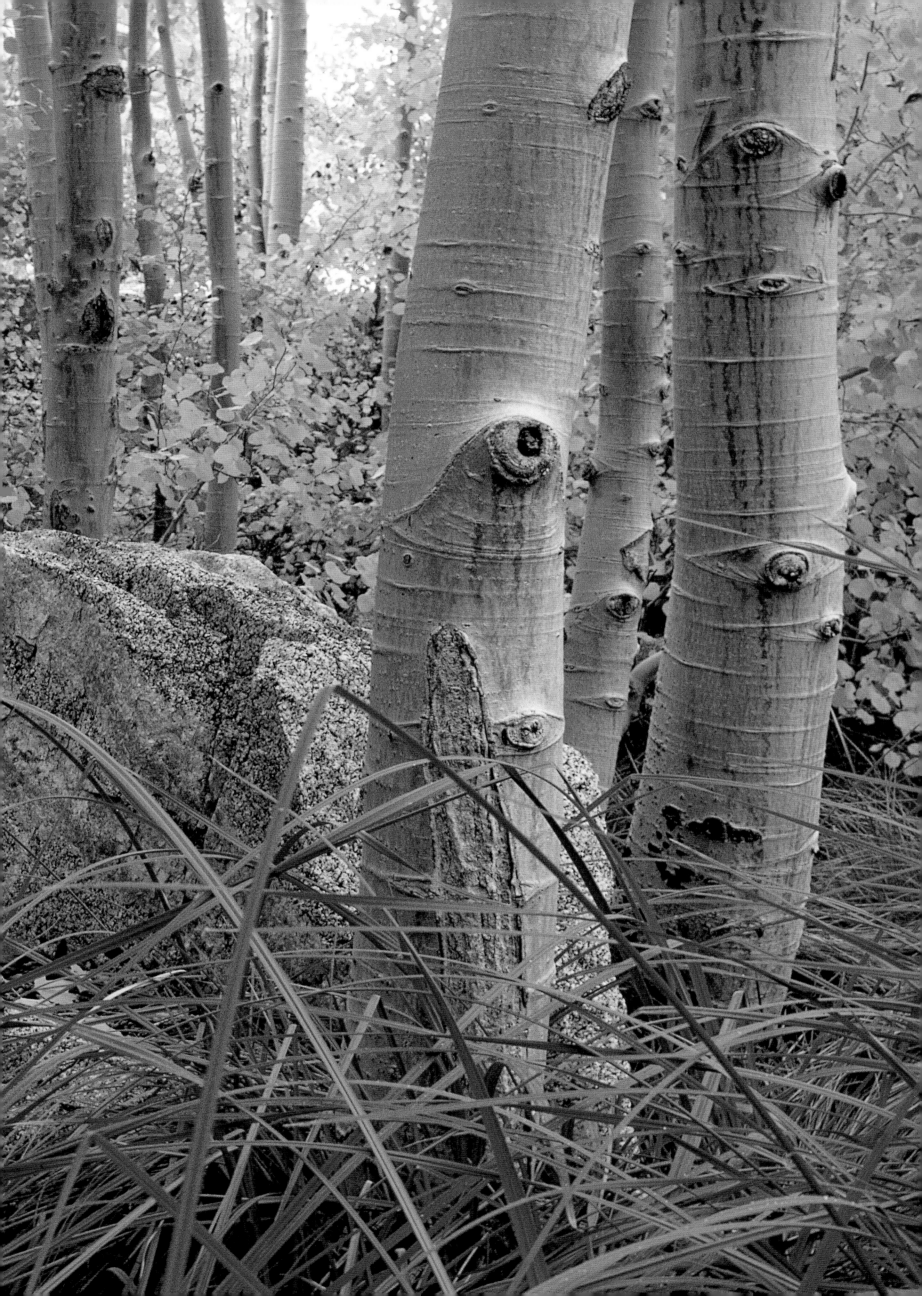

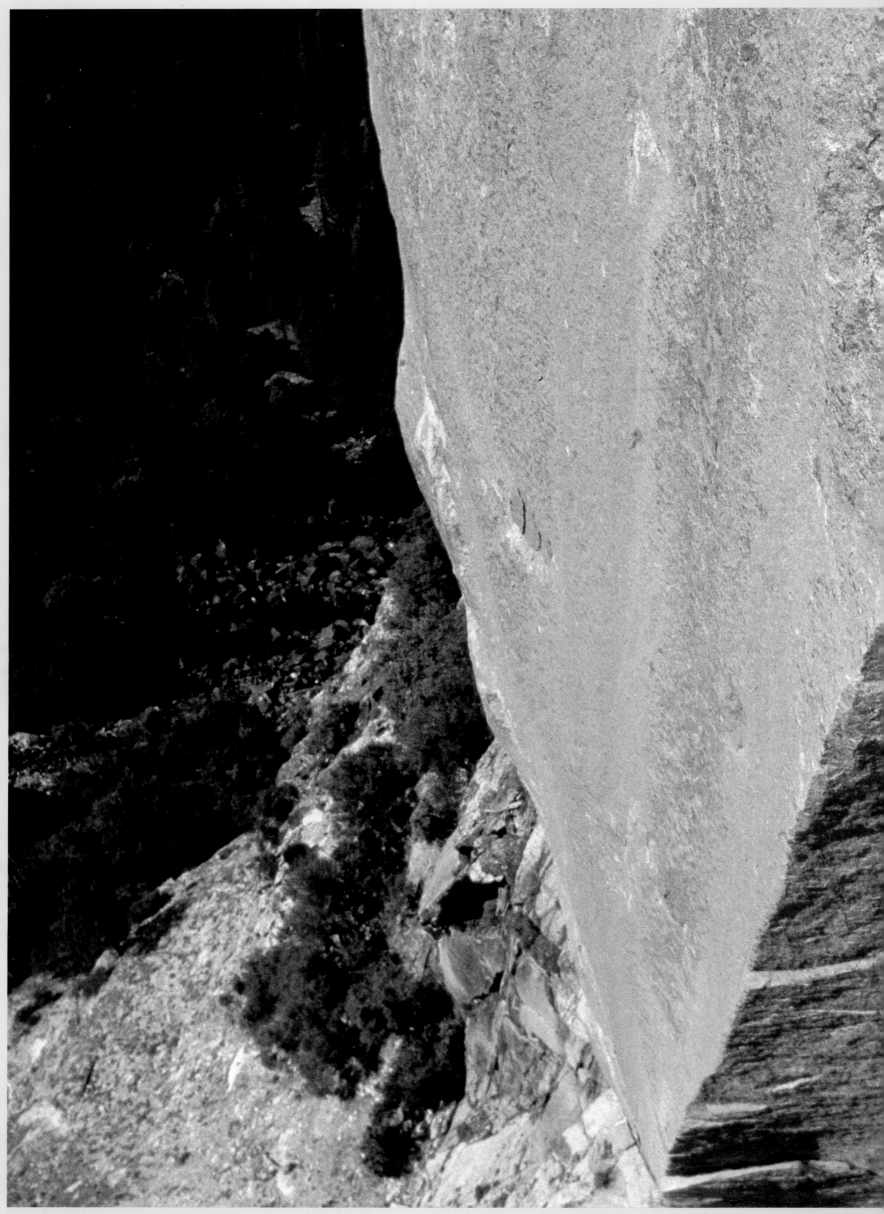

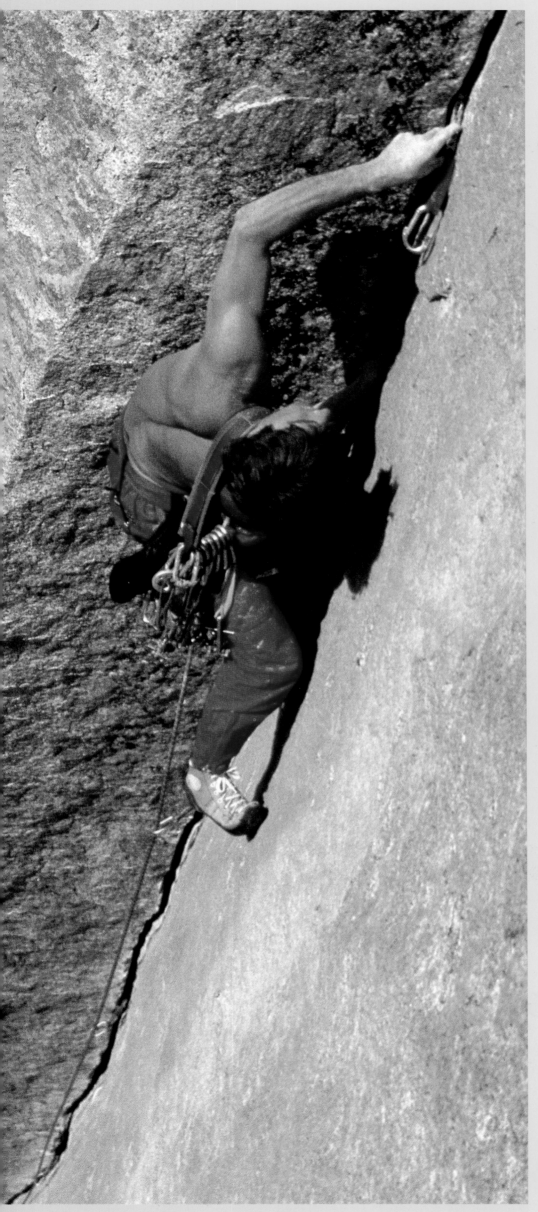

R

on Kauk is
a Yosemite legend. In 1975, at the age
of 17, he became the first man to free-
climb the Astroman, a 1400-foot over-
hang on the eastern exposure of Wash-
ington Column in Yosemite Valley.

The face of Astroman poses a
serious challenge to the skills of a free-
climber, who must use only his hands
and feet (sometimes shoulders, knees
and elbows) to do all the hoisting and
holding on. Ropes, pitons, chocks, cams
and stoppers are used the way acrobats
use safety nets: only in an emergency,
to stop a fall.

Ten years after Ron's historic feat,
Galen teamed up with him for this diz-
zying portrait of a rock-jock. At left,
Ron sets a friend, a cam device used to
anchor the safety rope, in a jam crack
on Astroman's sheer granite face.

Rock-climbing routes are broken
up into pitches determined by the length
of the climbing rope and the availability
of places to stop. A 1,400-foot route
such as Astroman breaks down into 12
pitches with a 165-foot rope.

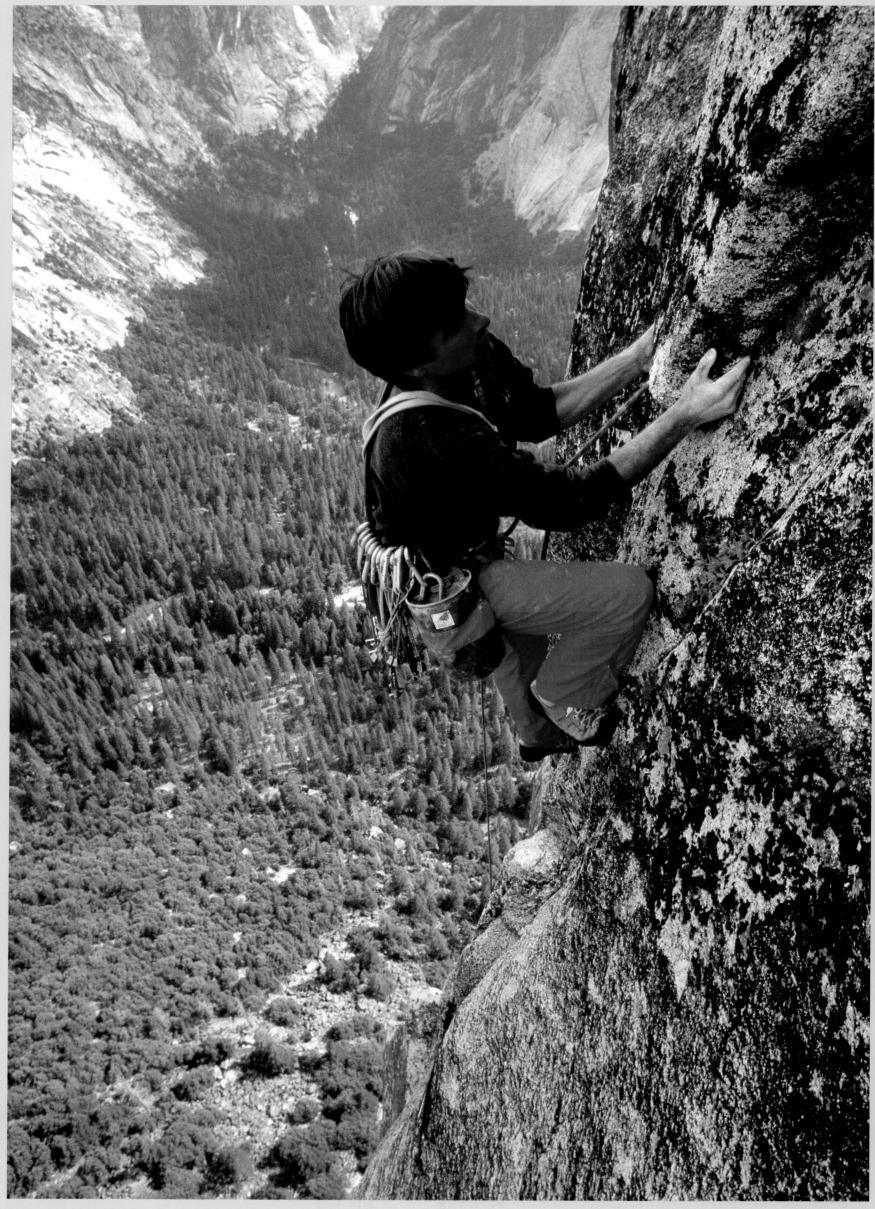

THE SPIDERMAN MOVES AND GROOVES

*of a free-climber. Above: Gymnasts' chalk increases the friction
between skin and stone. Left: High above Yosemite Valley, Ron Kauk
casually clings to a knobby handhold. To get this shot, Galen, a
world-class climber in his own right, ascended on a separate rope just
ahead of Ron. He dangled close to his subject, catching views
only a curious hawk would otherwise see.*

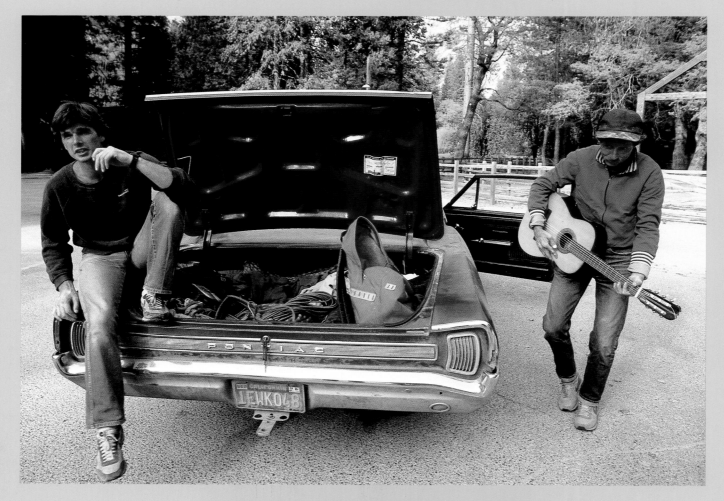

OLYMPIAN WHILE ON ASTROMAN,
*climbers Ron Kauk and Werner Braun resume a bohemian exis-
tence in the parking lot. The trunk of Werner's Pontiac
holds most of his earthly possessions.*

◆

FIGURES ON A VERTICAL LANDSCAPE, 1985
*Skip Guerin and, once again, Ron Kauk, free-climb a rock face
at Joshua Tree National Monument in the California desert."To capture that
certain moment when something living is in fine balance with natural forces
is one of the most satisfying aspects of photography."*
—*Galen Rowell* Mountain Light

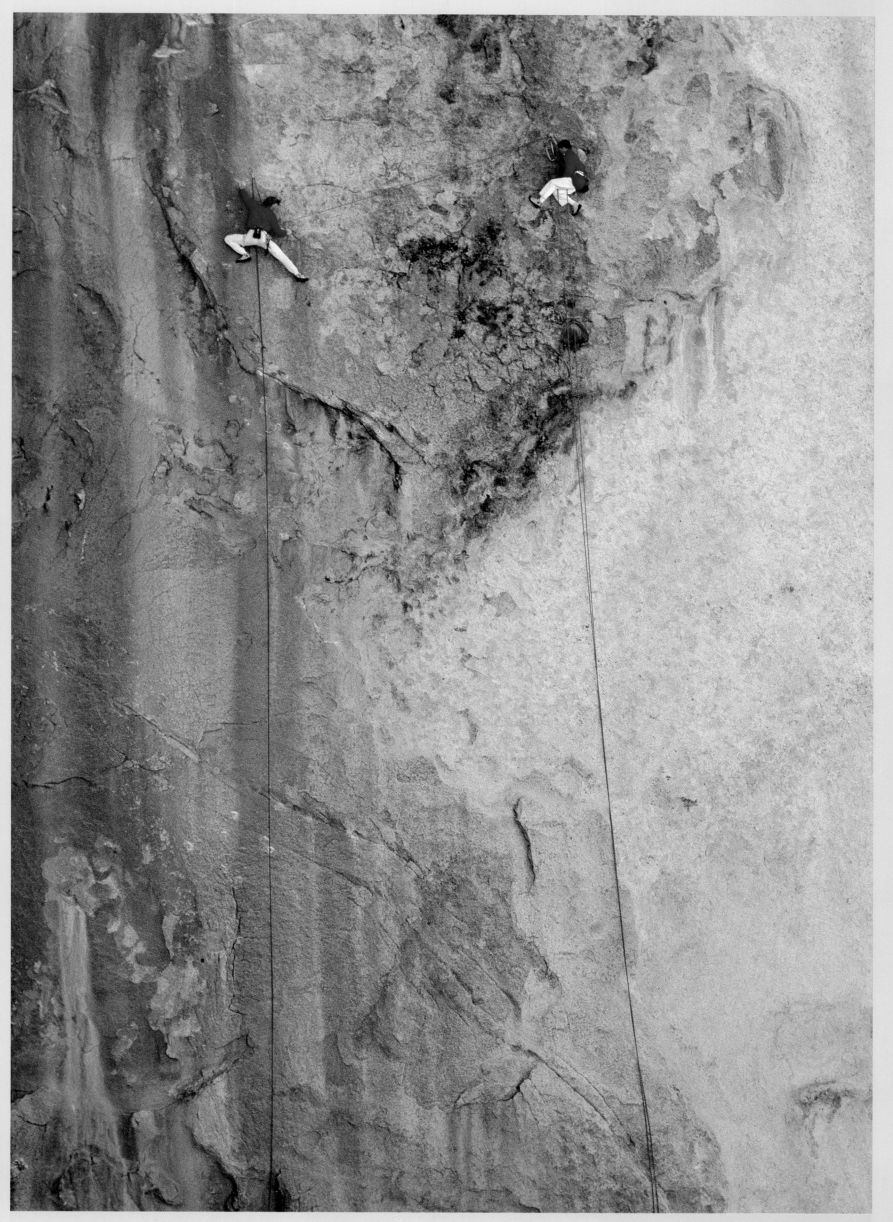

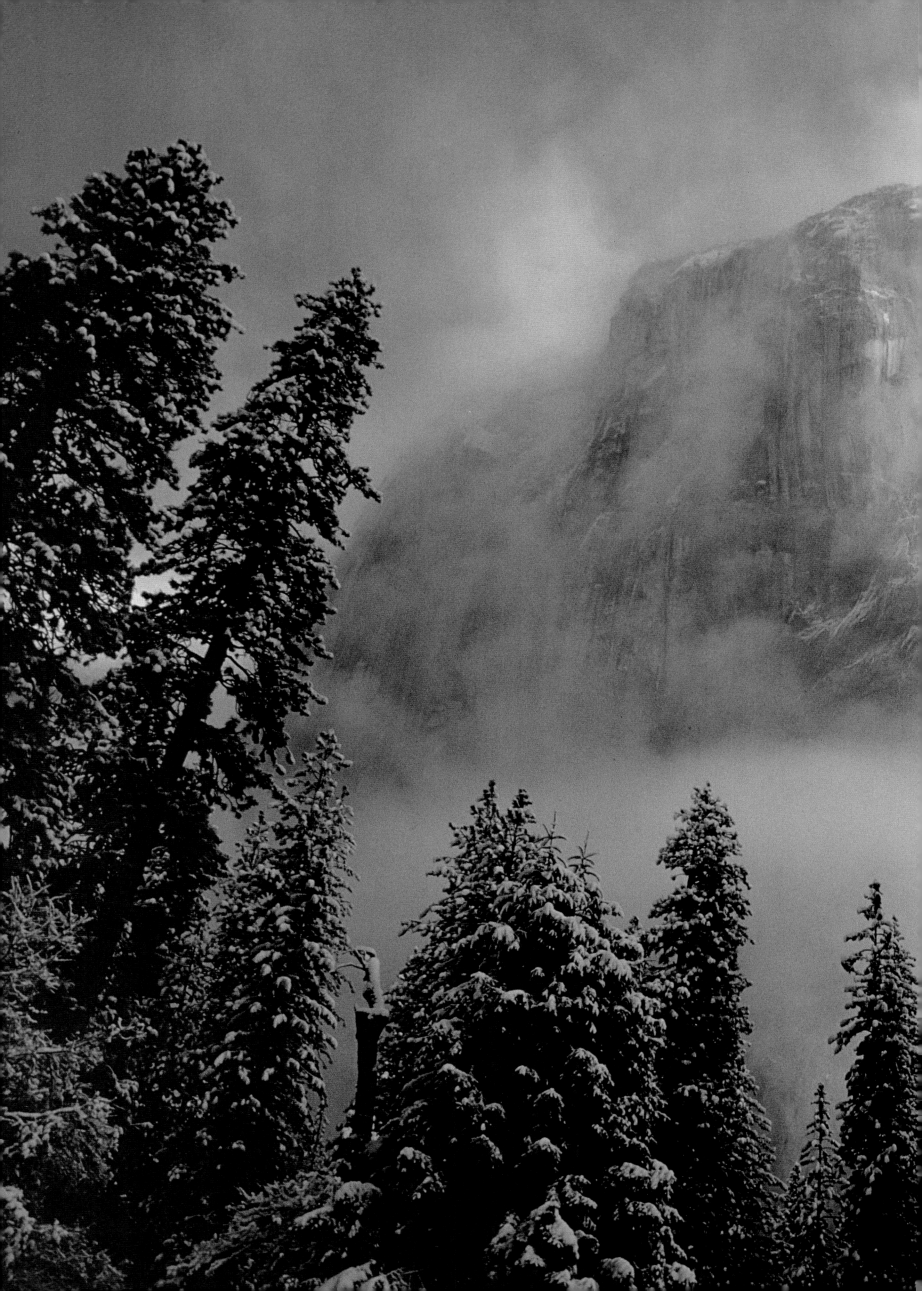

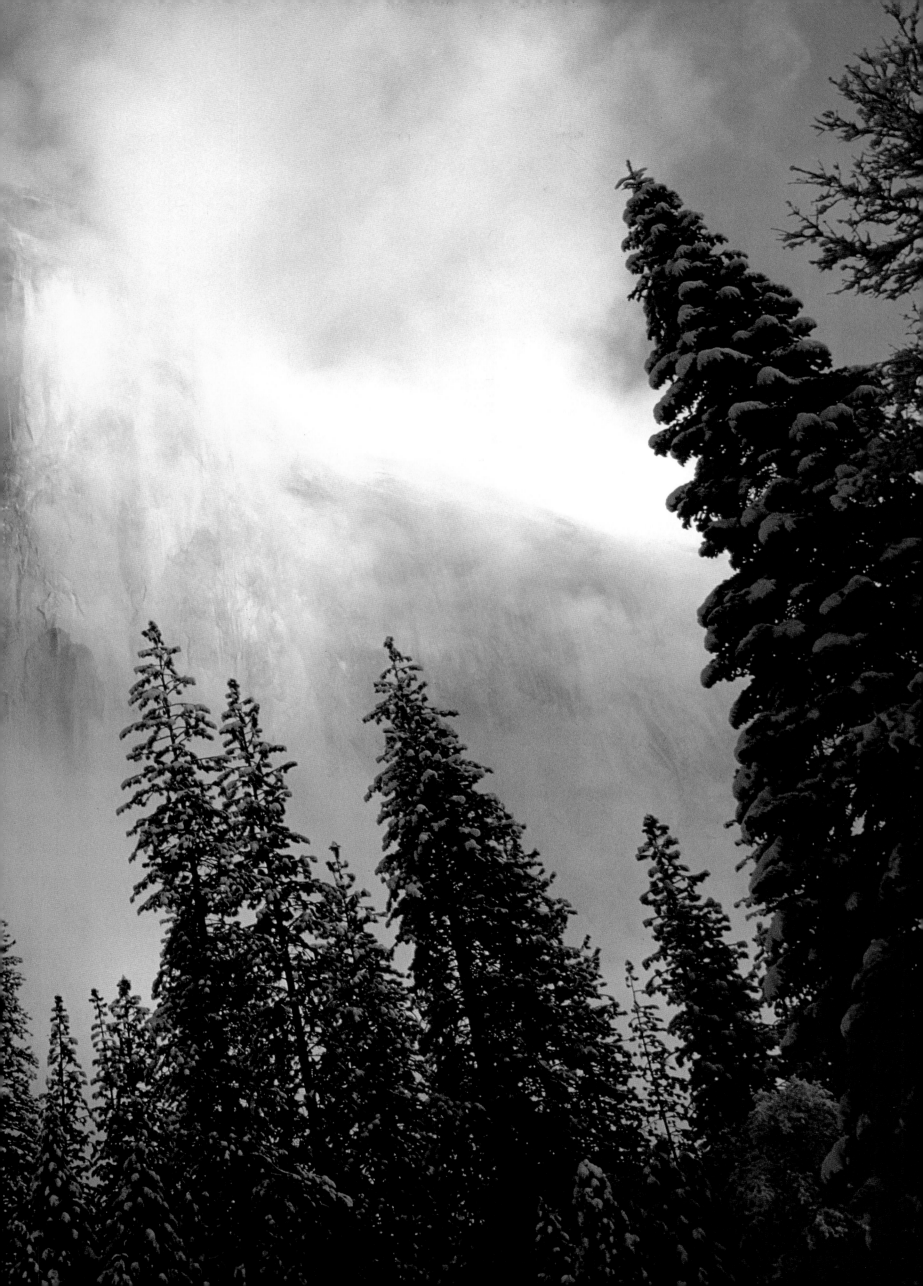

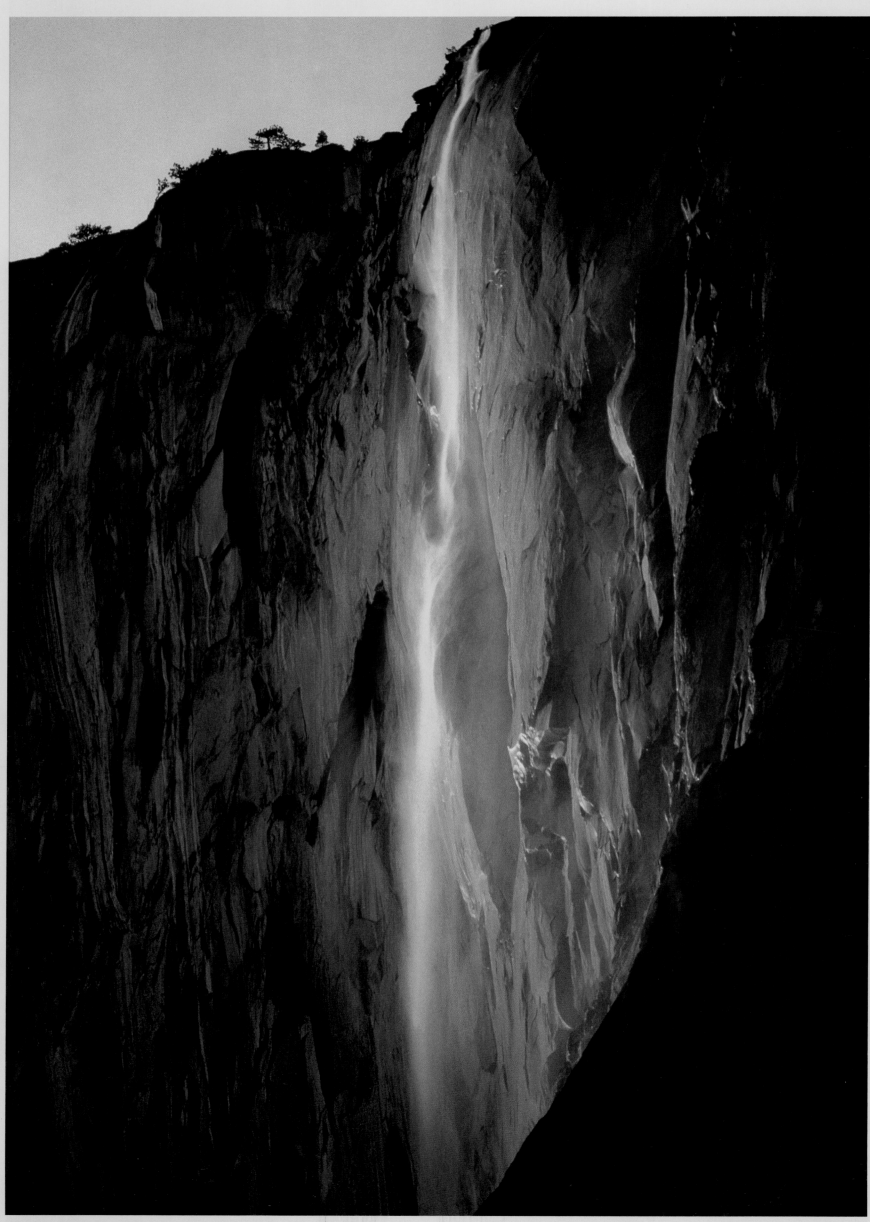

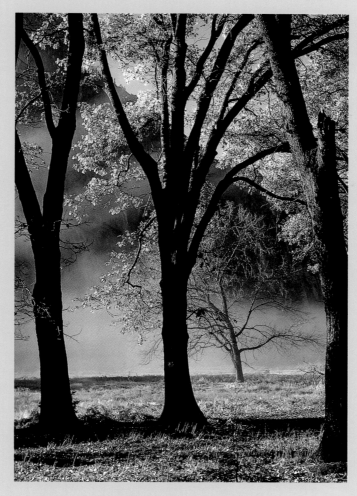

For A Few Days In February,

if conditions are perfect, the setting sun lights Horsetail Fall against
the shadowy East Buttress of El Capitan in Yosemite Valley (left).
This rare display bears an uncanny likeness to the old Yosemite Firefall,
a spectacular shower of burning embers pushed off Glacier
Point by park rangers for the entertainment of tourists. The popular Firefall
was stopped by park officials in 1968. Horsetail Fall, however,
continues to burn brightly when streamflow, clear skies and the angle of
the setting sun conspire. Above: Oak trees on the floor
of Yosemite Valley. (1973)

◆

A Storm Clears Over El Capitan In Yosemite, 1973

Preceding page: "Mist and vapor hold the color and intensity of light
far better than any solid object. Landscape artists have
traditionally used mist as a vehicle to show off their most extravagant colors.
The more visionary their approach, the more mist they include."
—*Galen Rowell*, Mountain Light

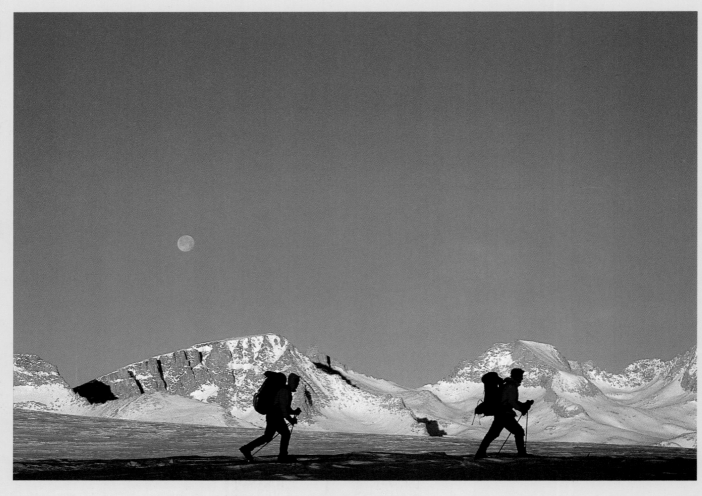

SILHOUETTED SKIERS GLIDE
across the High Sierra's Kern Plateau on the John Muir Trail.
The 212-mile path, named for the 19th century naturalist,
is the longest unbroken wilderness trail in America. Galen and two compan-
ions spent 17 days traversing the entire Yosemite-to-Mt. Whitney
route in the winter of 1988.

◆

THE YOSEMITE HIGH COUNTRY, 1987
According to Galen, who was born and raised in California,
his home state "has everything I ever wanted to
photograph, more beauty and diversity than any other mountain land-
scapes I've ever seen. But," he says, "I had to go
to the Himalayas, New Zealand, Africa, Canada and Alaska
before I could say that with any authority."

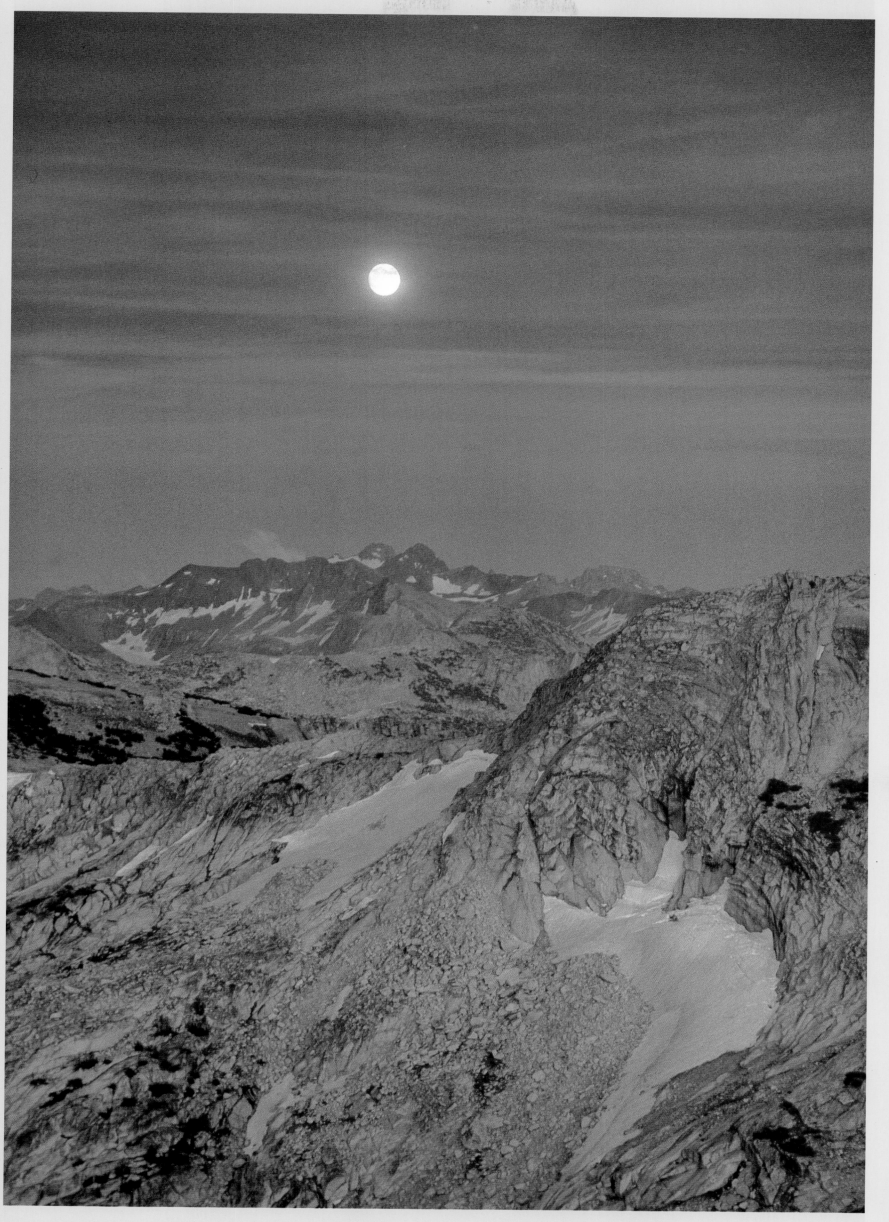

AN UNEARTHLY MOONSET AT SUNRISE

*over Wheeler Crest. For this picture, Galen took advantage of "the clearest
air I've ever seen in the eastern Sierra. The red glow of the sunrise happened
right when the setting moon kissed the horizon." (1972)*

———————◆———————

MONUMENT VALLEY, ARIZONA

*After many trips to this Navajo tribal park, Galen wanted to avoid photo-
graphic clichés while shooting the valley's well-known
sandstone towers (following page). To get a new angle, he positioned himself
several miles away from his subjects for this low-lying profile
against the eastern sky. (1986)*

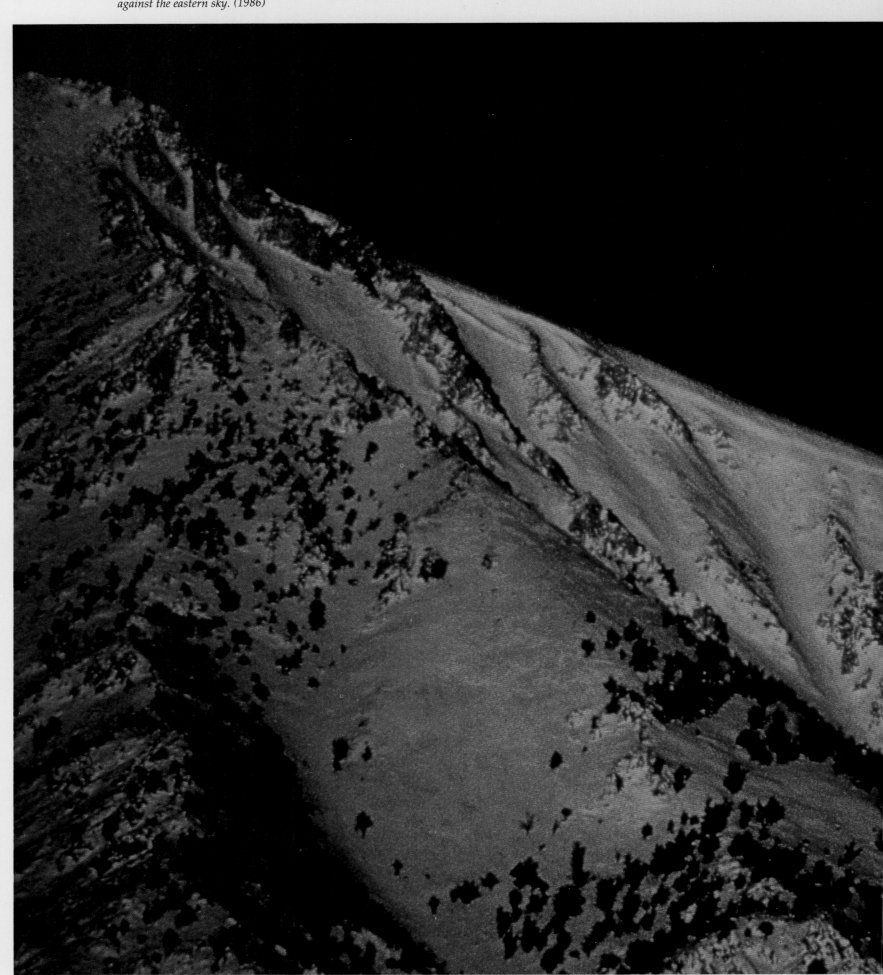

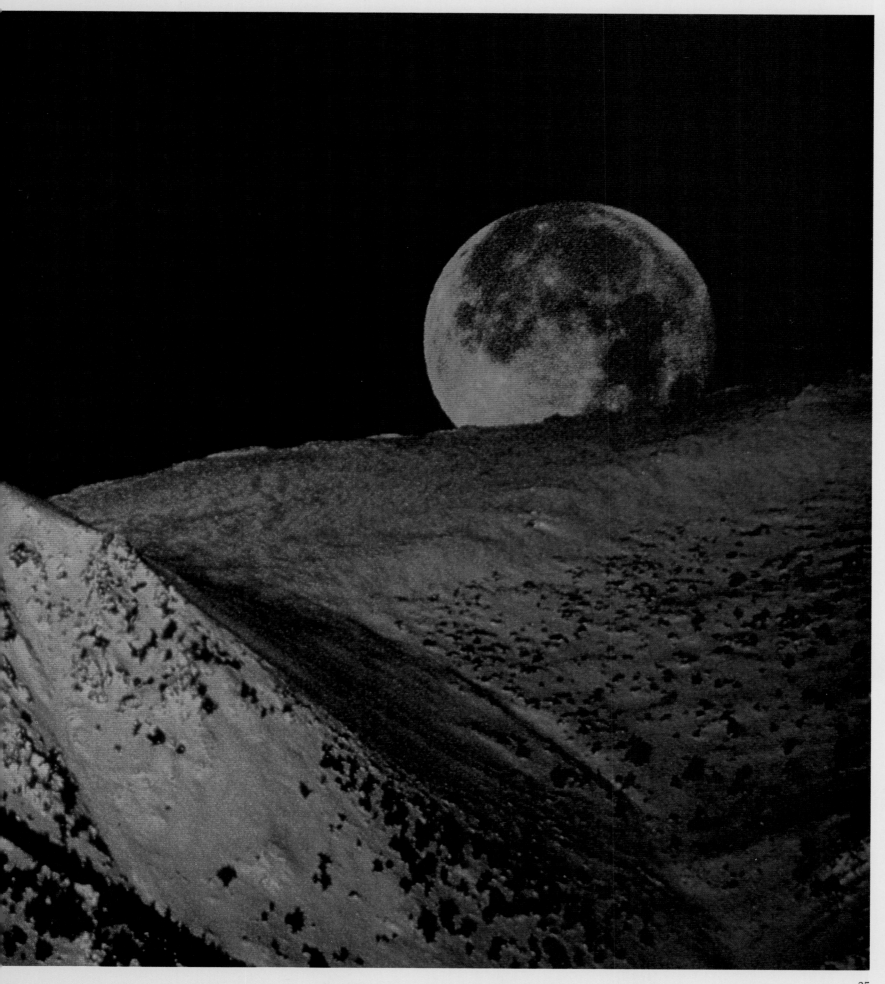

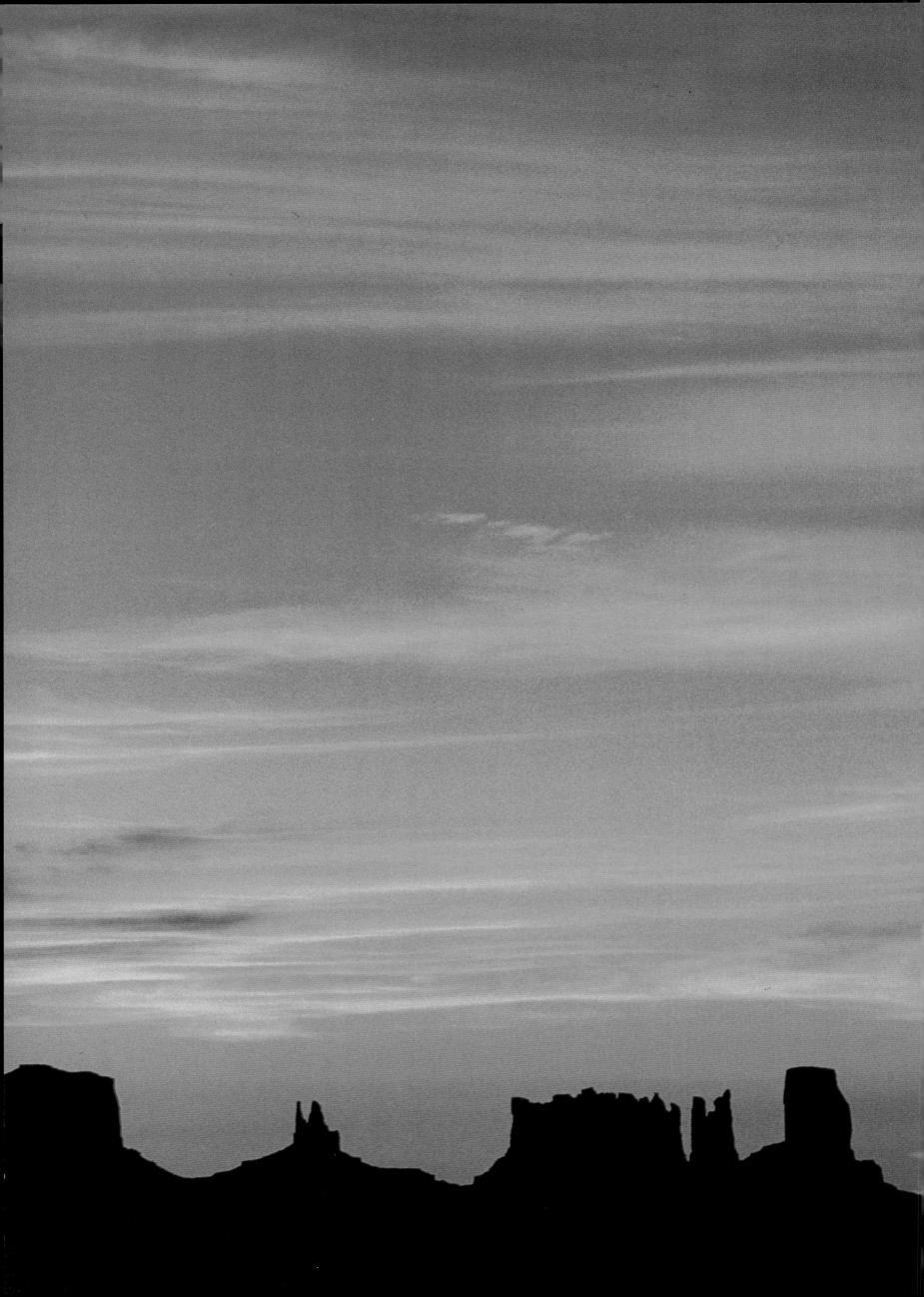

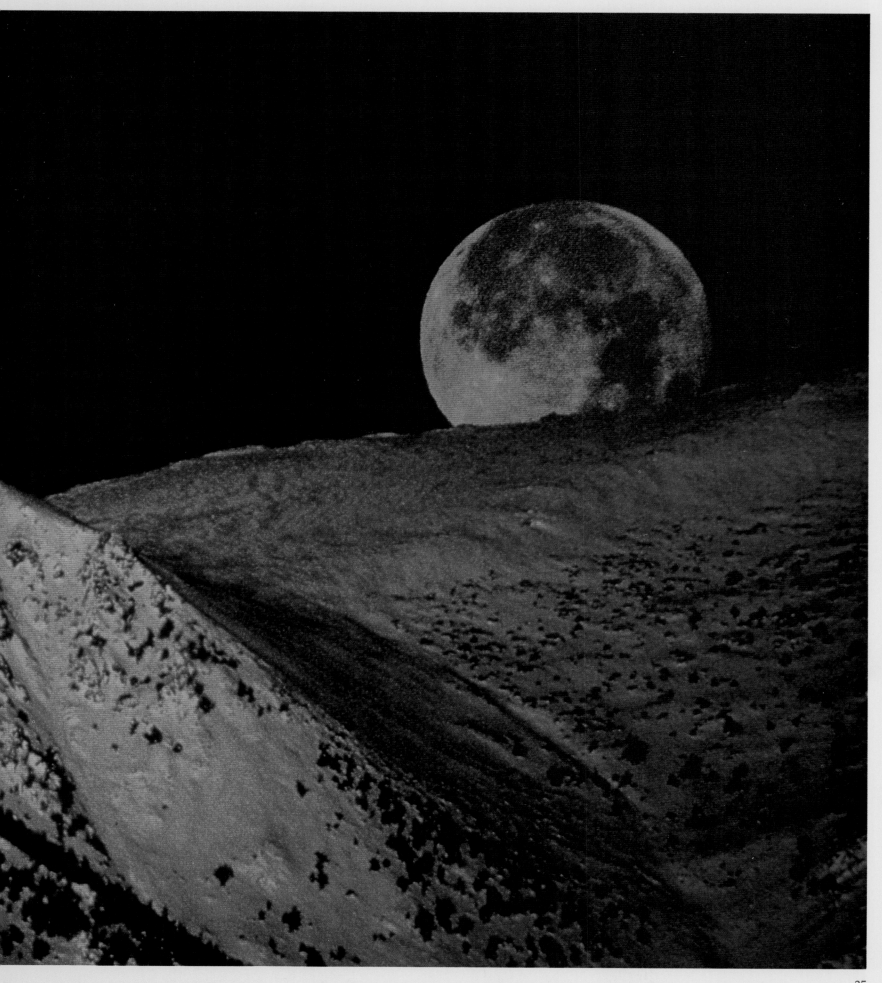

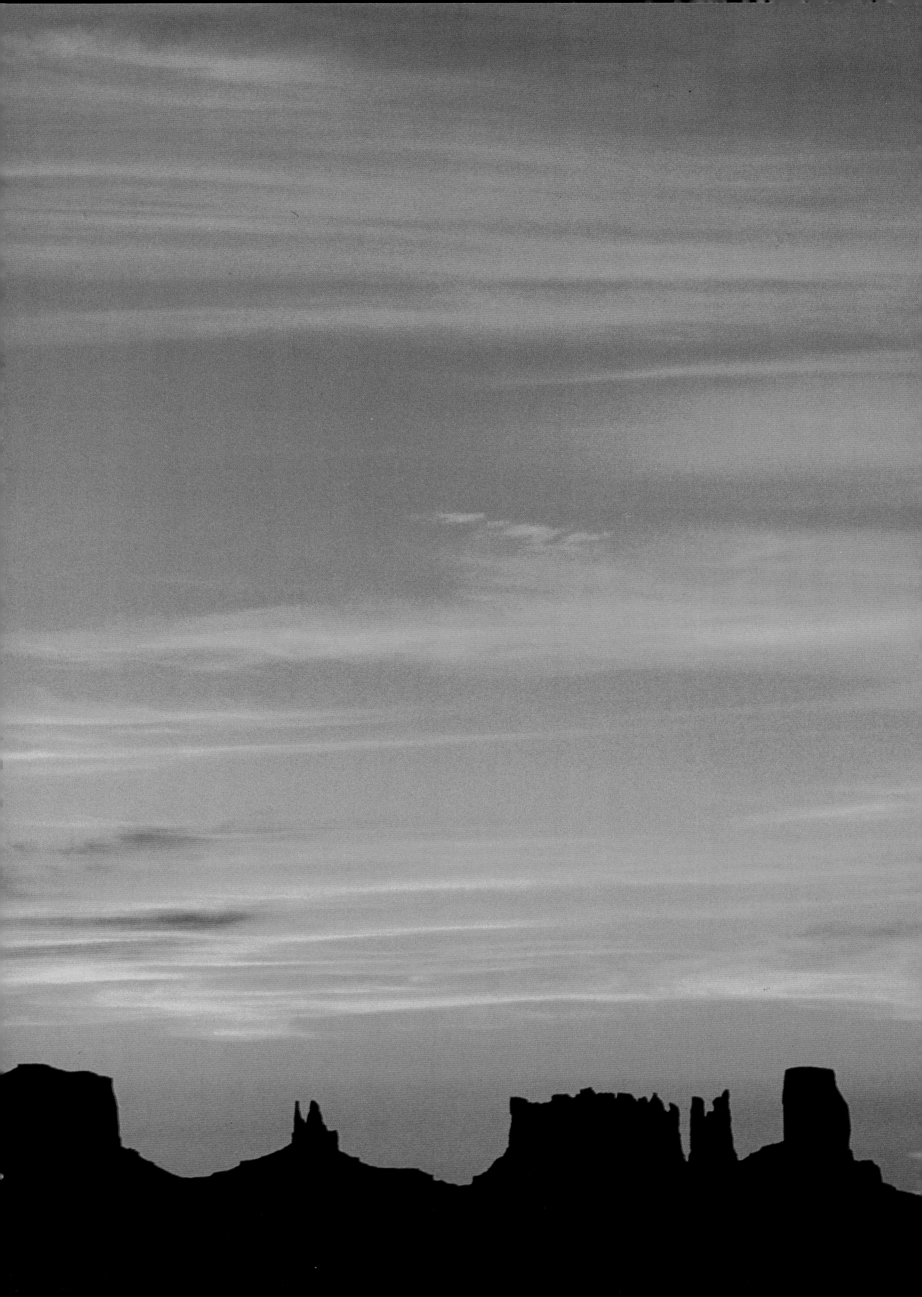

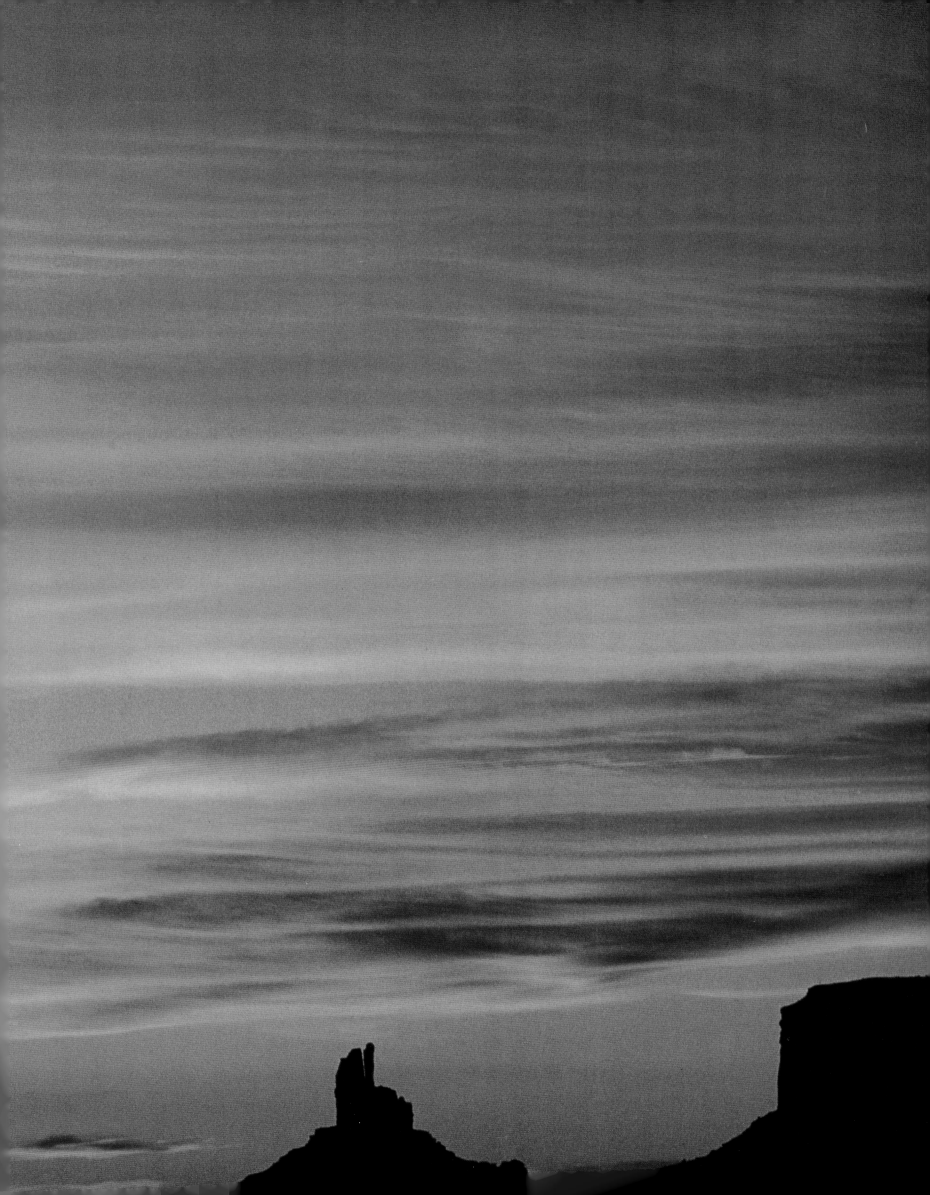

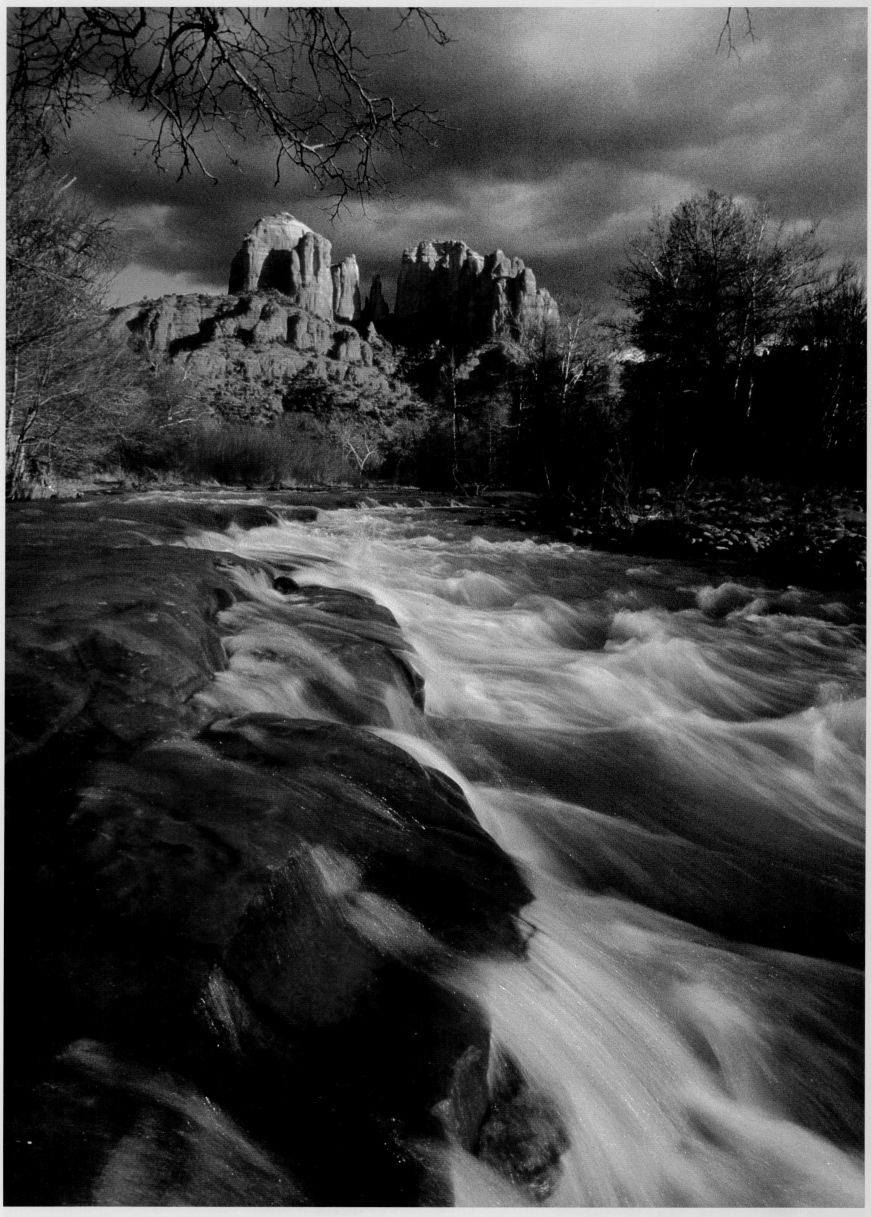

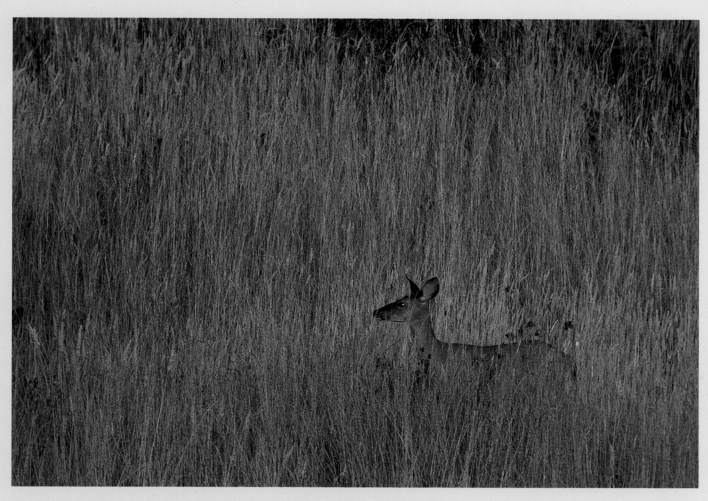

The Watchful Eye Of A Mule Deer

Galen was set up to photograph sunset over the Oregon coast when he
discovered he wasn't alone: "I heard a little noise and turned
around. In the grass, far behind me, I noticed a gleaming point of light catch
in the deer's eye. Otherwise, I wouldn't have seen a thing." (1984)

◆

With Tripod Set In A Creek,

Galen recorded the clearing of an Arizona thunderstorm at Oak Creek
Canyon. He used a wide-angle lens, graduated neutral-
density filter and 1/4-second exposure to balance the sharp stillness of Court-
house Rock between the brushed glitter of the water and the
smudgy, lifting clouds. (1987)

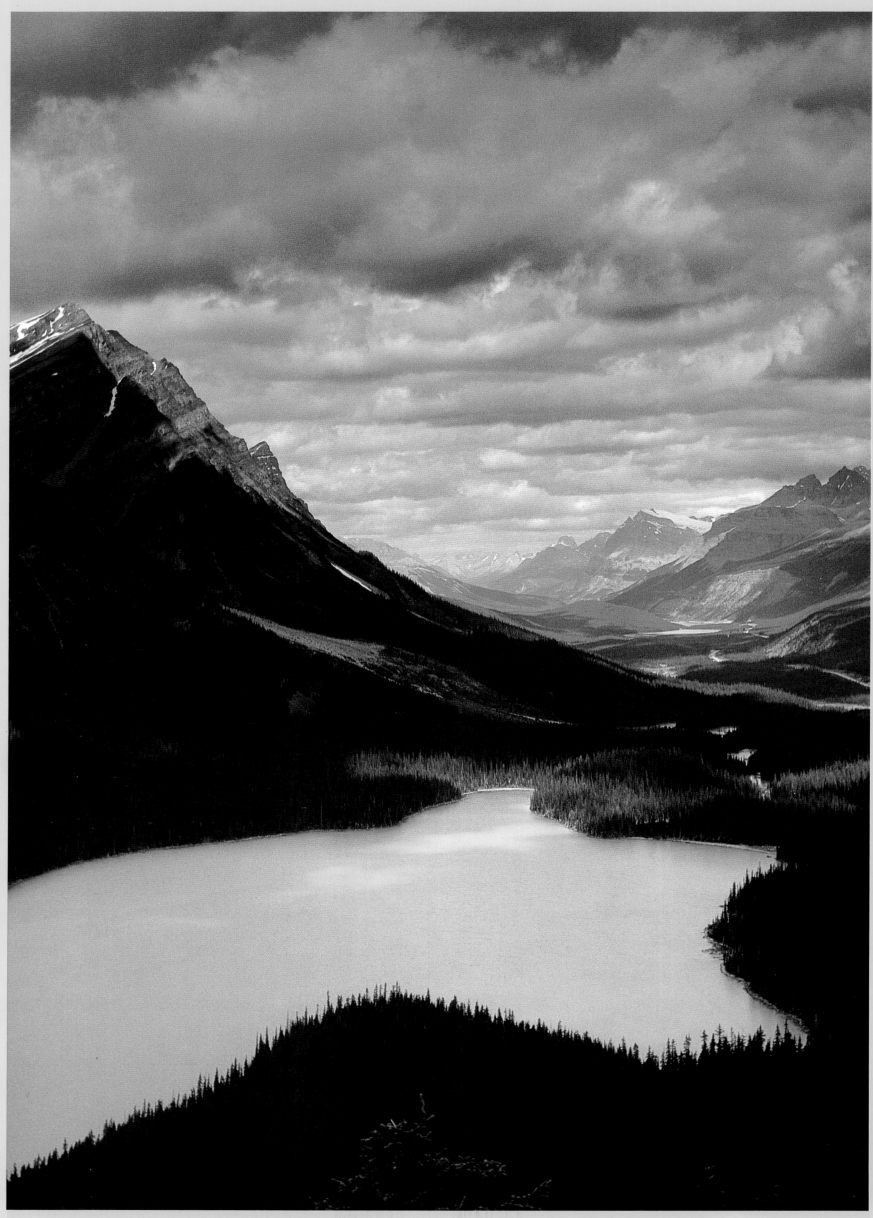

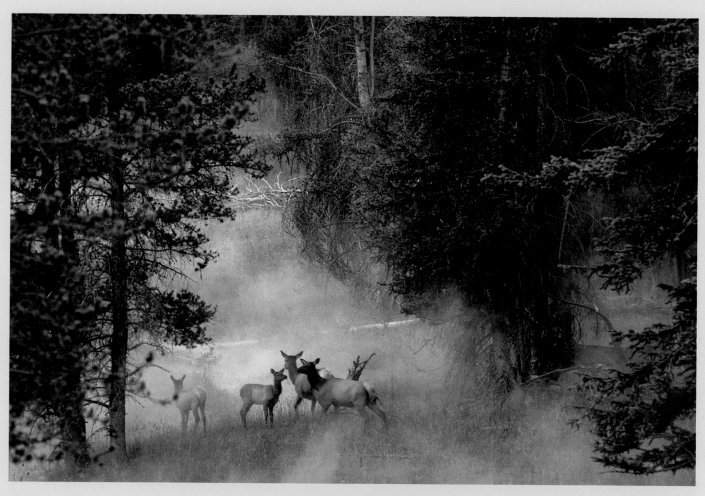

Drifting Through The Mist,

a small herd of elk gathers near a hot springs in Yellowstone National

Park. Even in winter, grasses thrive near the park's steamy

springs and geysers. (1978)

◆

The Turquoise Of Peyto Lake

in Banff National Park, Alberta, is caused by the fine silt suspended

in glacial runoff. Galen believes this basin in the Canadian Rockies

is one of the loveliest in the world. (1982)

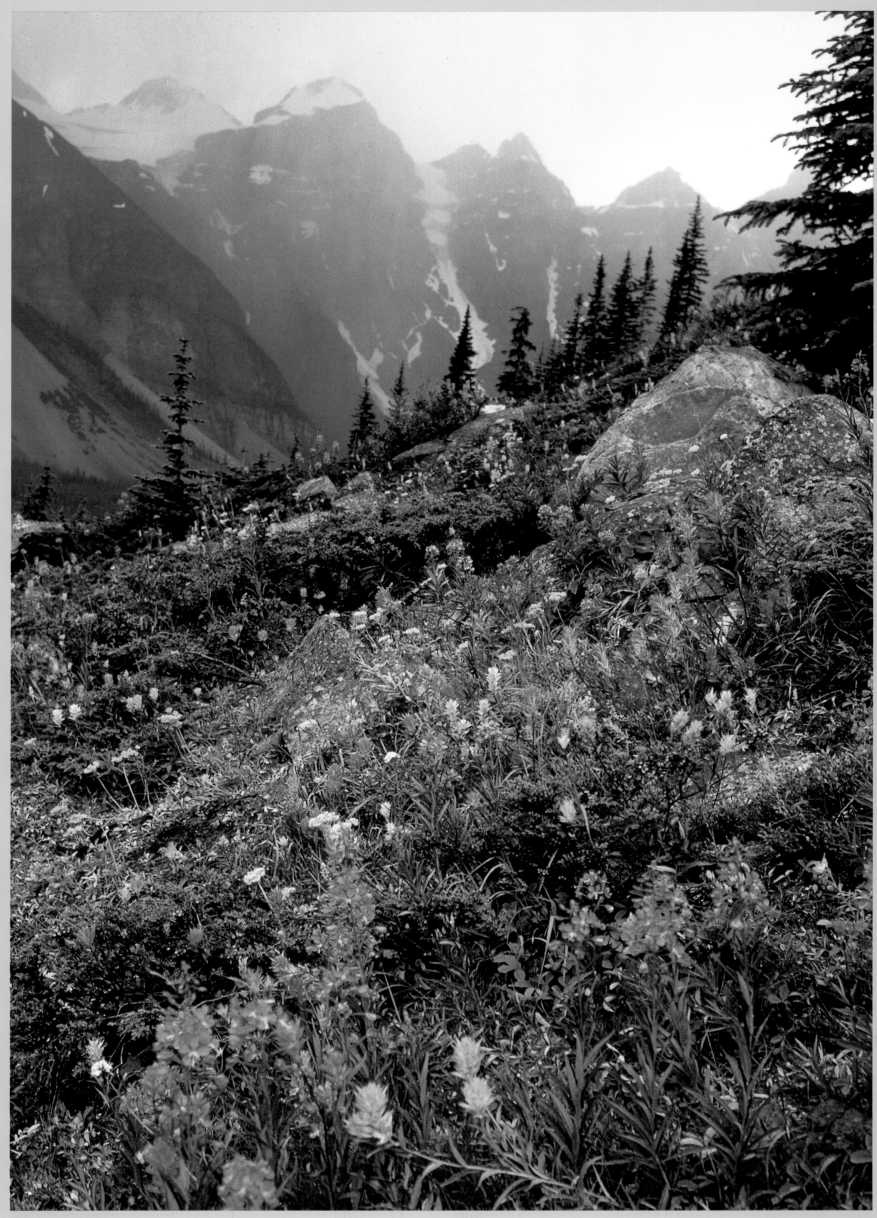

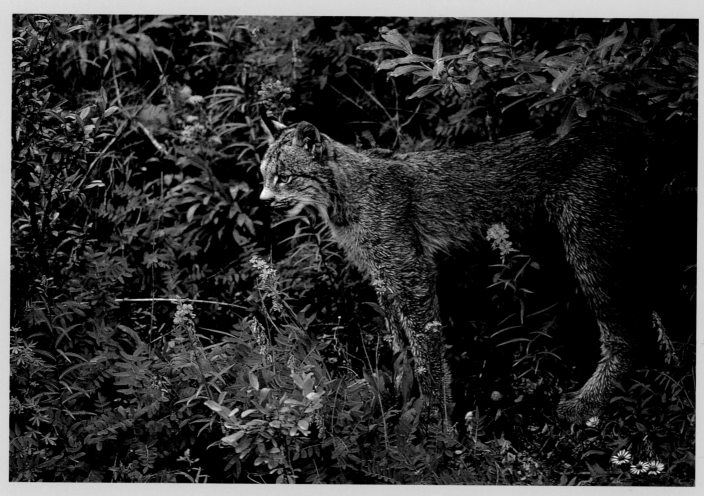

Portrait Of A Hungry Lynx

in Denali National Park, Alaska. In 1974, the rabbit popu-

lation in the park had one of its cyclical collapses. Nocturnal lynxes, who

live on rabbits, were forced to hunt their prey in daylight.

Galen made this rare photograph as a skinny lynx, fully aware of the

photographer's presence, stalked a snowshoe rabbit.

---◆---

In The Valley Of The Ten Peaks

of Banff National Park, Galen found an opulent carpet of wildflowers,

their colors intensified by the wetness of a summer

thunderstorm. (1973)

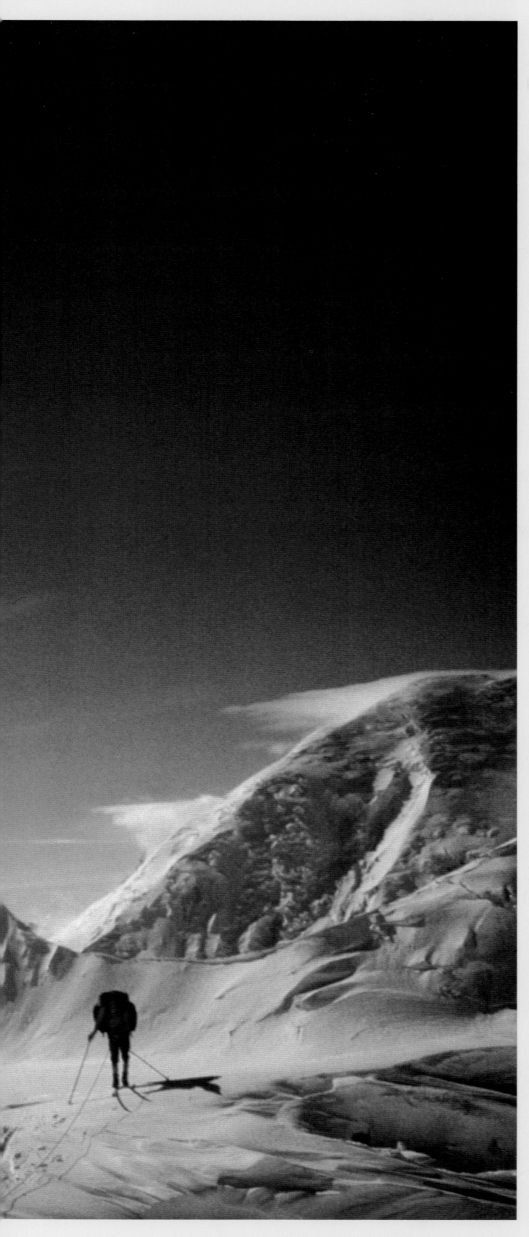

Twenty-thousand-foot Mt. McKinley is the highest peak in North America, and the Kahiltna Glacier is one of five major ice rivers that flow down and around its base. At about 8,000 feet, these glaciers begin to level out and circle the mountain, creating a 90-mile river of ice. Galen Rowell first saw this glacial beltway during a fly-over in 1972.

Six years later, he joined three other adventurers to circumnavigate McKinley on skis, using this route, which no expedition had ever completed. The pioneering three-week trek went relatively smoothly, despite a number of falls, one dislocated shoulder, brittle ice, abrupt storms and more than one unexpected avalanche. On the 19th day of the expedition, the small group discovered faint ski tracks in front of them. It took them a moment to realize that the tracks were their own. They had closed the great circle.

After the expedition, Galen and Ned Gillette, the original planner and leader of the McKinley orbit, decided to try the first one-day ascent of McKinley.

The plan was to get up and down the mountain quickly, so they wouldn't need a lot of gear. Speed would also help them avoid high-altitude pulmonary edema, an acute altitude sickness. This kind of climbing, on a mountain like McKinley where expeditions are normally three weeks long, is almost superhuman.

On their first attempt, the snow abruptly turned to blue ice at 13,400 feet. Ned slipped as he was about to switch from skis to crampons. The two men were roped together, and as Ned fell, he popped Galen off the mountain with him. Galen tried to break the fall by jamming his ski pole into the ice. The tip didn't hold, but the brief lull

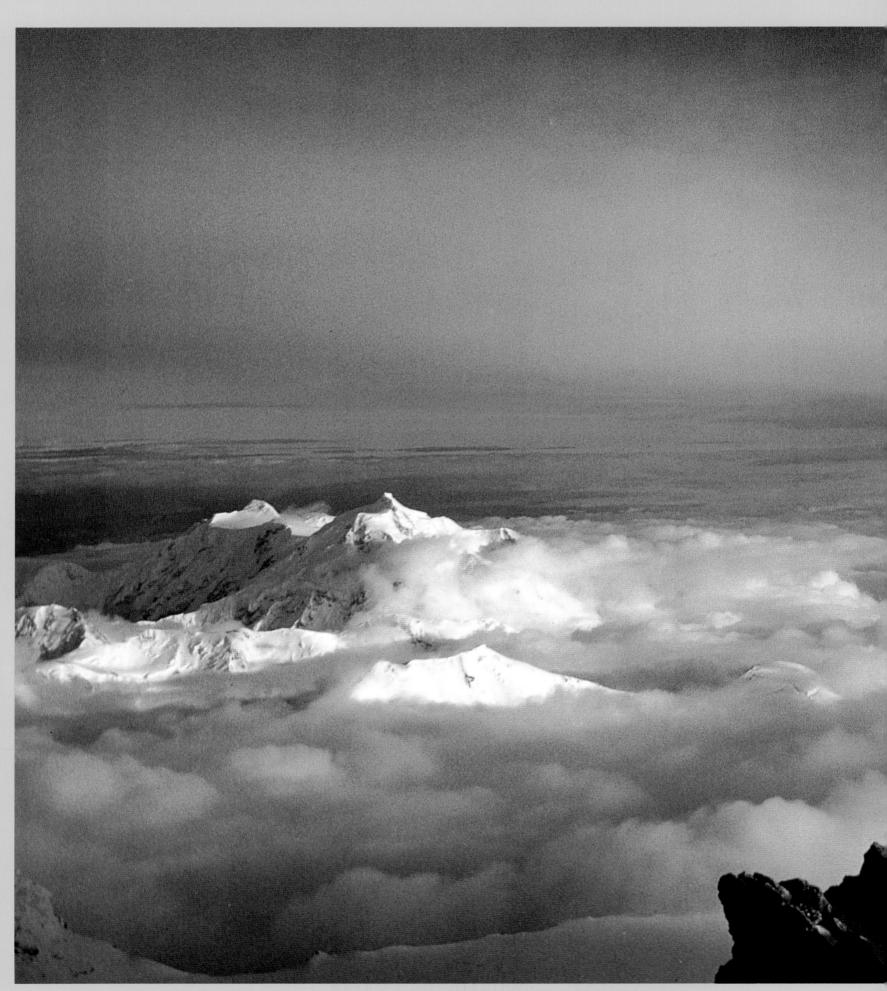

gave Ned the chance to grab an old polypro-pylene rope fixed on the mountain by a previous expedition. Ned's one-handed grip on the rope stopped their fall less than a yard from a 3,000-foot drop to the glacier below. Galen landed on top of Ned, and seriously slashed his face on the metal edges of Ned's skis. Later the same day, after a 12-mile journey down the mountain and a 180-mile ride to Anchorage, a plastic surgeon stitched Galen's face back together. A month after that, Galen and Ned were back on the mountain. This time, they made the summit, becoming the first men to climb McKinley in a single day.

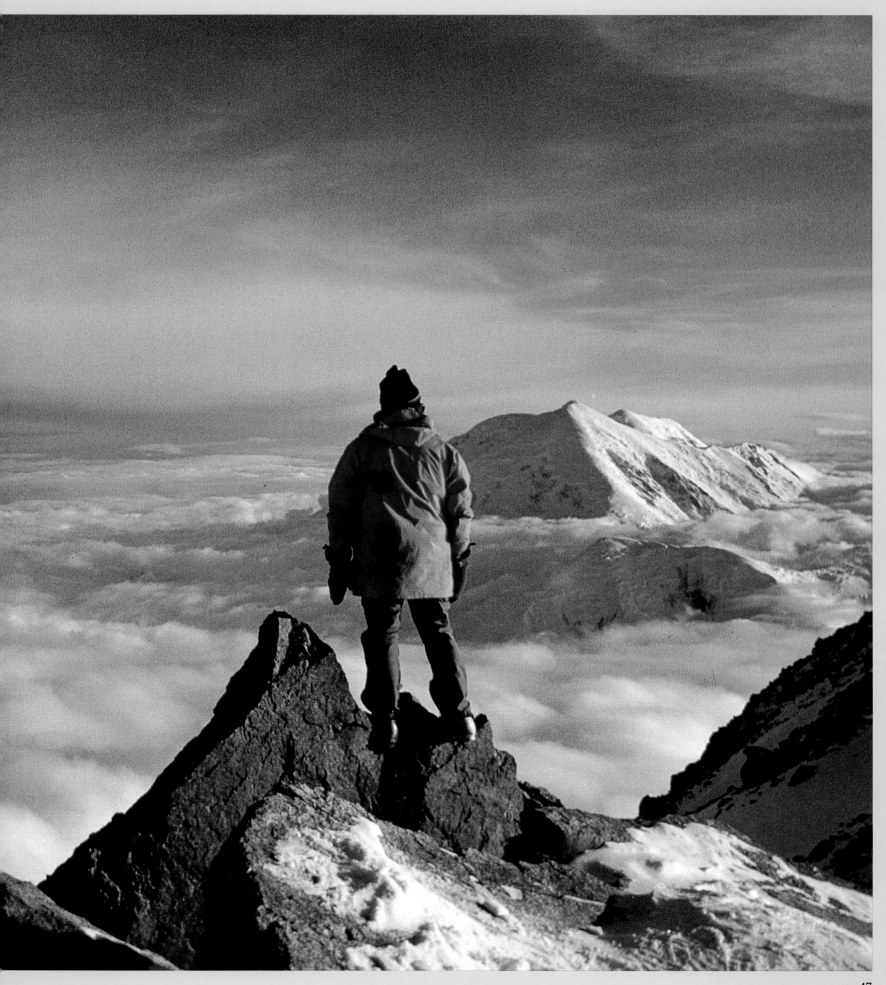

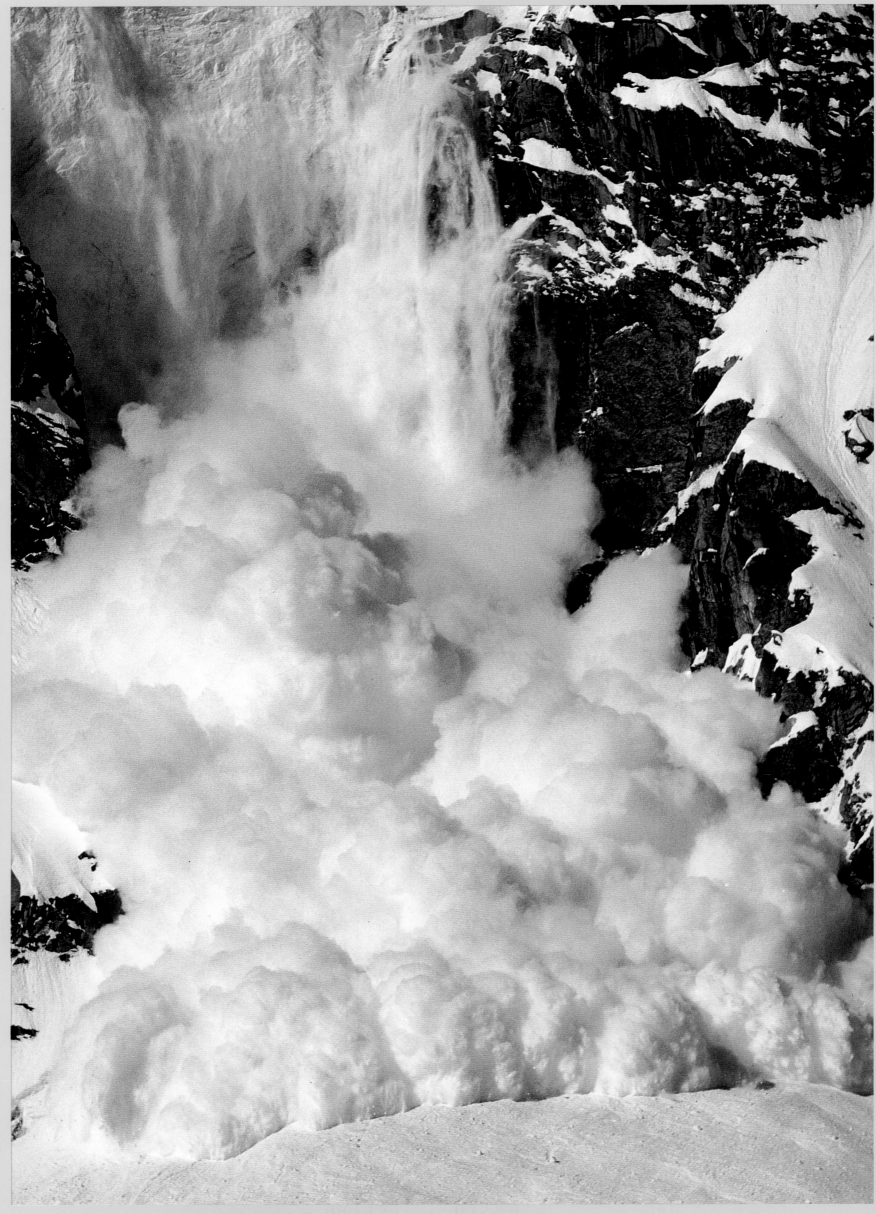

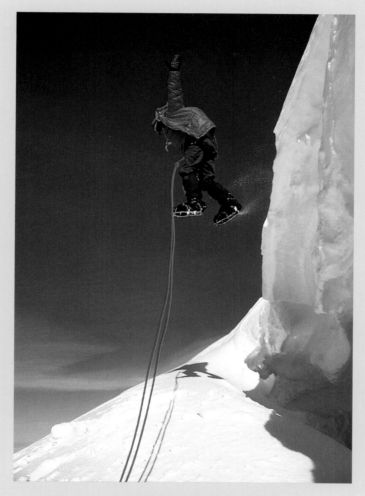

CRAMPONS FLASHING,

Doug Weins leaps across one of the many crevasses on the Peters Glacier
that bedeviled the Mt. McKinley orbit expedition.

◆

A FURIOUS AVALANCHE

off one of McKinley's hanging glaciers interrupts a still morning on
Ruth Glacier. With a sudden blast of cold wind, the cloud from
the avalanche roared across the narrow valley, engulfing Galen and the rest of the
skiers. They were coated with a half-inch of snow that
powered through parka seams, zippers and cuffs, down to their polypropy-
lene underwear. Galen snapped this photo before quickly
zipping his camera in his hip sack.

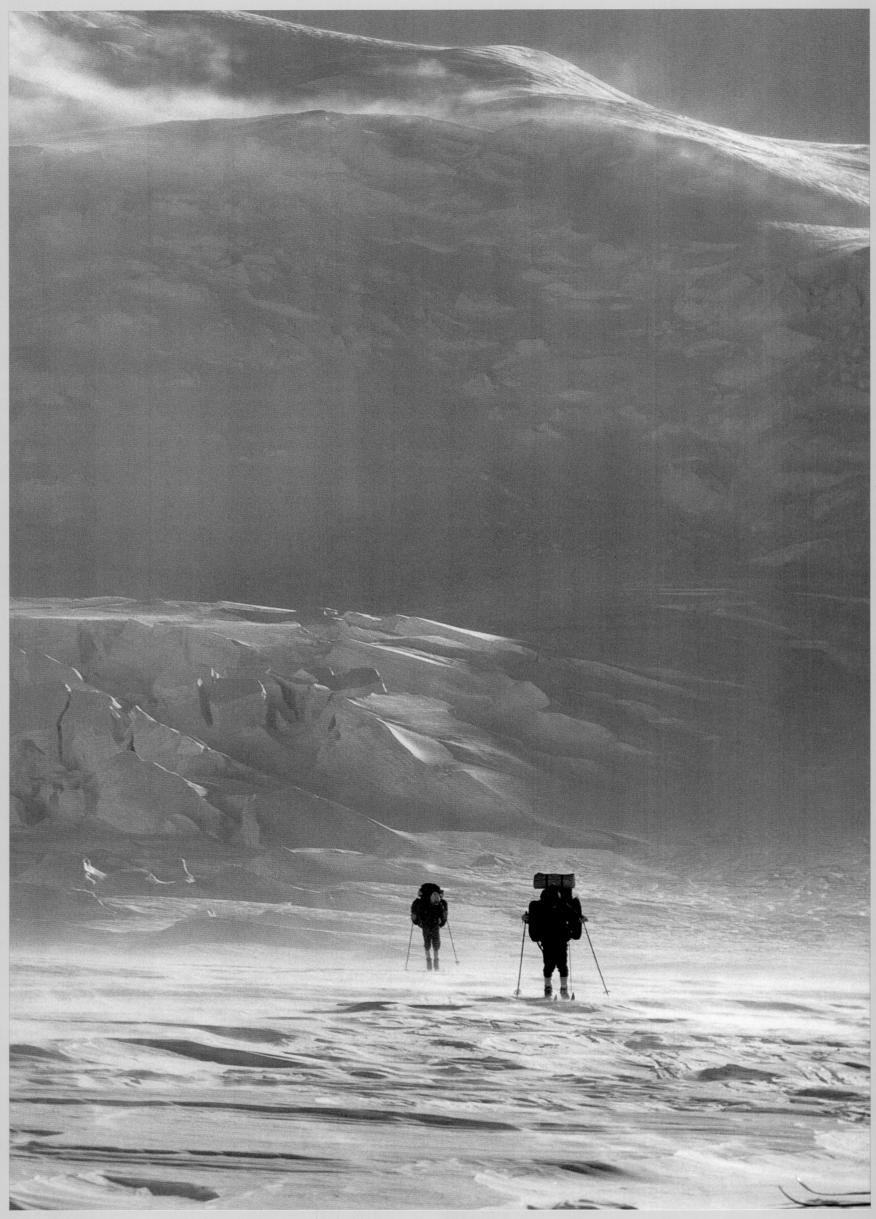

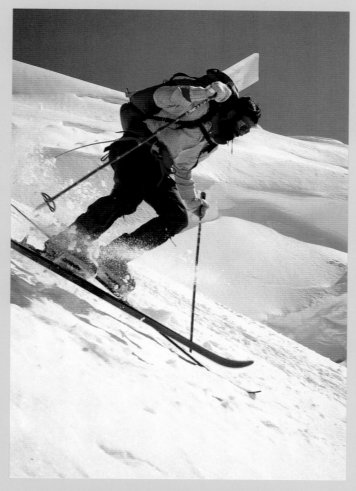

AFTER CLIMBING McKINLEY IN ONE DAY,

Ned Gillette flies down the mountain on skis he and Galen had
stashed, along with Galen's 35mm camera, at 13,000 feet
on the way up. Sadly, Galen's photographic record of the summit was
lost, permanently shredded in the frozen mechanism of a
6-ounce Minox camera.

◆

ICE AGE TERRAIN OVERWHELMS ADVENTURERS

on Peters Glacier during the McKinley orbit expedition. The vast
glaciers and mind-bending isolation of the Alaska
Range later fed Galen's dream of an even more ambitious ski tour
through the Karakoram Himalaya.

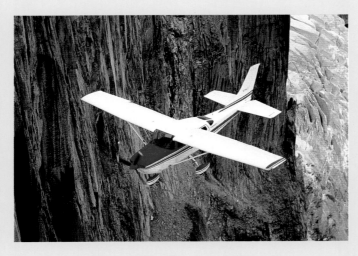

ALASKA'S TRANSPORTATION OF CHOICE

*Galen's wife, Barbara, flies close to the dizzying walls of the
upper Ruth Gorge in their Cessna 206 Turbo. Alaska bush pilot Doug
Geeting flew Galen into position for this shot. (1986)*

◆

LIKE YOSEMITE IN THE PLEISTOCENE,

*Ruth Gorge in the Alaska Range is a sheer-walled granite valley.
In 1974, Galen made the first ascent of the 5,000-foot
southeast face of Mt. Dickey, the highest wall in the gorge, visible just
right of center in this aerial view. (1986)*

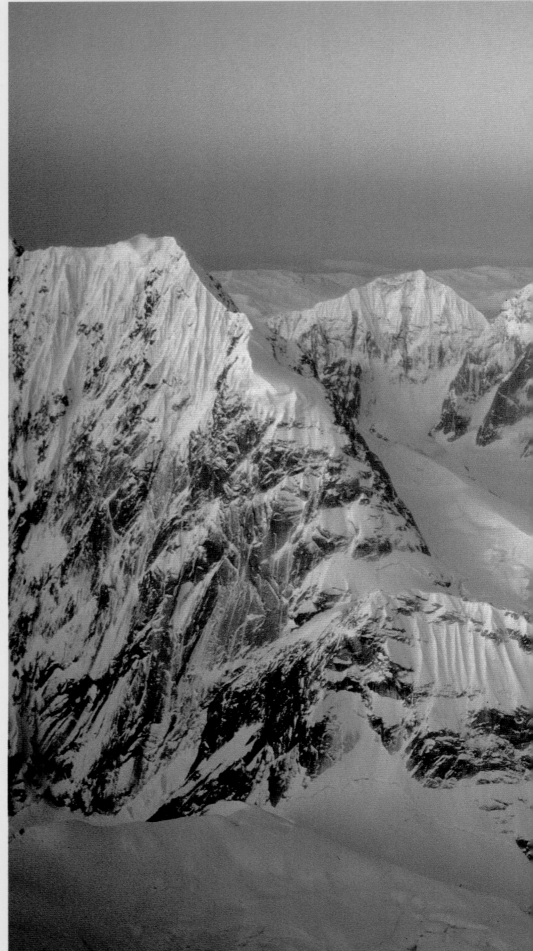

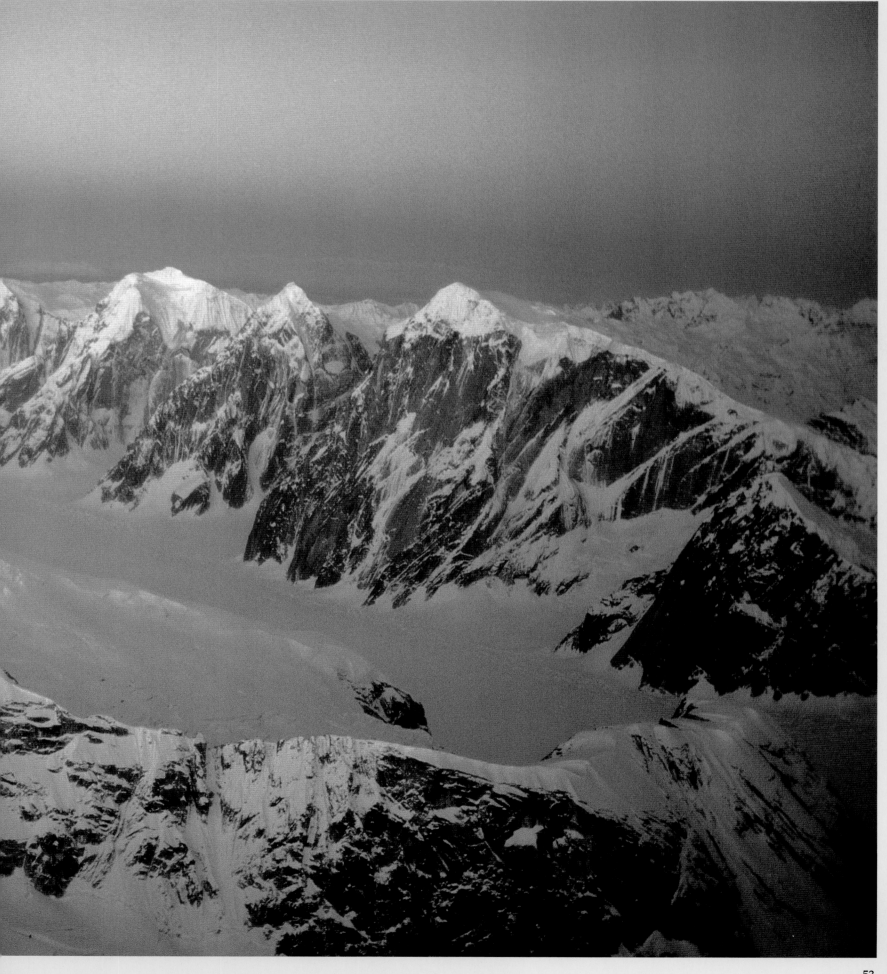

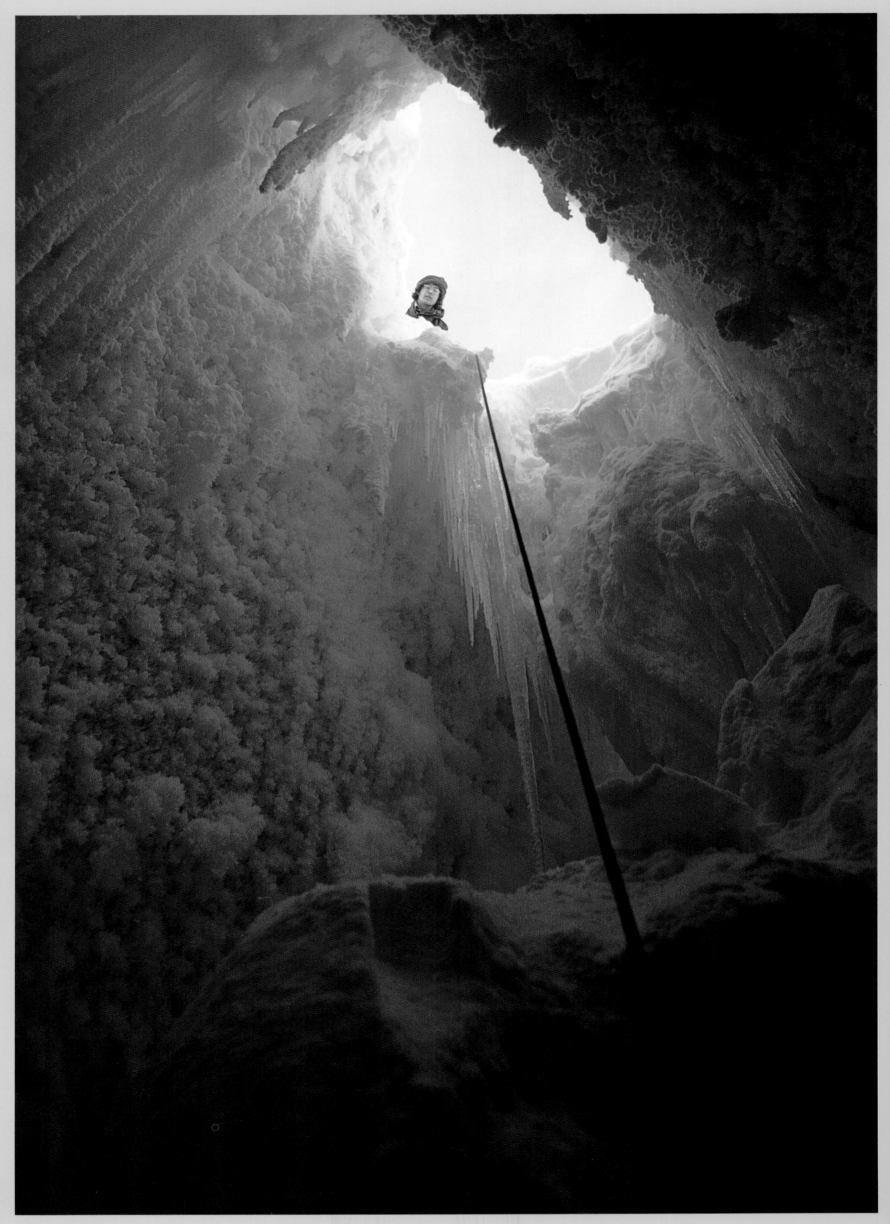

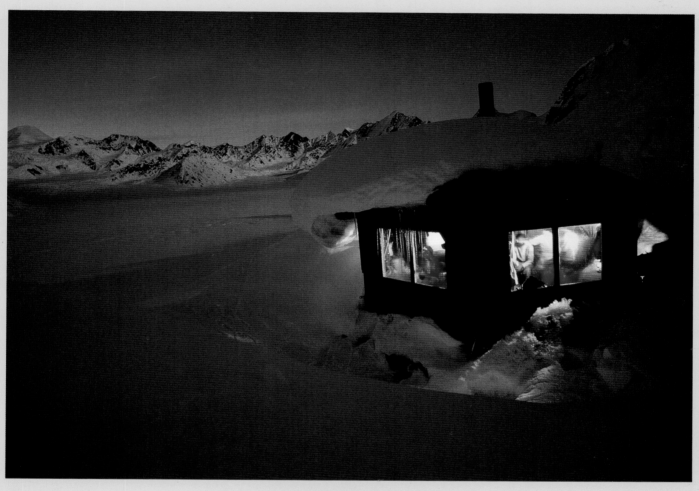

Don Sheldon's Mountain House

*on the ledge of Ruth Gorge is the only building in thousands of
square miles of icy wilderness in the Alaska Range. (1978)*

◆

On The Backside Of Mt. Dickey,

*Galen suddenly found himself dangling from a safety rope
35 feet down a deep, hidden crevasse. Despite the
plummet, Galen had the presence of mind—and sense of humor—
to snap this picture of his concerned companion
peering into the hole. (1974)*

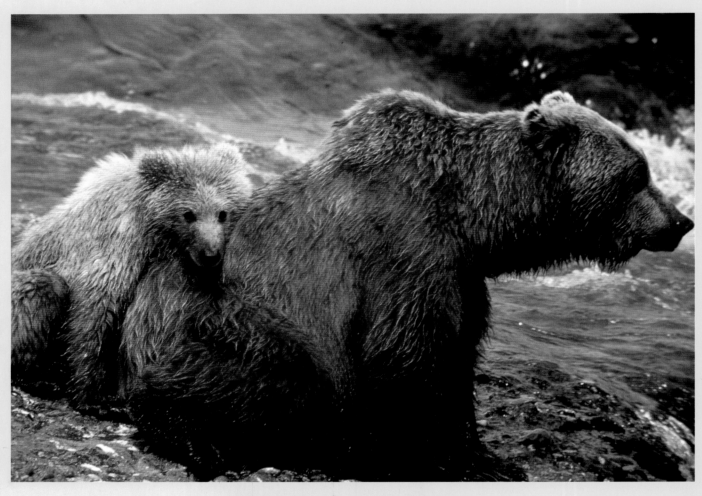

Every Summer, Alaska's McNeil River
hosts a convention of giant Kodiak brown bears that gather to feed on
spawning salmon. At one point during this
portrait session, Galen counted 31 bears within a hundred yards of his
camera. For safety, Galen was accompanied by a fish and
game warden carrying a loaded shotgun. (1979)

———————◆———————

Reflection Pond, Denali National Park, Alaska
"I had fine light coming in from three different places," Galen says of one
of his favorite landscapes, "alpenglow up in the clouds,
side-light coming onto the grasses, and the soft light from the sky
on the berries and leaves in the foreground." (1986)

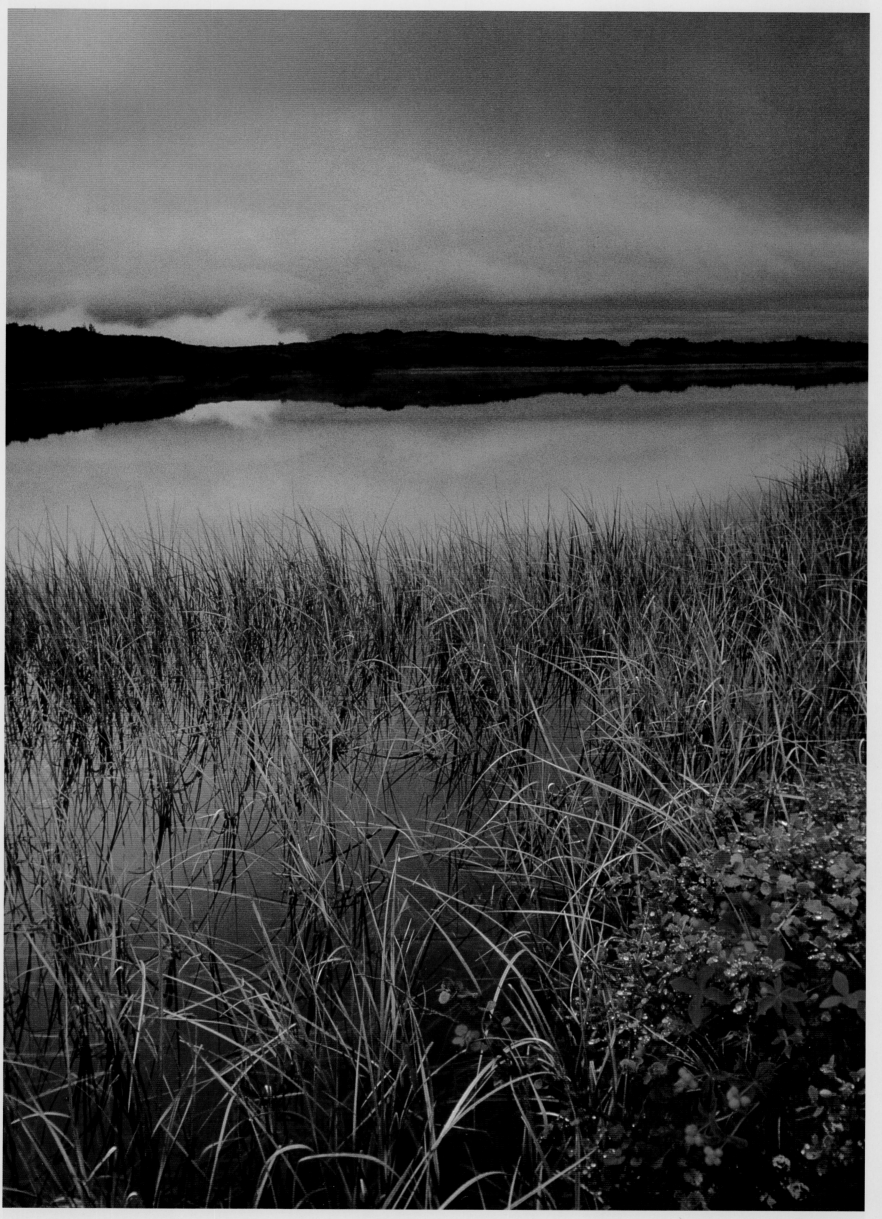

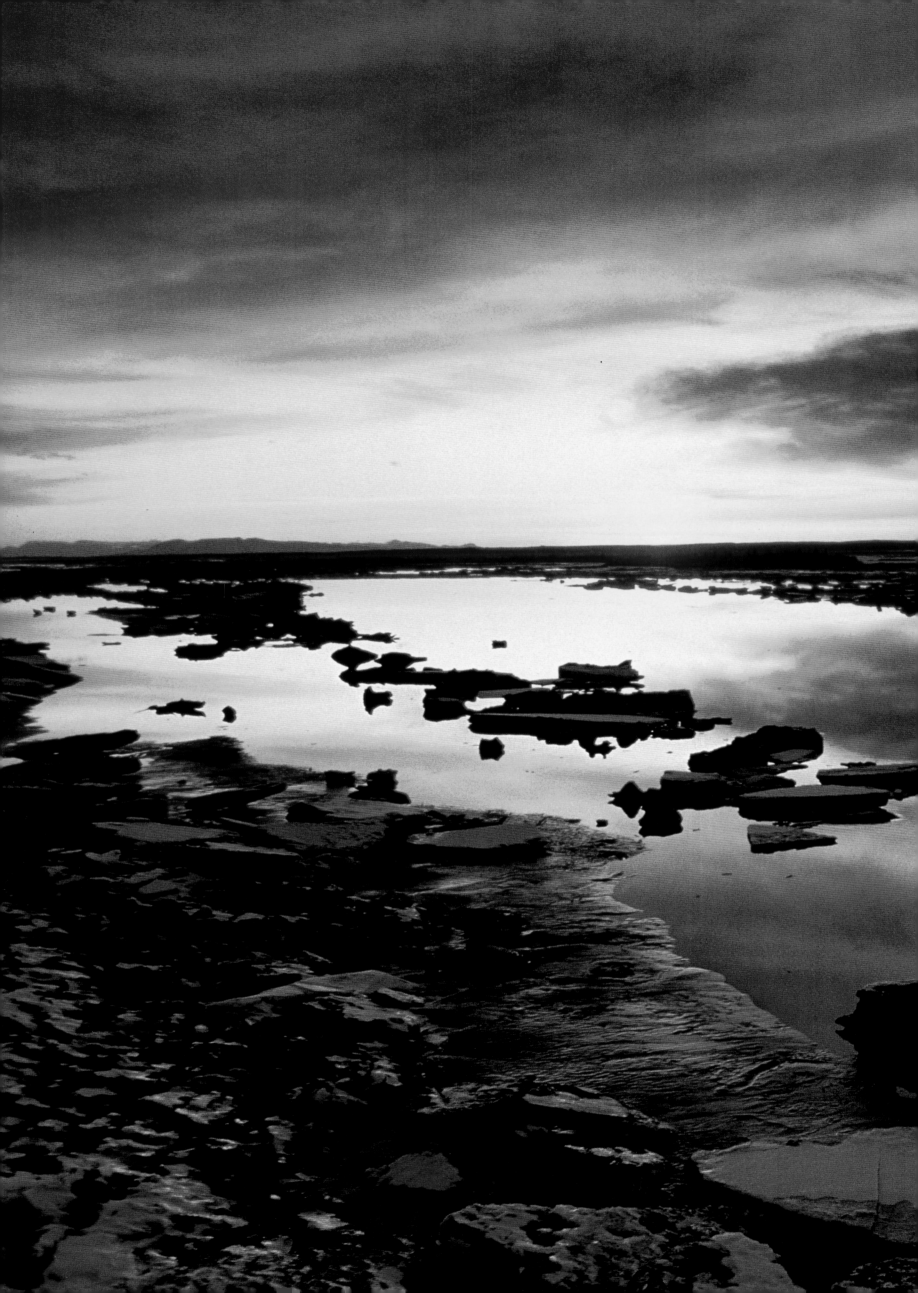

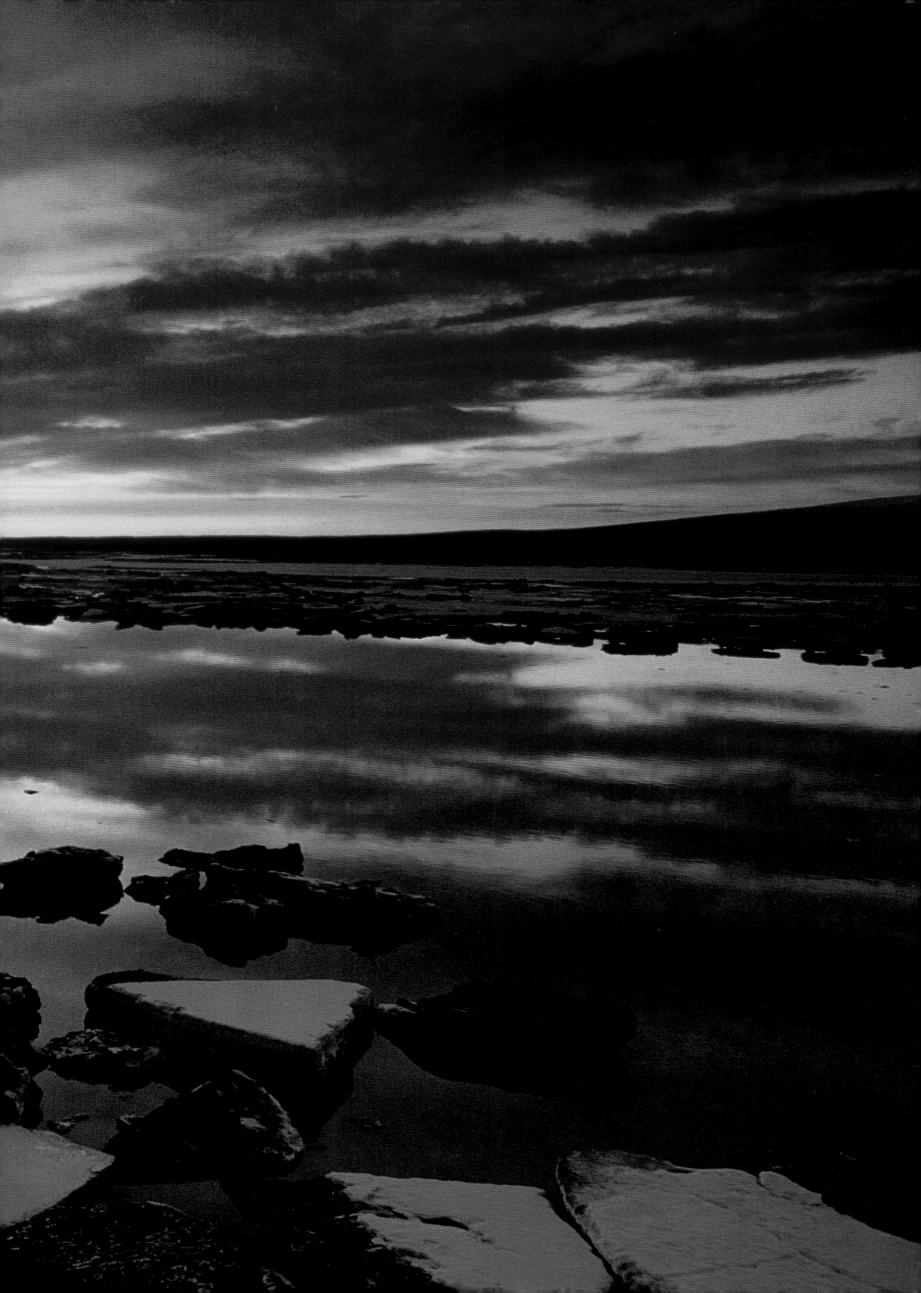

"ICE CREATES ITS OWN PALETTE,"

Galen says, "a shifting blueness caused by the way light rays scatter, much like the variable blueness of the sky." Here, ice-bergs in front of Portage Glacier south of Anchorage, Alaska. (1980) Preceding page: A lurid sunset and blue snow on the ice-clogged Knik River, near Anchorage. (1988)

———◆———

THE GRANDEUR OF CENTRAL ASIA

A colossal sand dune dwarfs two Kirghiz riders at 13,000 feet in the heart of the Pamir mountains in western China (following page). (1980)

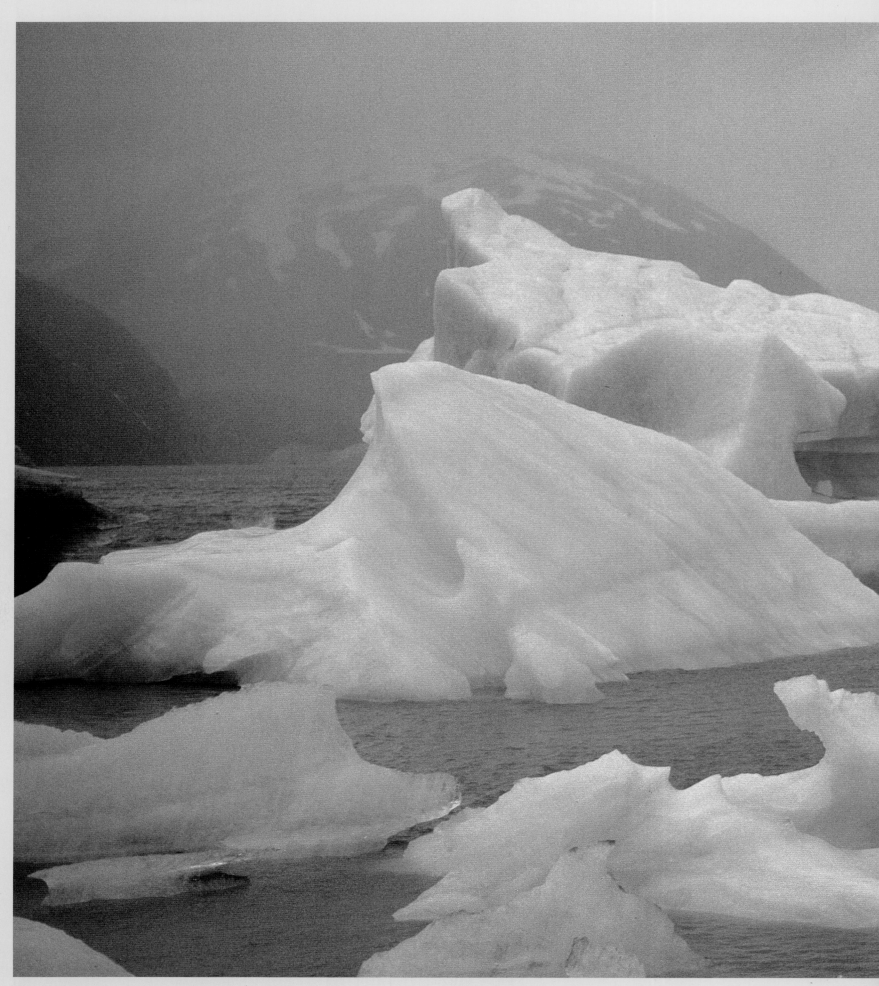

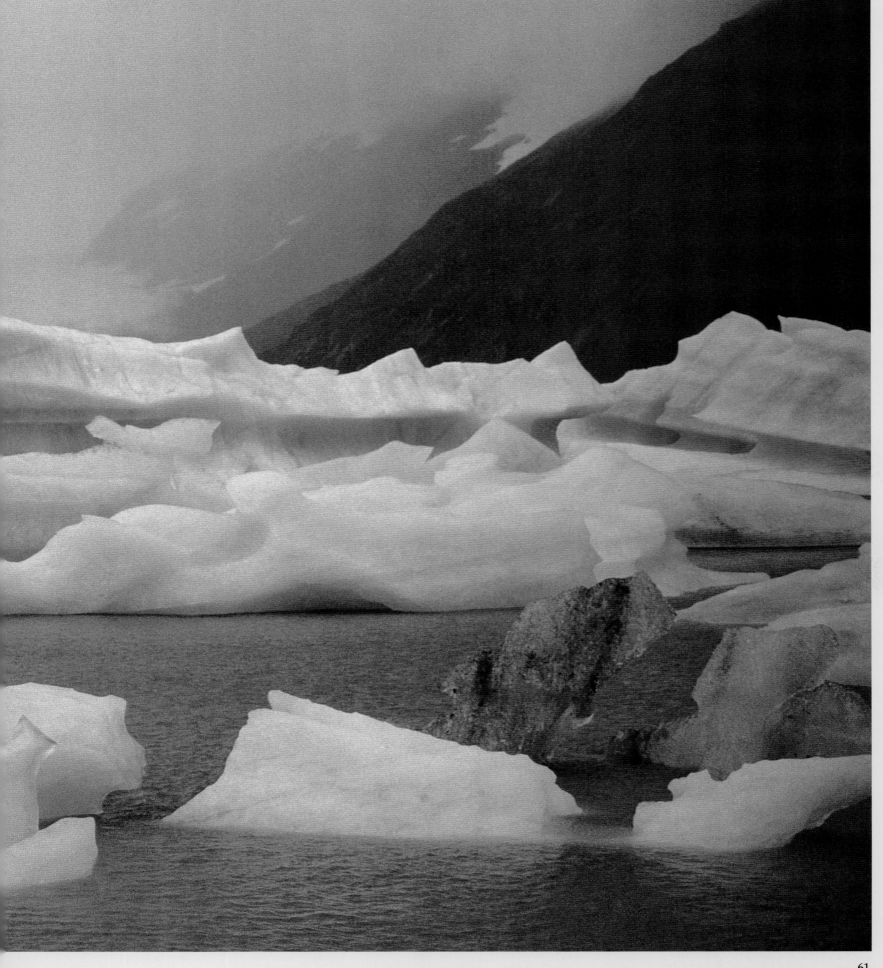

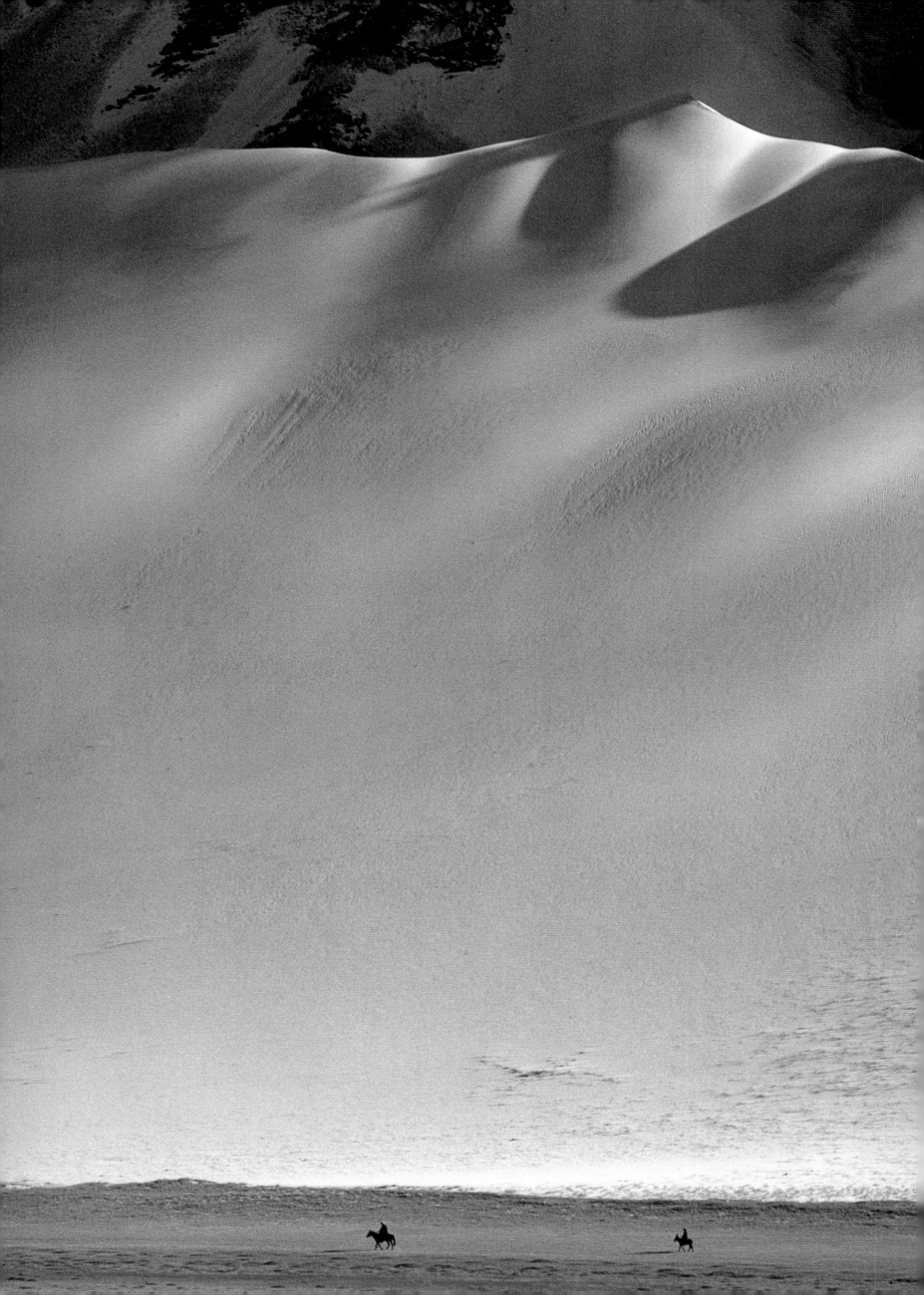

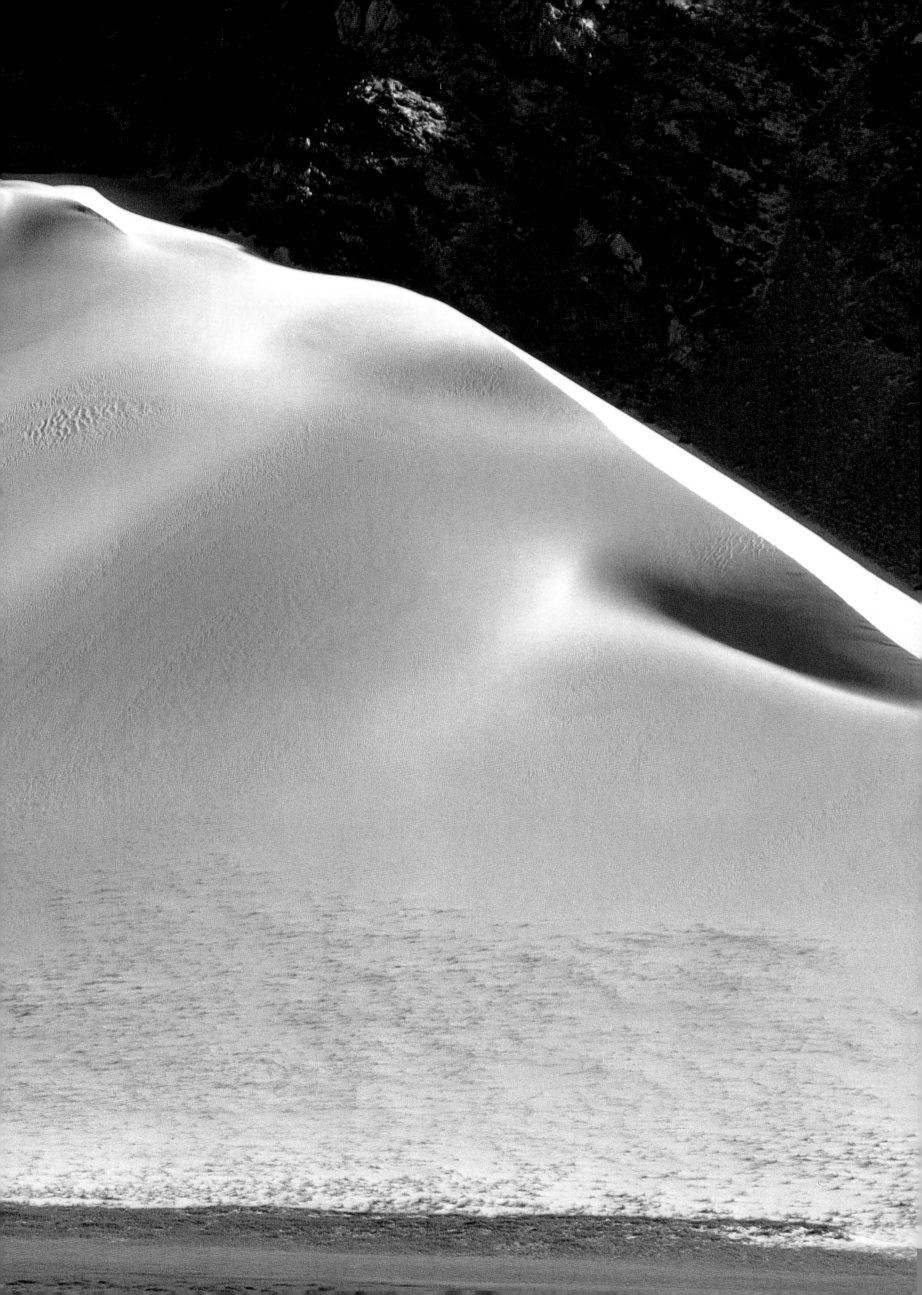

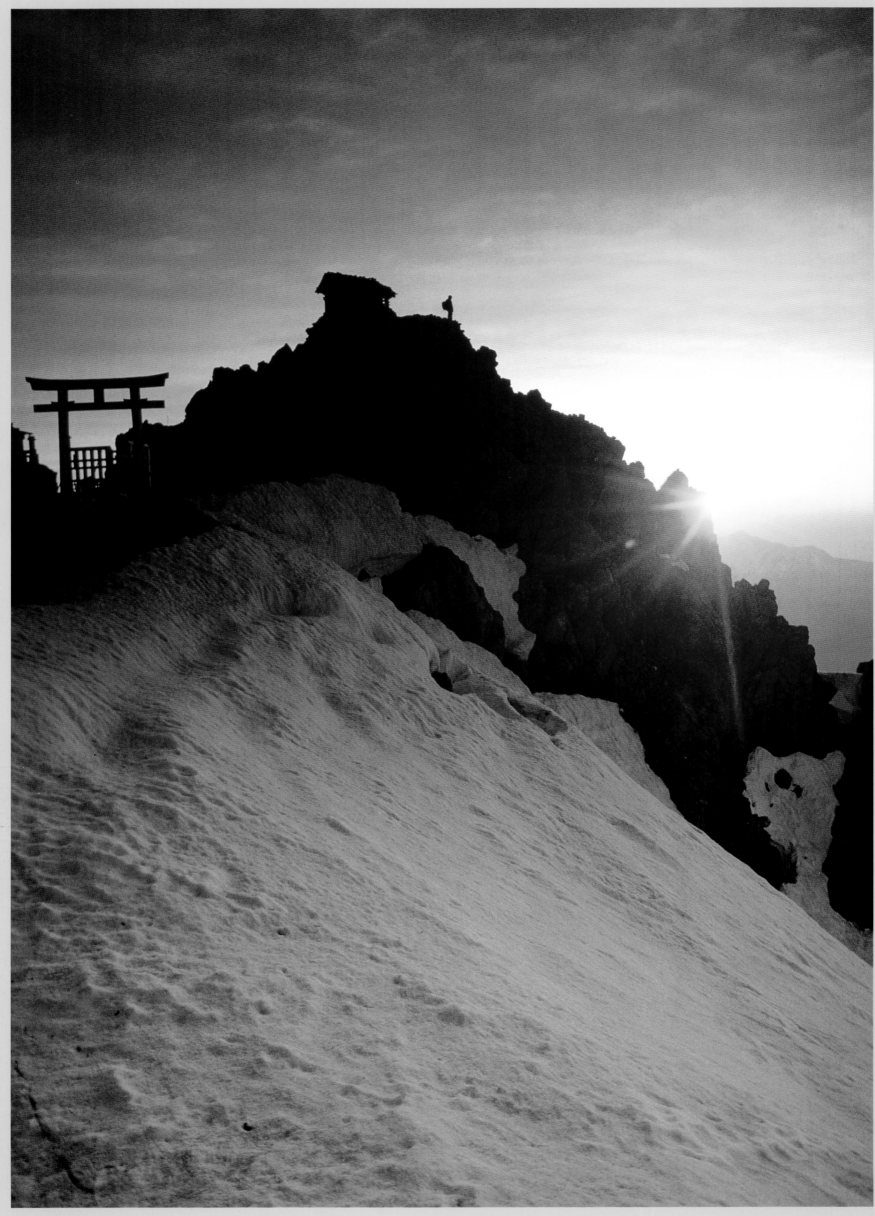

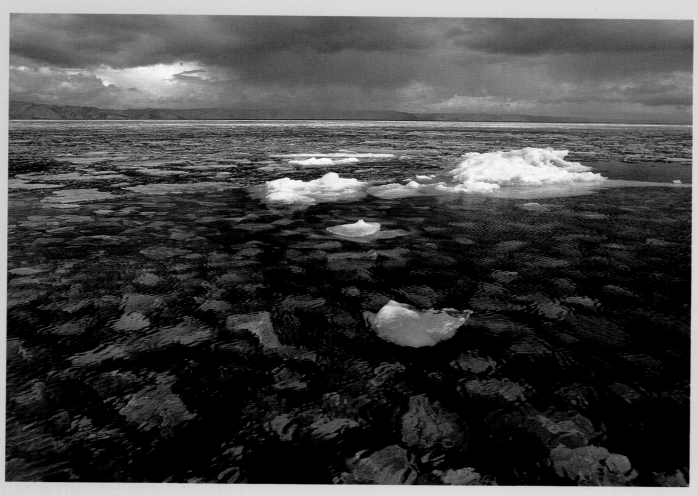

SIBERIA'S "BLUE PEARL,"

Lake Baikal is the deepest lake in the world, a natural reservoir

for 22 percent of the earth's fresh water. Galen

photographed the crystal waters in southern Siberia on May 15, 1987,

when he joined 100 international photographers to document

A Day in the Life of the Soviet Union.

◆

A SHINTO SHRINE, CIRCA A.D. 703,

tops Mount Tateyama in Japan's Northern Alps. Galen climbed

the peak during the night to make this image at dawn on June 7, 1985,

while working on A Day in the Life of Japan.

THE ANNAPURNA RANGE

rises behind a camp in the Nepal Himalaya. Galen donated his time to the

World Wildlife Fund to document the creation

of the Annapurna Conservation Area, a model for future nature

preserves in the Third World. (1987)

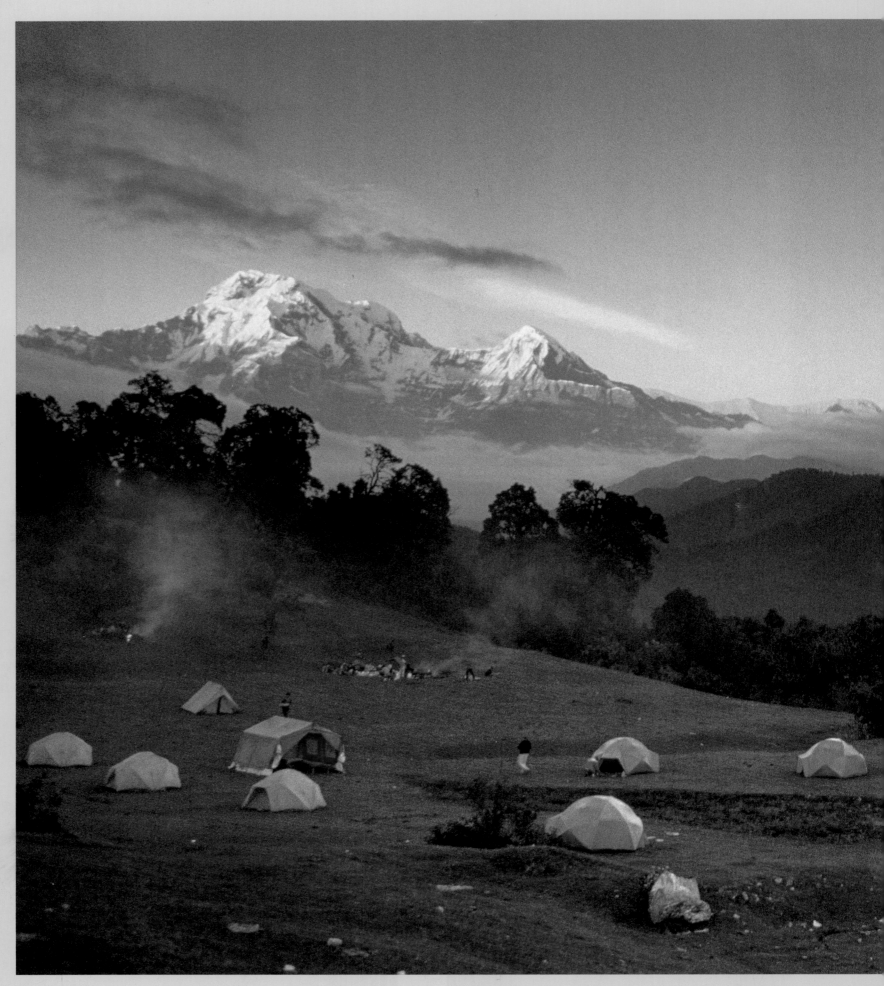

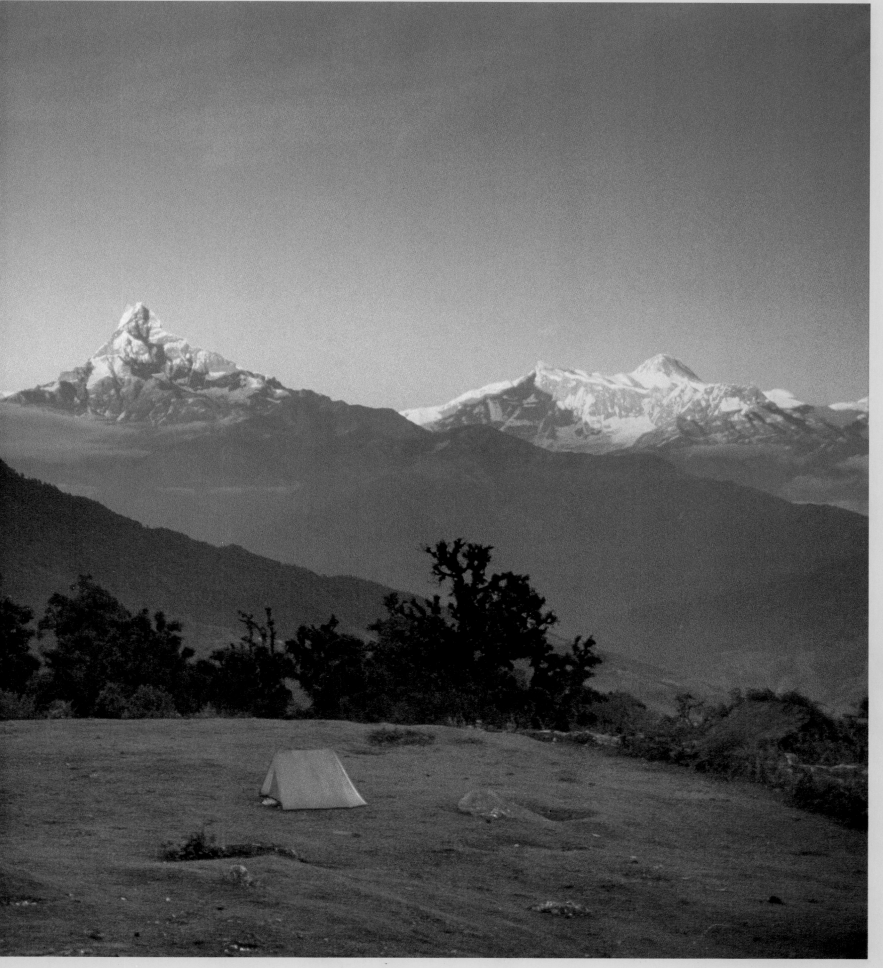

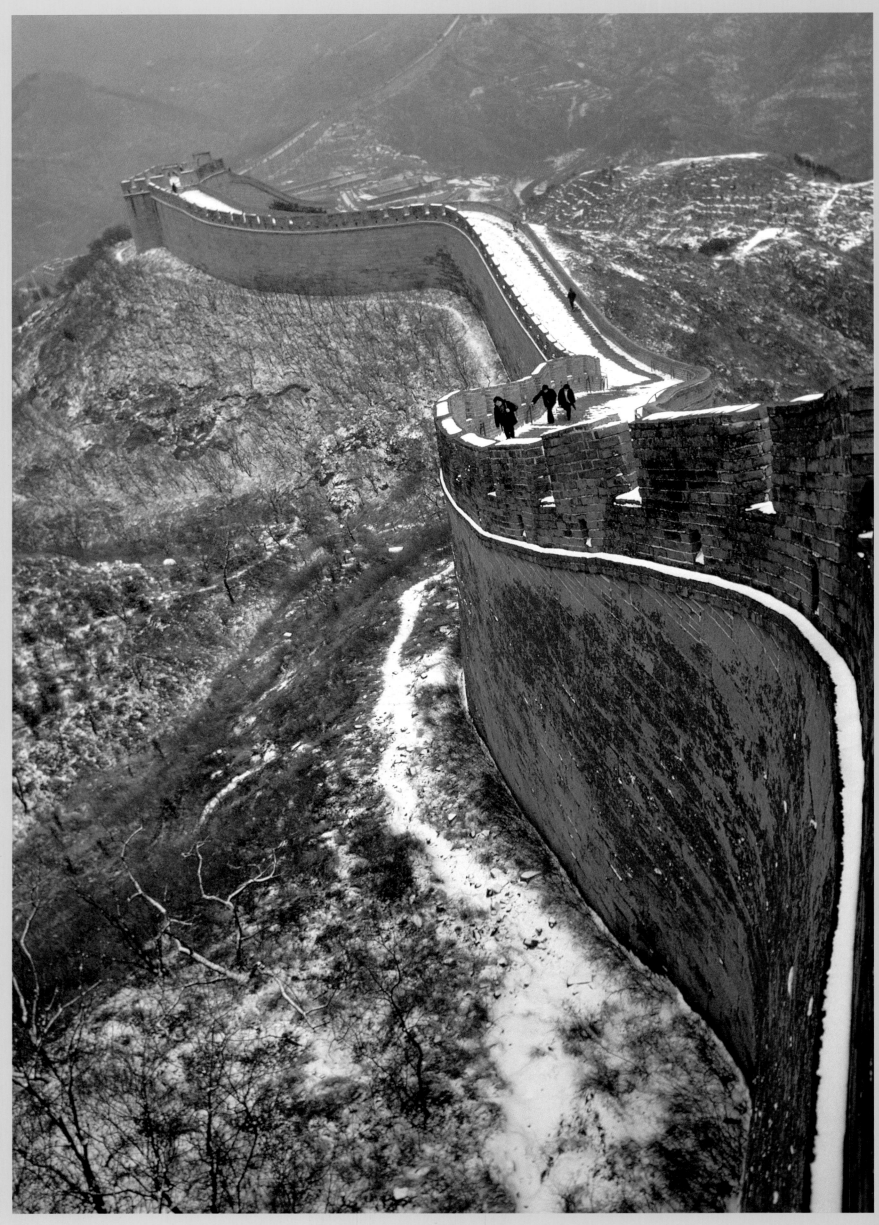

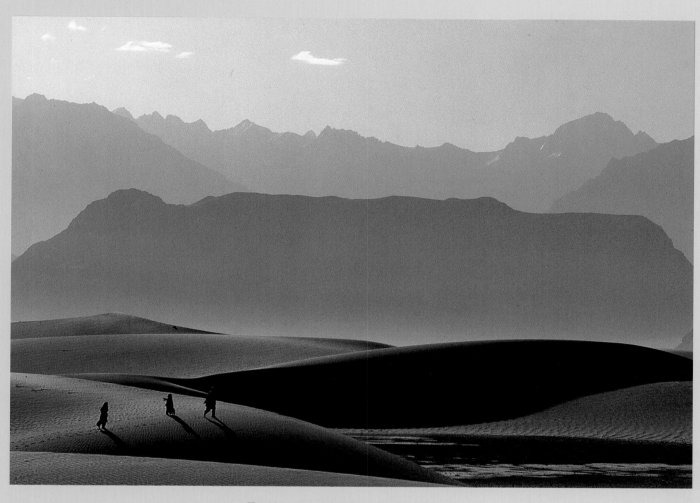

THE ANCIENT KINGDOM OF BALTISTAN,

*now part of Pakistan, was founded where sand and snow meet in
the heights of Central Asia. Here, three members of a Balti
family cross the Skardu Valley on their way to market. Behind them
lie the foothills of the Karakoram Himalaya. (1984)*

◆

VISIBLE FROM OUTER SPACE,

*the 1,500-mile Great Wall of China was completed
in A.D. 221. More than 300,000 men took ten years to complete the
barricade. Galen first encountered the Great Wall in
1980, and returned three years later to make this winter image
on his way to Mt. Everest.*

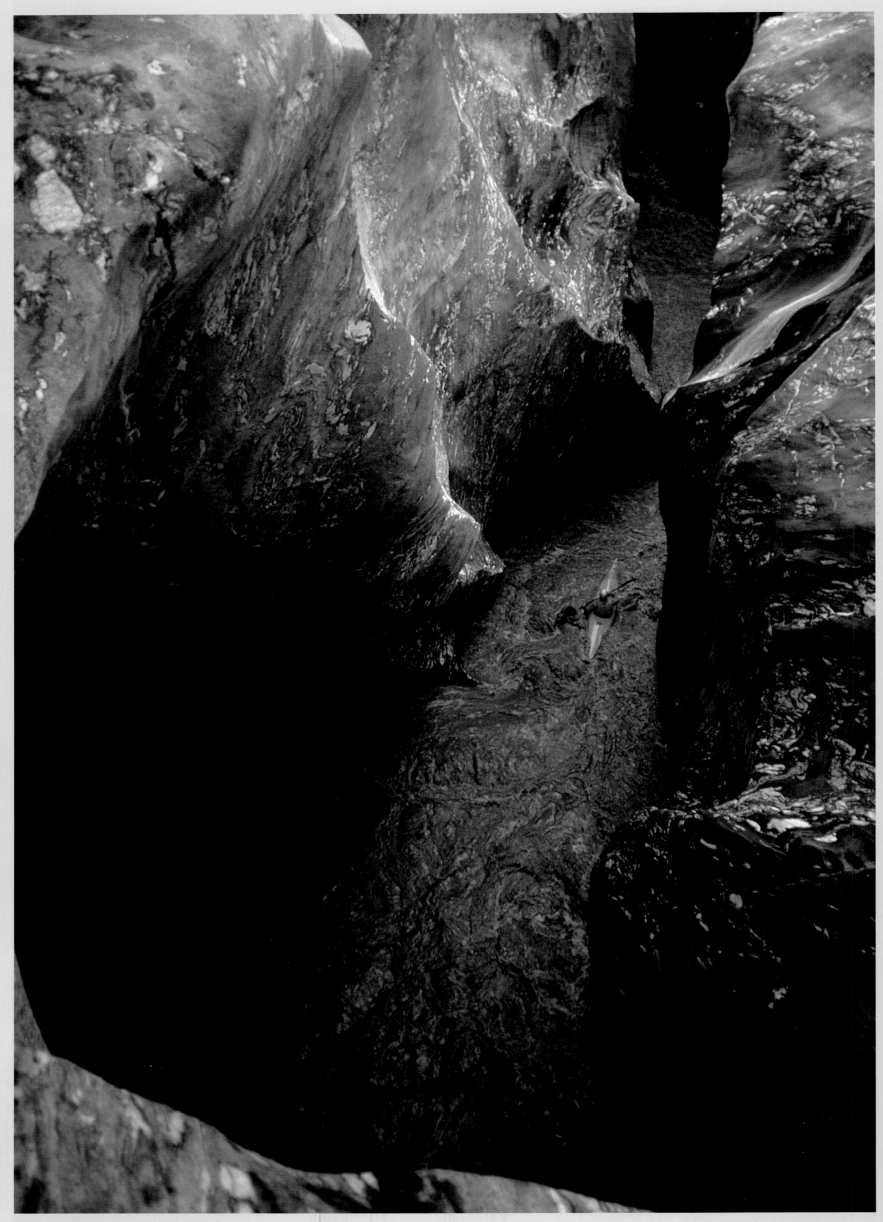

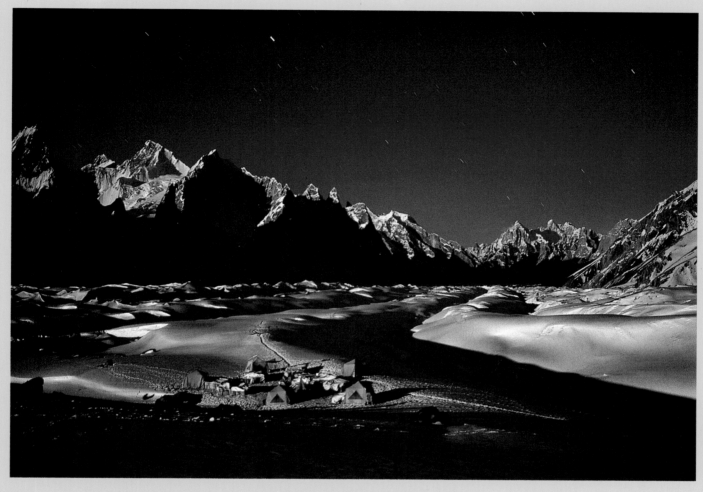

GALEN'S FAVORITE PLACE IN THE HIMALAYAS:
Concordia, where six glaciers join the great Baltoro ice flow in the
heart of the Karakoram Range. Here at the crossroads,
on the deceptively still surface of a frozen river, expeditions traditionally camp
en route to the mountains they plan to climb. Galen took this moonlit,
four-minute time-exposure of his Concordia camp
during an unsuccessful 1975 attempt to climb K2, the world's
second-tallest mountain.

———————◆———————

THE NARROWS OF THE BRALDU RIVER
are carved by furious waters flowing from the glaciers of the Karakoram
Himalaya. Galen joined a dual-purpose expedition of kayakers
and climbers bound for the Braldu and the peaks beyond in 1984. The photog-
rapher ran along the rugged banks of the river for two days to
chronicle this first successful descent. Left: A vertiginous shot of kayaker/
mountaineer Andy Embeck shows him entering a
"slot of no return."

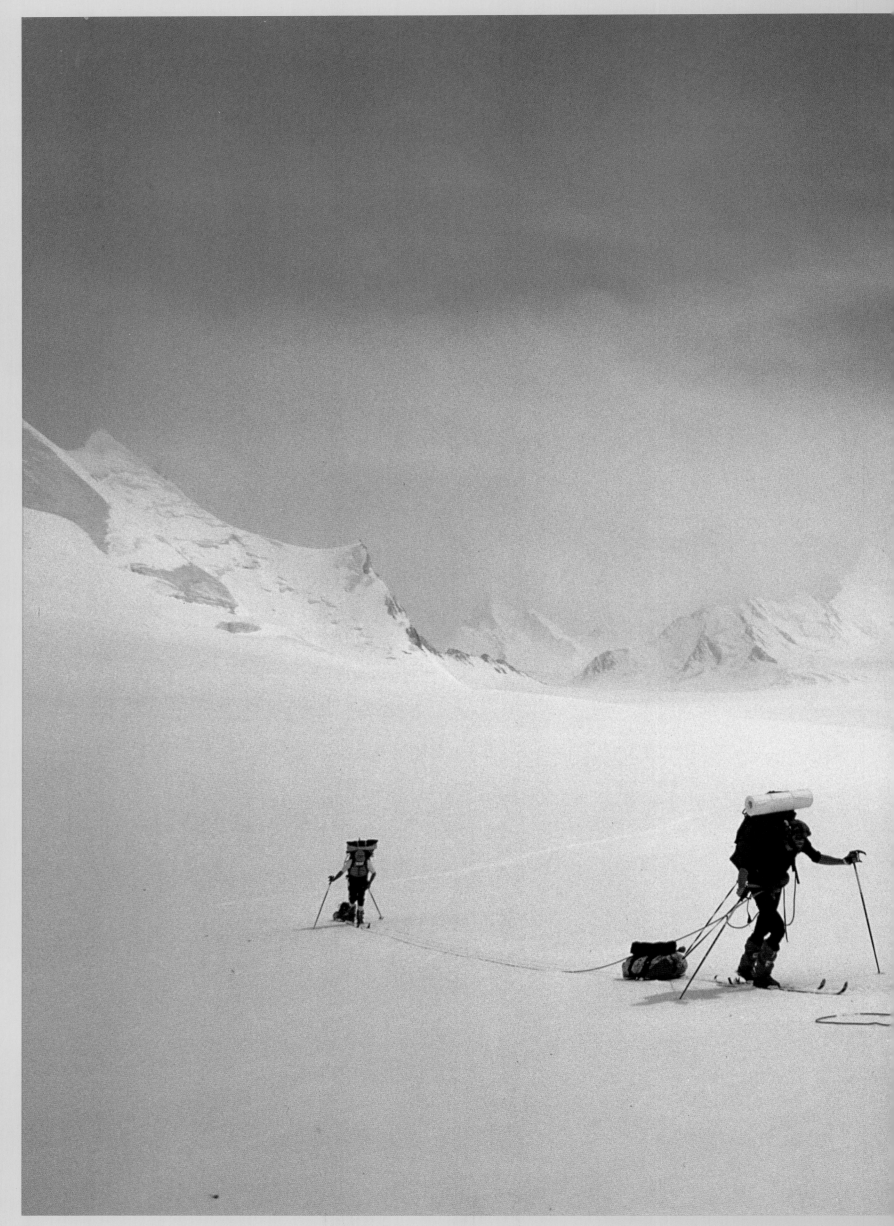

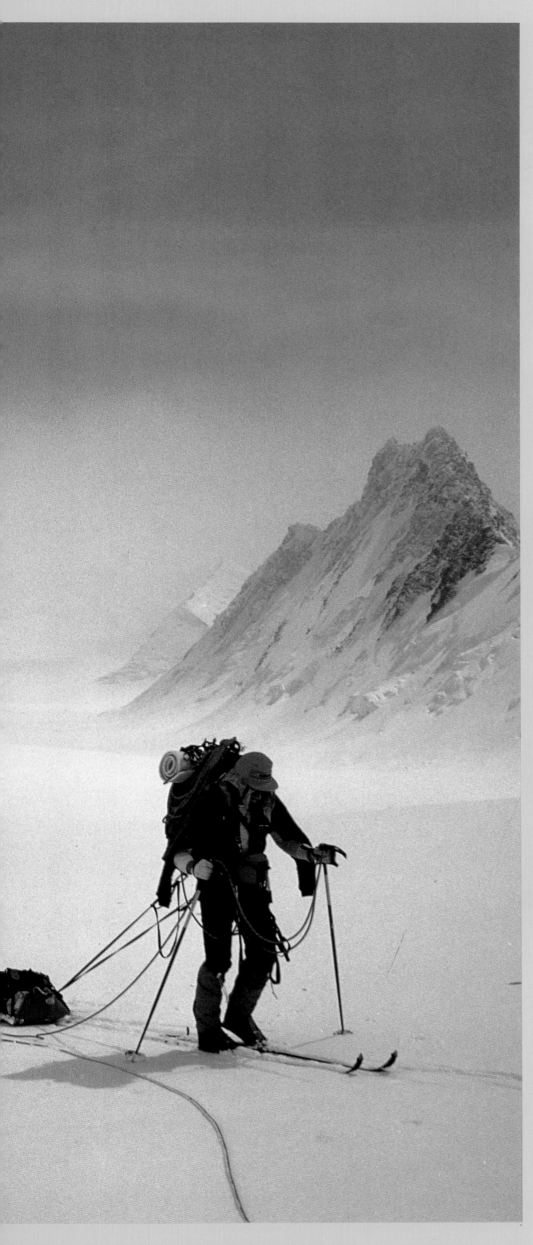

"We have each known greater cold, but never in such an utterly vulnerable situation. Our umbilical cord to civilization has been purposely and completely severed. We are totally dependent on what we can carry ourselves ... What if a ski, a boot, or a tent fails? We have no other."—from Galen Rowell's journal

In the late winter of 1980, Galen Rowell, Dan Asay, Ned Gillette and Kim Schmitz set off on a 285-mile ski-traverse across the remote Karakoram Himalaya in northern Pakistan. Their route followed four of the longest glaciers outside the subpolar regions (Siachen, Baltoro, Biafo and Hispar) through the planet's highest and most exotic peaks: K2, Mustagh Tower, Broad Peak Masherbrum, Gasherbrums I-IV, the Ogre, Great Trango Tower and Chogolisa.

As much as the mountains beckoned, the team had no plans to climb them this time out. Instead, Galen had dreamt up a ski tour that followed a glacial highway through a high, remote and mystical part of the world. This six-week Karakoram traverse turned out to be his most taxing, most difficult adventure.

During those six weeks, the temperature some-times dropped to minus 25 degrees F. Often, the fabulous peaks—and the skiers—were shrouded in clouds. Still, the expedition crept along on skis, each man bowed under 120 pounds of food, fuel and equipment—everything he would need for the journey. Supplies that wouldn't fit on their backs were dragged behind on children's plastic sleds. On good snow, they traveled at four miles per hour downhill; on bad snow, clambering amidst meltwater streams, they slowed to four miles a day. On these days, time and distance became glacial.

Forty-four days after stepping onto the Sia-

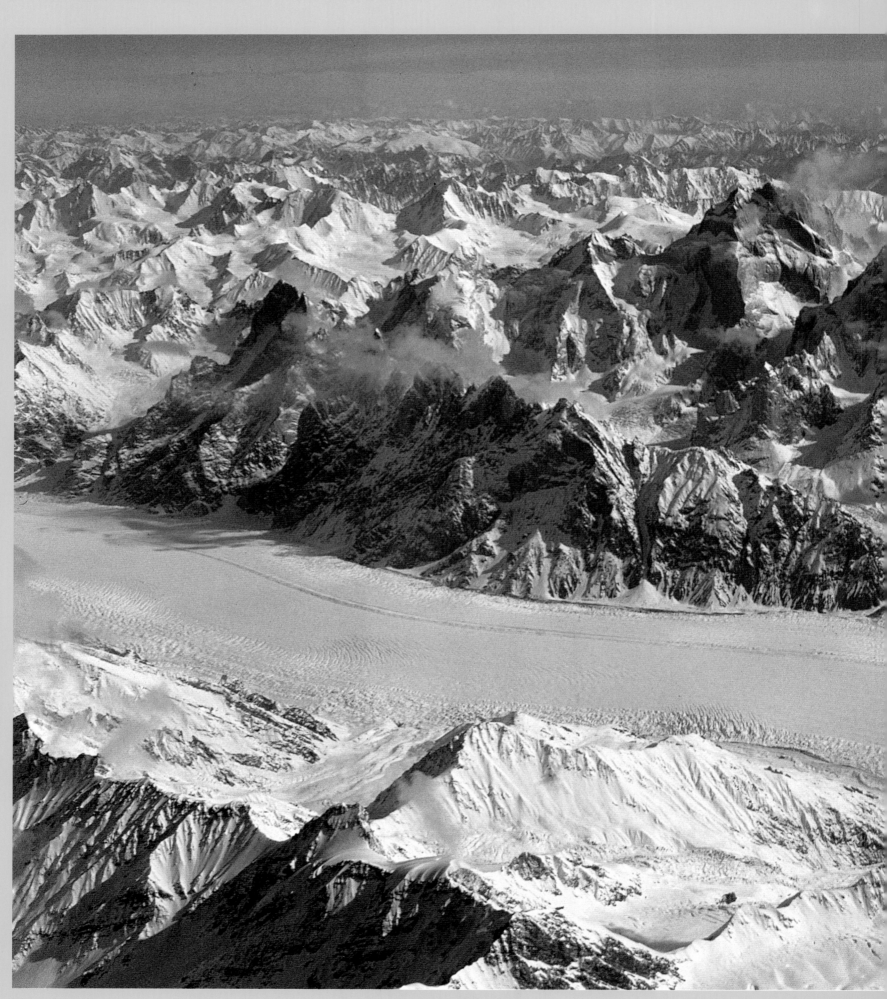

chen Glacier, the expeditioners ended their trek at Hunza, having traversed most of Pakistan, east to west from the Indian border almost to Afghanistan. Below: An aerial view of Biafo Glacier, the third leg of the Karakoram traverse.

The adventurers' re-entry to civilization was muted. The trauma of moving through the Kar-akoram, day after day under their own power, had numbed them and drained the color from the experience. Their capacity for emotional response had shrunk to near zero. It was not until months later that Galen felt full satisfaction from the most unprecedented adventure of his life.

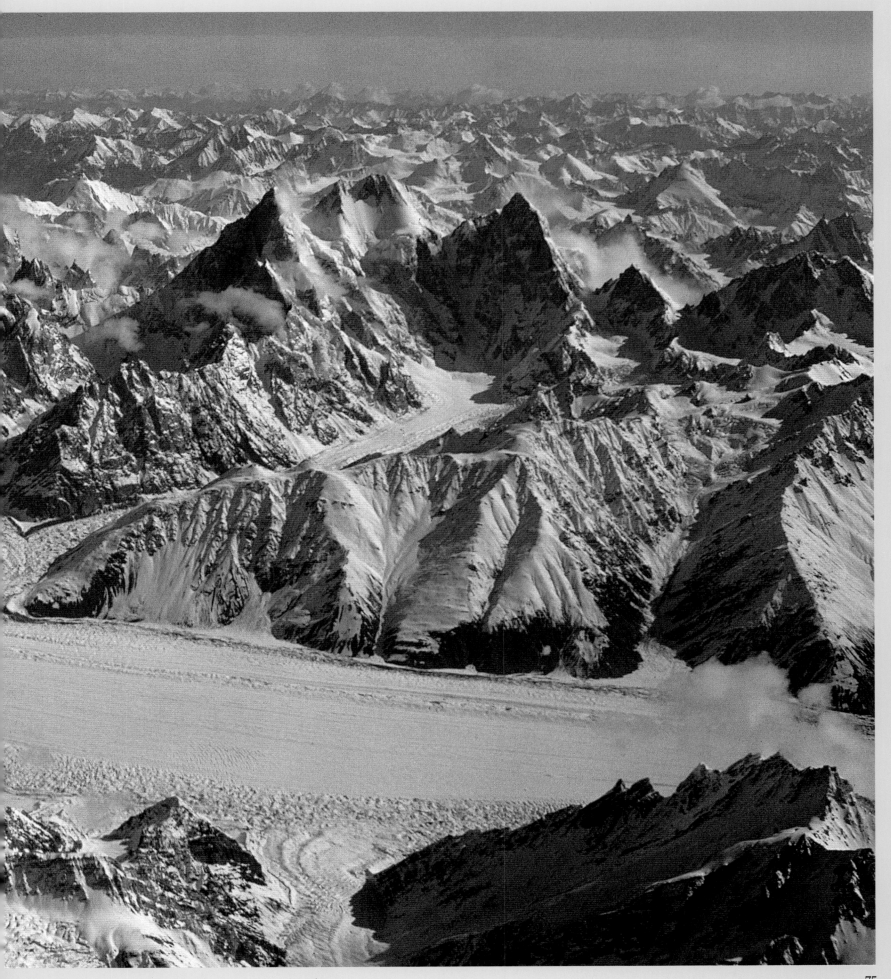

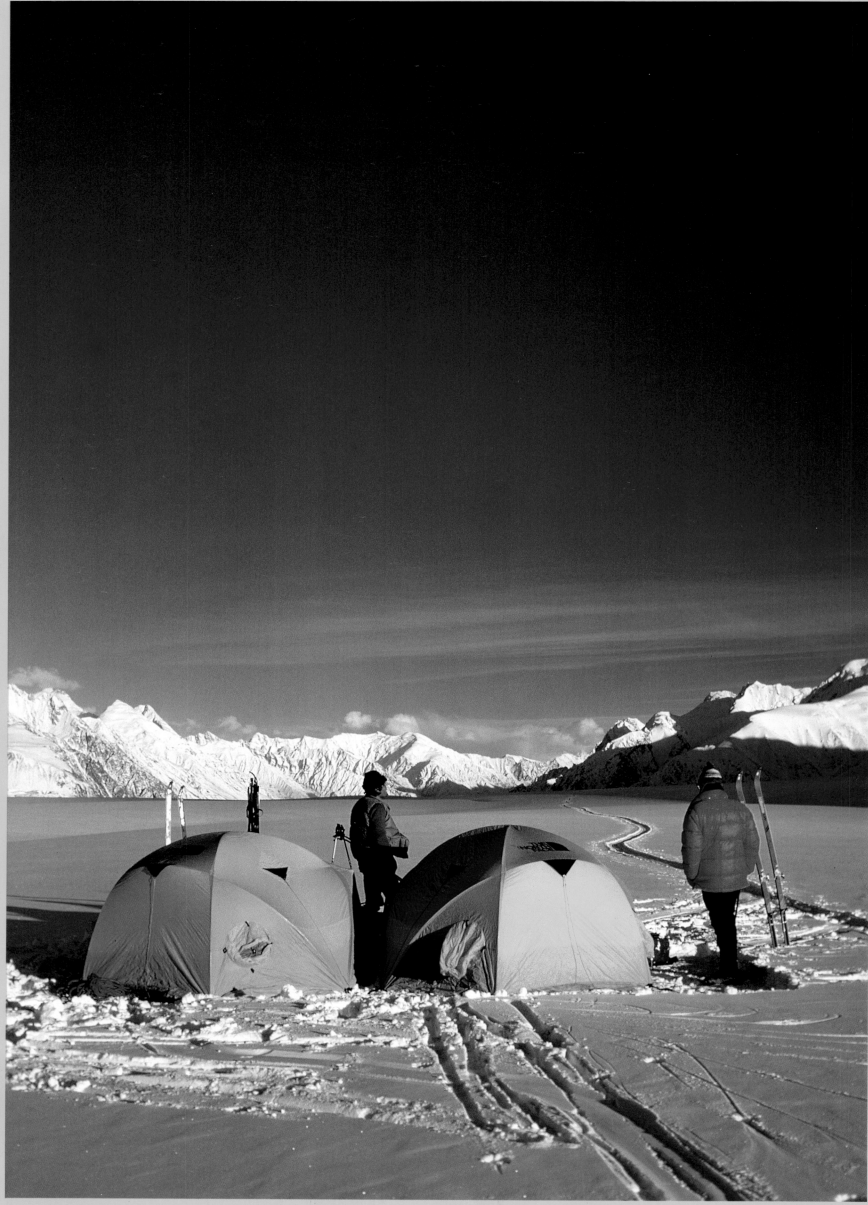

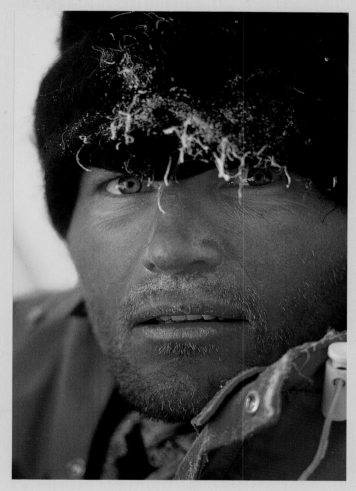

A PORTRAIT OF KIM SCHMITZ,

*Galen's tentmate, on a minus-25 degree morning during
the Karakoram traverse. A veteran of six Himalayan expeditions with
Galen, Kim's strength is legendary among mountaineers.
One sports writer called the steel-eyed climber a cross between
Captain Marvel and Conan the Barbarian.*

◆

CAMP ON THE SIACHEN GLACIER

*near the starting point of the Karakoram traverse. From Galen's
journal: "There is little conversation today. We wait for the
sun to warm us so we can break camp. I wonder if my friends share
the fears that kept me awake in the hours before dawn."*

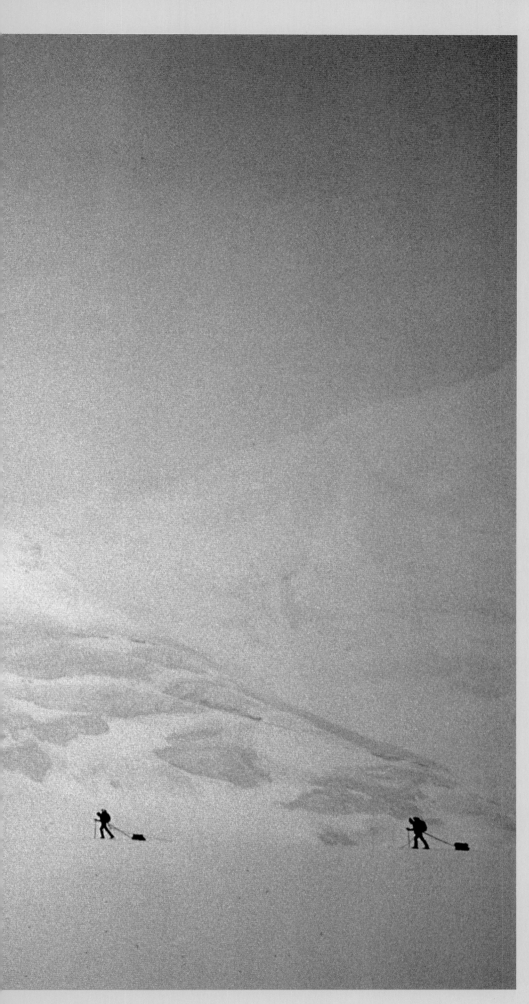

"THE DAYS MERGE INTO ONE ANOTHER,"
Galen wrote in his journal. During the 285-mile traverse,
the four skiers split into two teams. The members
of each team were roped together in case a hidden crevasse
took one of the skiers (left).

———————————◆———————————

THREE MEN COMPLETED THE TRAVERSE
Dan Asay developed knee trouble and left the group midway,
descending the Baltoro Glacier and walking out to
the village of Askole. For Kim, Ned and Galen, the foot of the Hispar
Glacier marked the end of the ski-traverse, although
several days of trekking to Hunza remained.

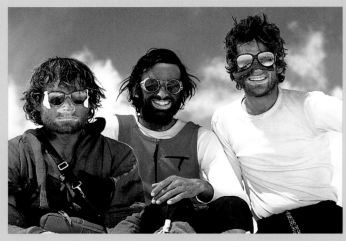

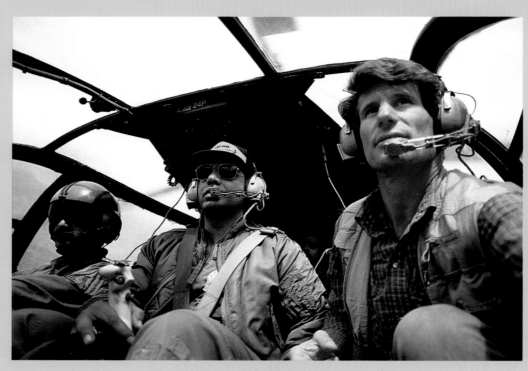

The Highest War In History

*began when Indian troops suddenly occupied the Pakistani-
controlled, uninhabited Siachen Glacier. In 1986,
while on assignment for National Geographic, Galen was invited by
the late President Mohammed Zia-ul-Haq of Pakistan to
enter the war zone by helicopter, and thus became the first photo-
journalist allowed to photograph the war.
Right: Pakistani army troops brandish a Chinese-made
anti-aircraft gun.*

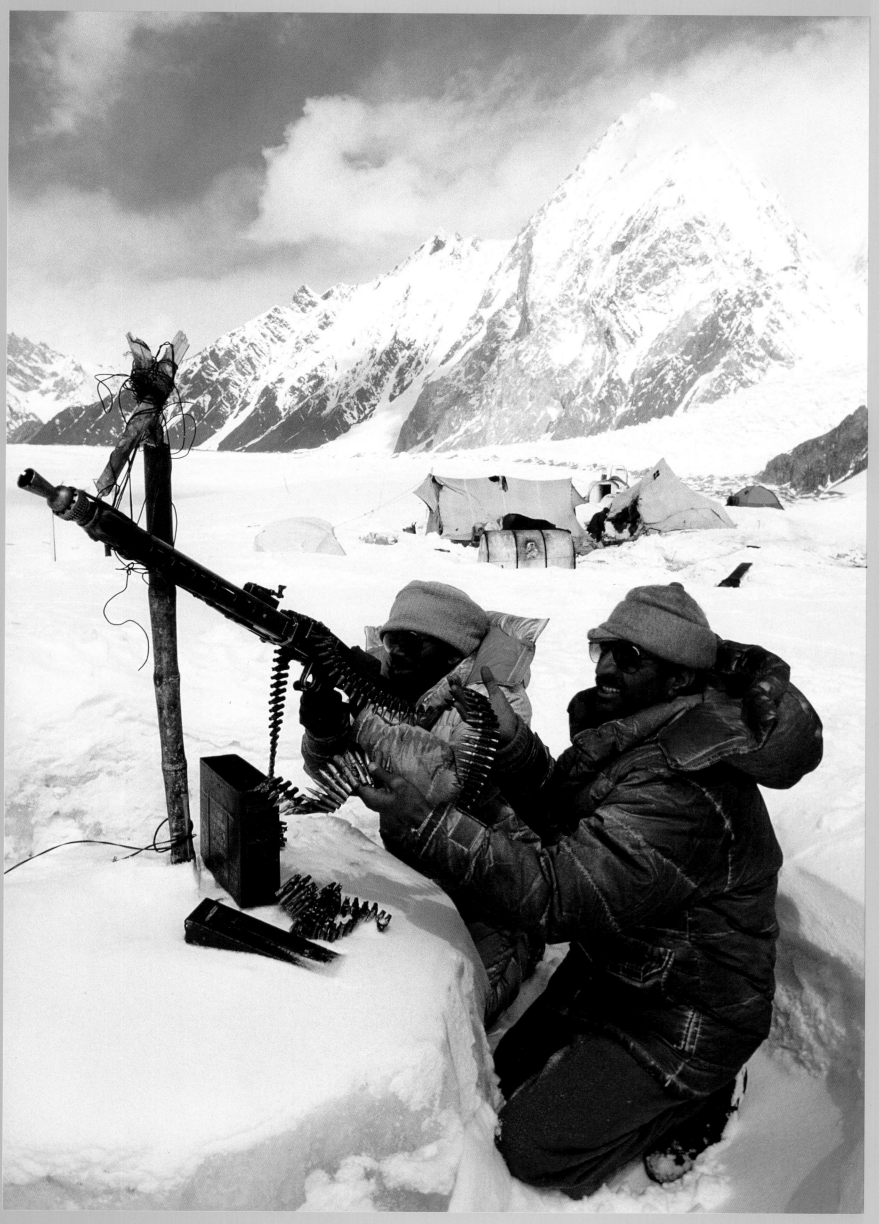

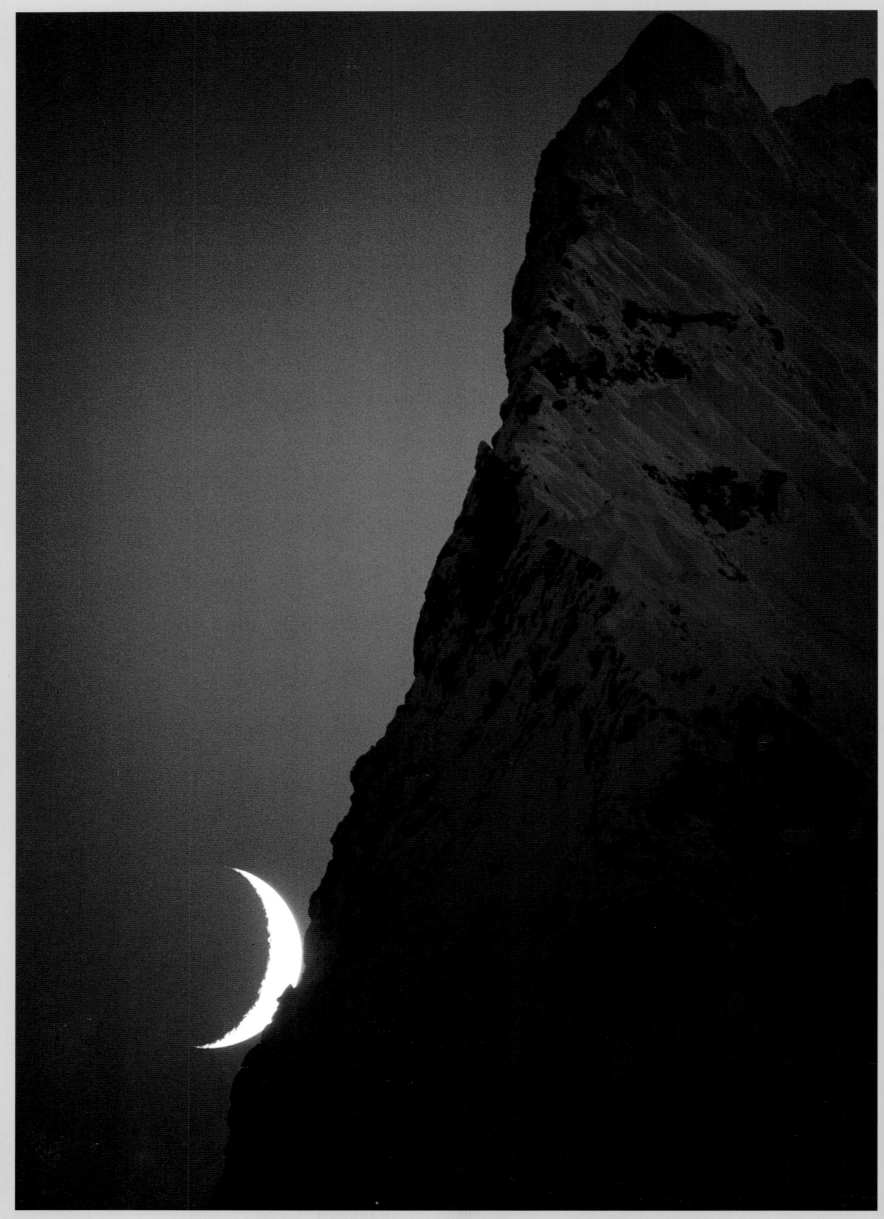

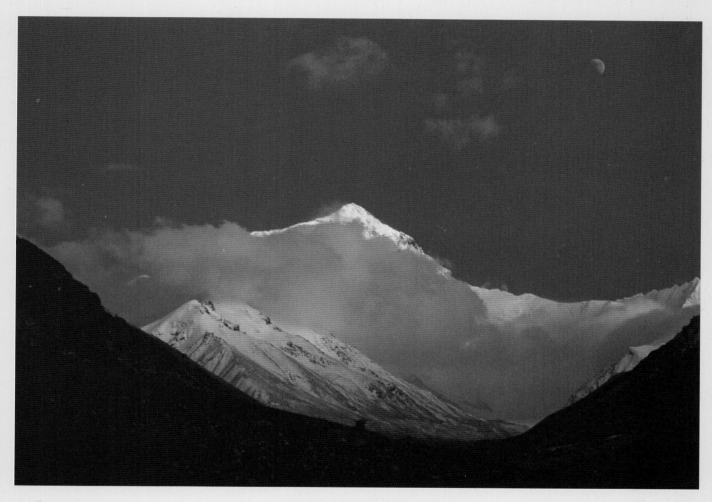

"Mother Goddess Of Earth,"

*Chomolungma is the Tibetan name for Mt. Everest, the world's
highest point at 29,028 feet. Galen was a leader of a
1983 expedition whose goal was the first ascent of Everest's West
Ridge from the Tibetan side. (1983)*

◆

An Unnamed 20,000-Foot Peak

*in the Karakoram Himalaya serves as a near-vertical horizon
for a retiring crescent moon. To get this shot,
Galen used a 500mm lens, underexposed the film to prevent blurring
by the movement of the moon and made a duplicate
negative to bring out the detail. "My secret Kodachrome 400,"
Galen says with a grin. (1975)*

THE WINDS RAGED AT 100 MPH

on Everest. The 1983 West Ridge Expedition reached 26,500 feet without

oxygen, but failed after a climber came down with pul-

monary edema and a series of storms covered the mountain in deep snow.

In 1924, the famous English mountaineer George

"Because it is there!" Mallory and his climbing partner, Andrew Irvine, disappeared

in a spring storm at well over 27,000 feet during Mallory's third

try. Climbers still look for signs of the ill-fated party, and the mystery remains:

Were Mallory and Irvine the first men to climb Everest or

just two of the many who failed?

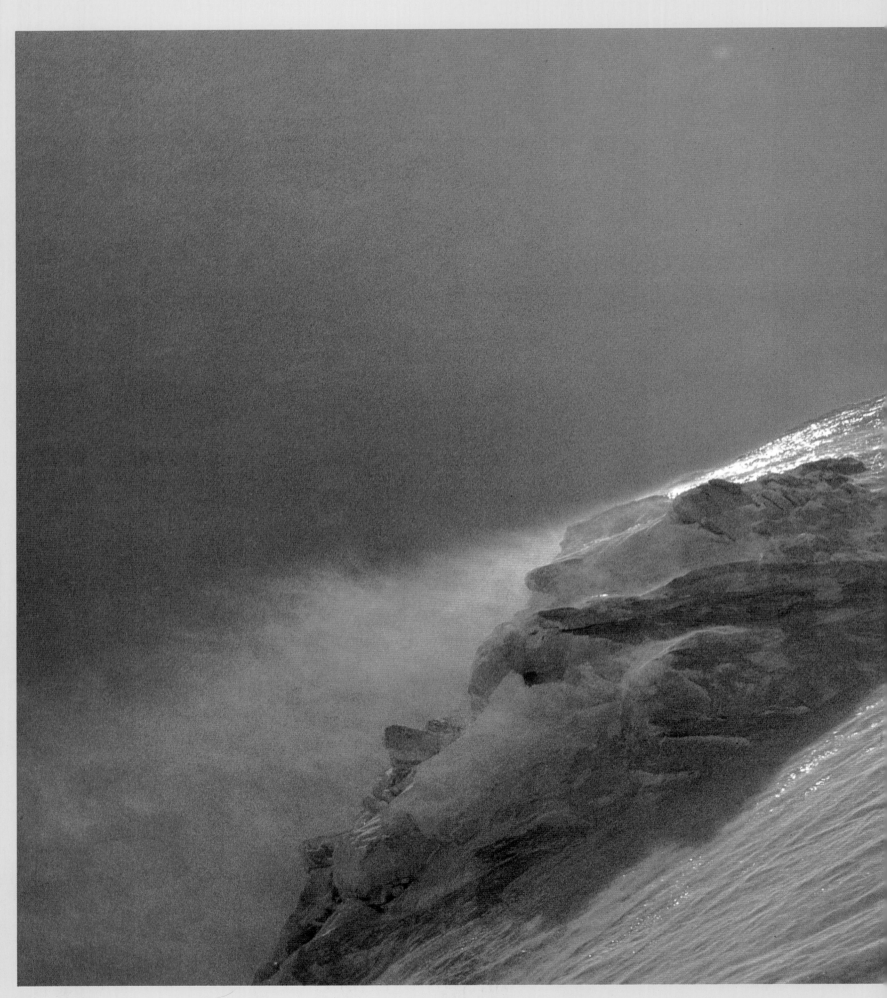

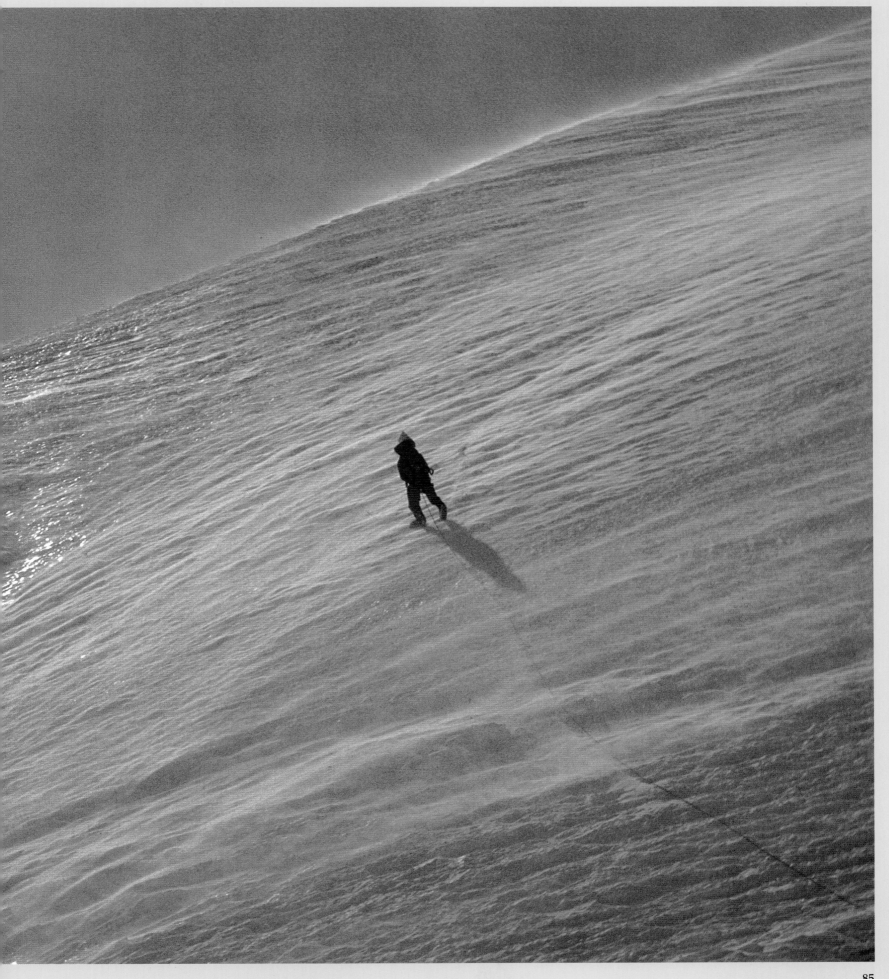

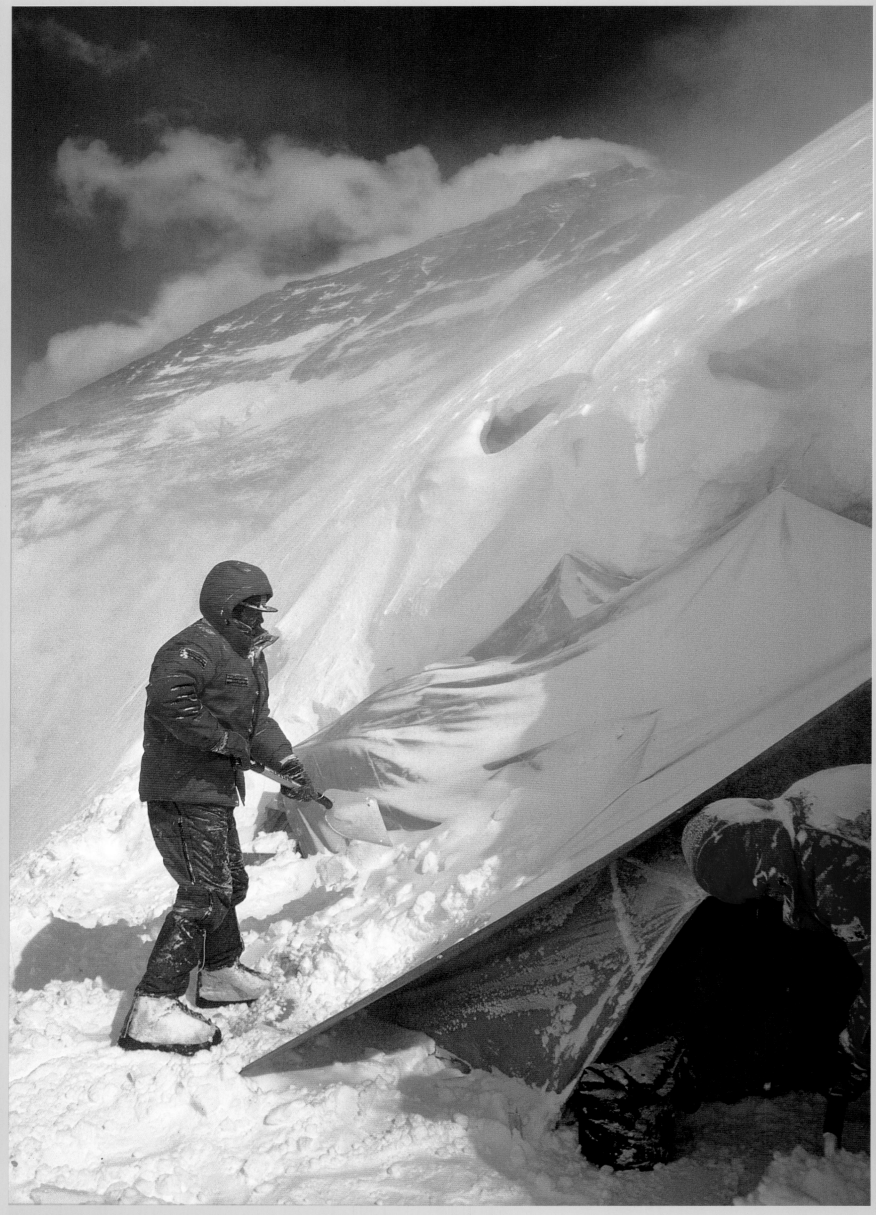

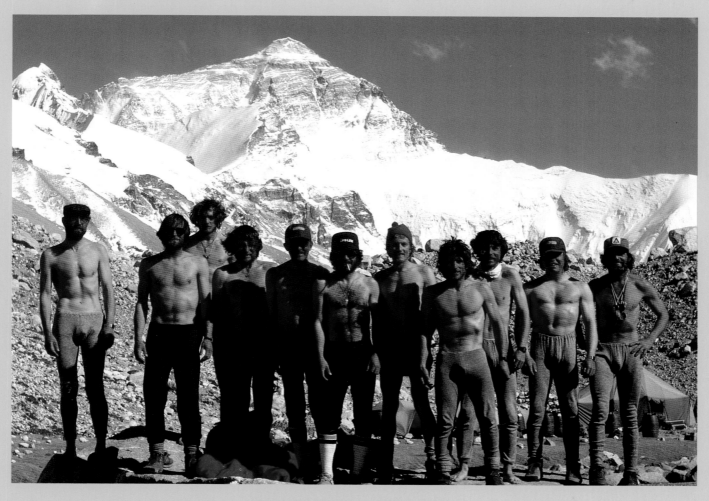

THE 1983 WEST RIDGE CHORUS LINE

struts its stuff in front of Everest. Topless for a moment in the near-zero cold, the men sportingly show off the 20 to 30 pounds each of them lost by the end of their unsuccessful, three-month expedition. Left: With the summit looking fierce more than a mile above them, climbers dig out Camp 2 at 22,000 feet on the West Ridge.

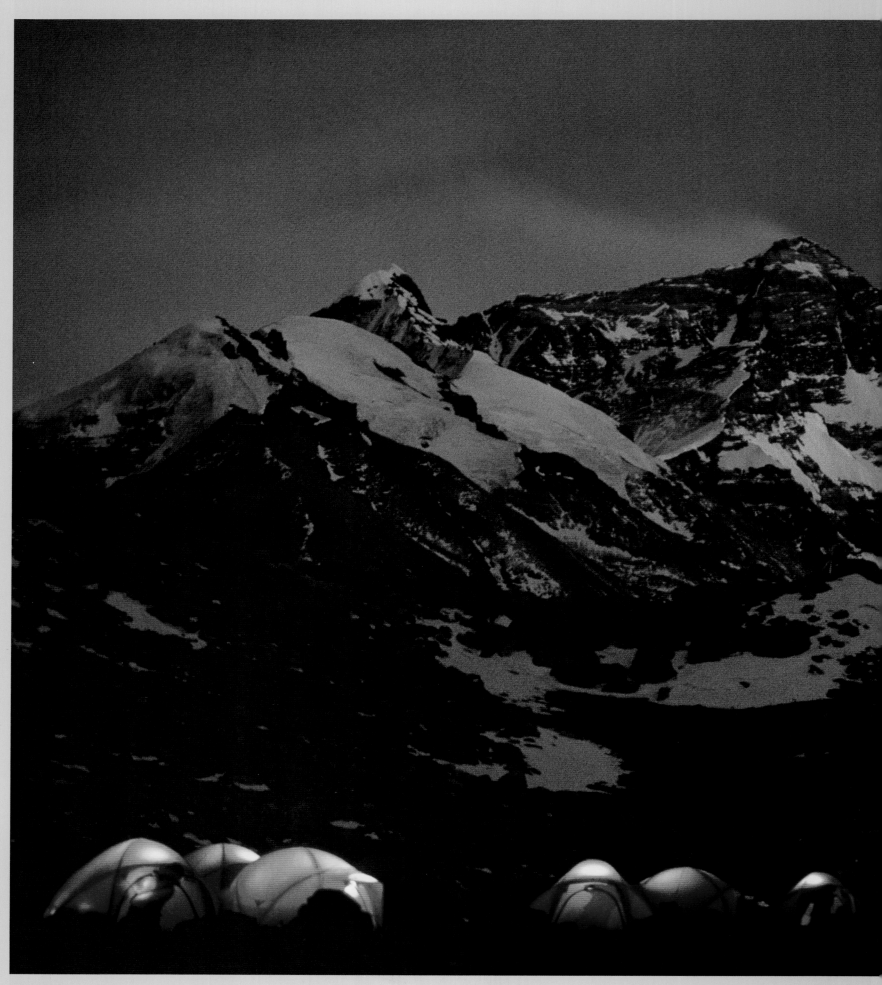

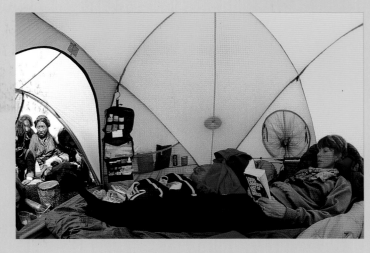

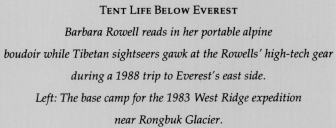

TENT LIFE BELOW EVEREST

*Barbara Rowell reads in her portable alpine
boudoir while Tibetan sightseers gawk at the Rowells' high-tech gear
during a 1988 trip to Everest's east side.
Left: The base camp for the 1983 West Ridge expedition
near Rongbuk Glacier.*

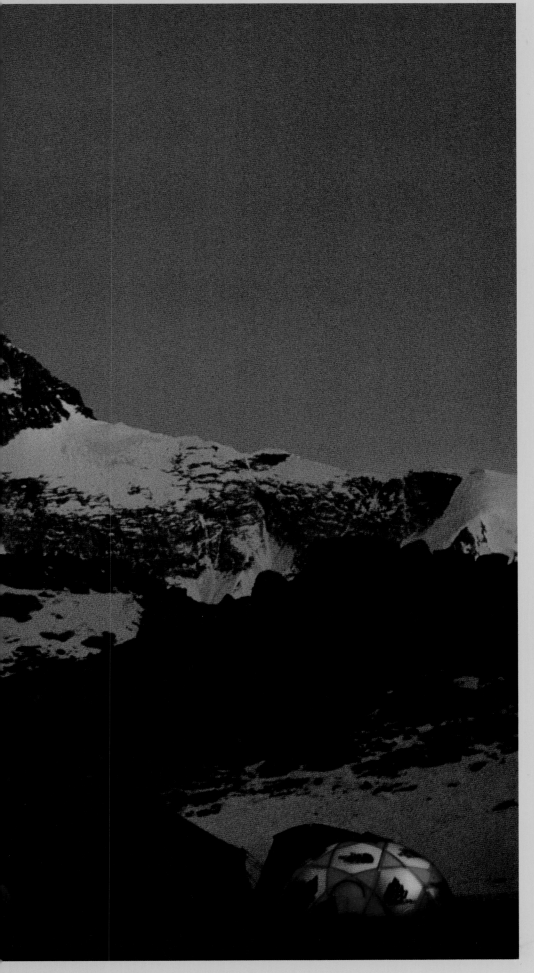

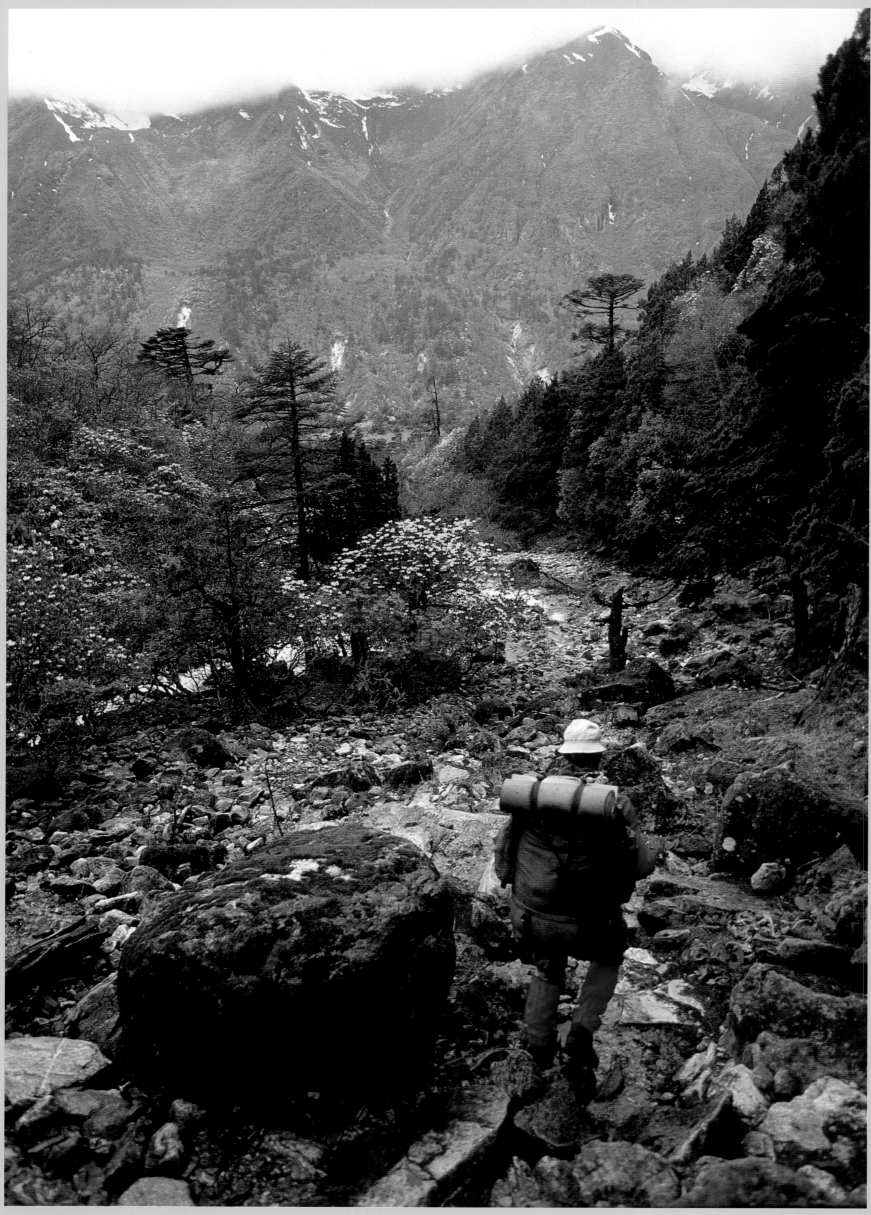

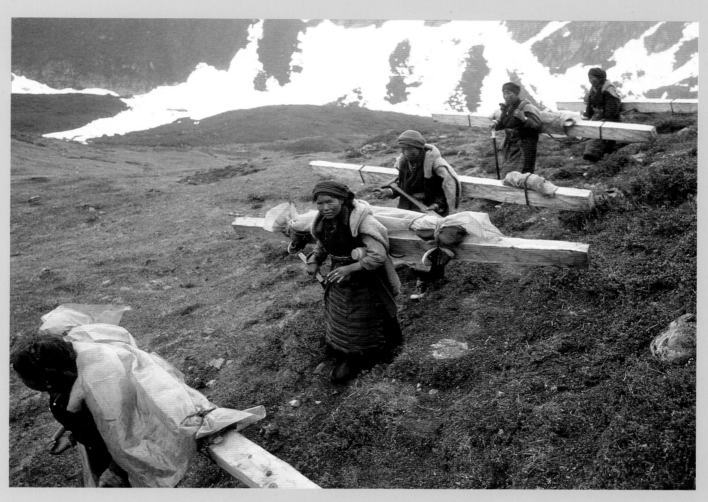

TIBETAN WOMEN CARRY 100-POUND TIMBERS

out of the Kama Valley on the east side of Mount Everest. It's a three-day
trek across a 16,000-foot pass to the village of Kharta, where
trucks pick up the wood for shipment to the treeless plains of central
Tibet. Deforestation, long a serious problem in the wet Himalayan valleys of
Nepal, is even more serious in arid Tibet where forest cover is
rare. Increasing demand for lumber and firewood, agricultural expansion
and improved road access to the remote forests are making
matters worse. Galen was the first journalist to report this story, for
National Geographic Magazine *in 1988.*

◆

THE VALLEY OF THE FLOWERS

another name for the Kama Valley, has already been damaged by
wholesale logging. Still, every spring more than 30 species of rhododendron,
each with a slightly different flower, splash the valley with rare
Himalayan color. (1988)

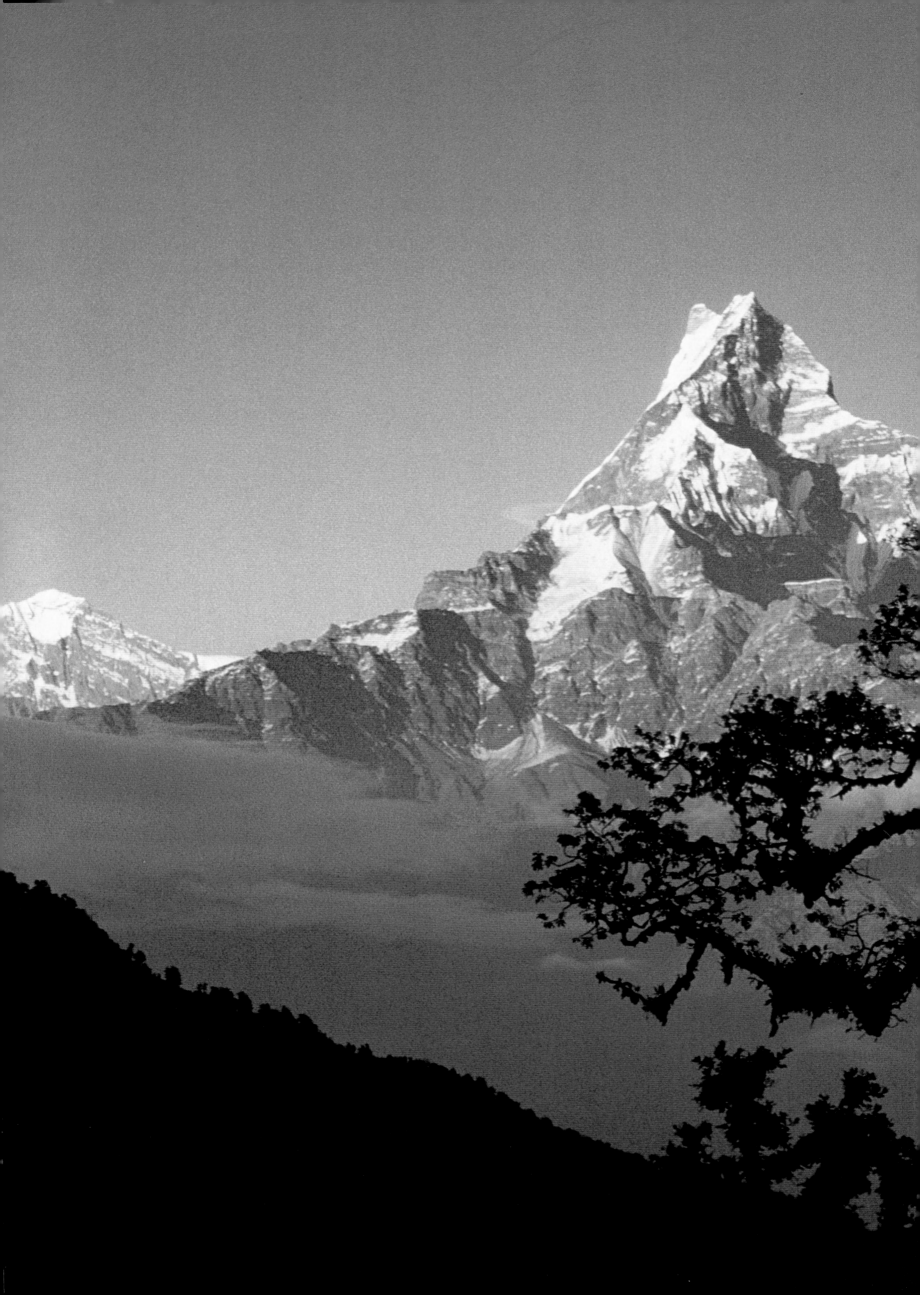

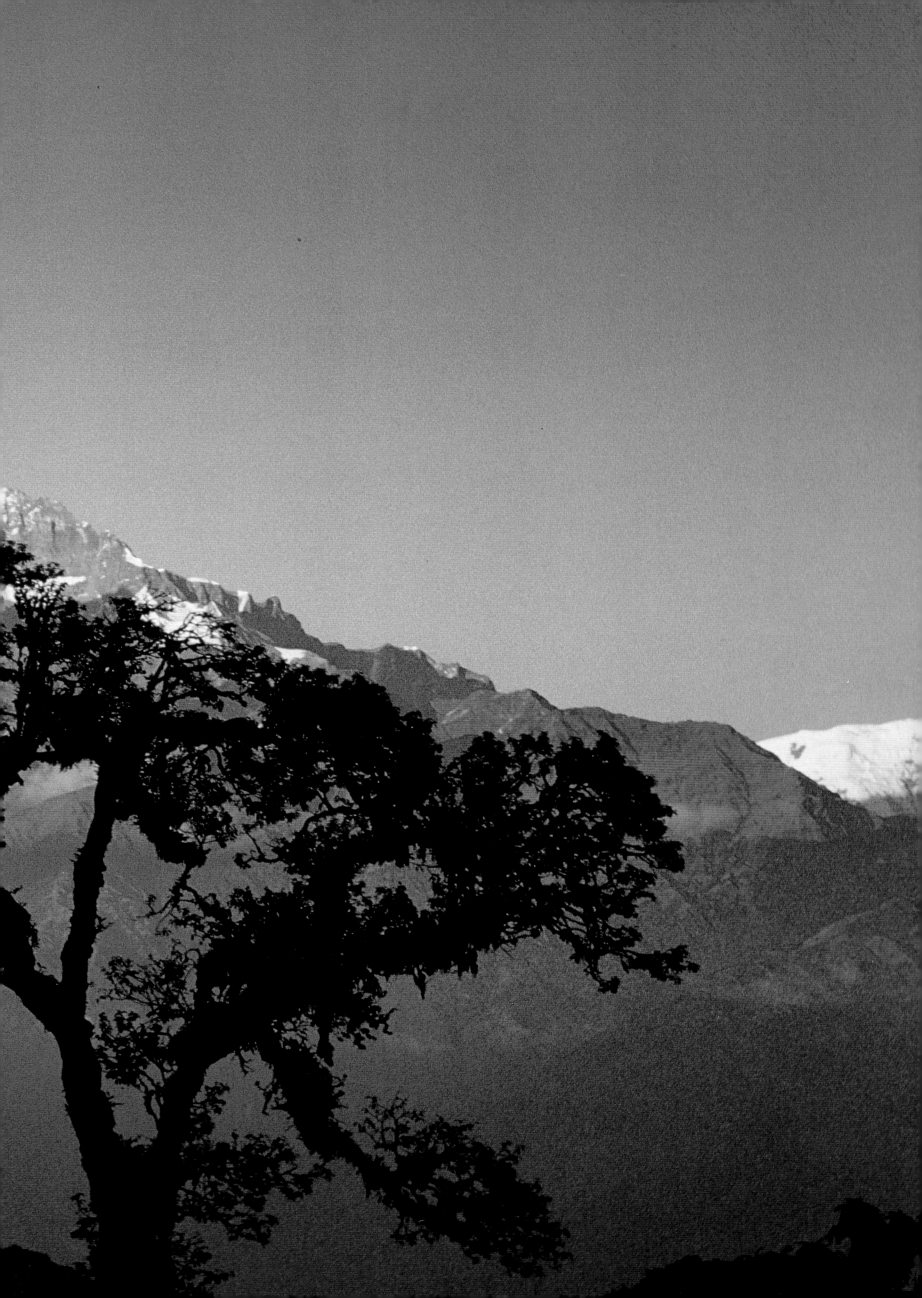

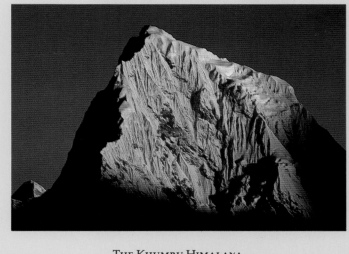

THE KHUMBU HIMALAYA

surrounding Mt. Everest is especially popular with climbers.
Cholatse, above, was the last major unclimbed peak in the region prior
to Galen's ascent in 1982. Left: Two Sherpa women pass a
Buddhist chorten *on their way to the barley fields of Khumjung,*
Nepal. Above them, a dusky sky silhouettes the shape of Ama Dablam,
the most distinctive peak in the Khumbu region. (1982)

━━━━━━━━━◆━━━━━━━━━

SUNSET ON MACHAPUCHARE,

a 22,958-foot peak in the Annapurna massif in Nepal (preceding
page). Considered sacred by the people of Nepal, the
summit remains off-limits to mountain climbers. Machapuchare
means "fish's tail" in Nepalese and refers to the shape
of the mountain's twin summits, barely visible on the peak's
top-most left face. (1987)

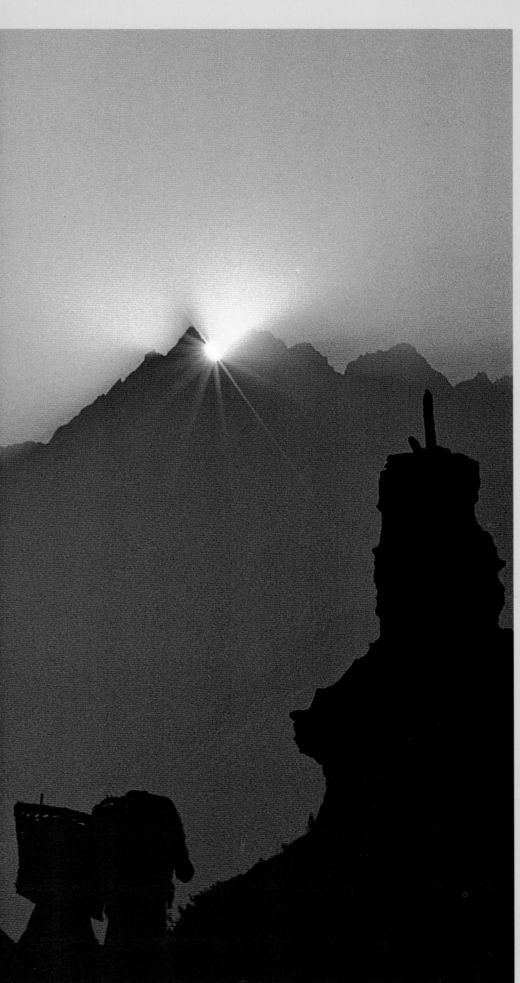

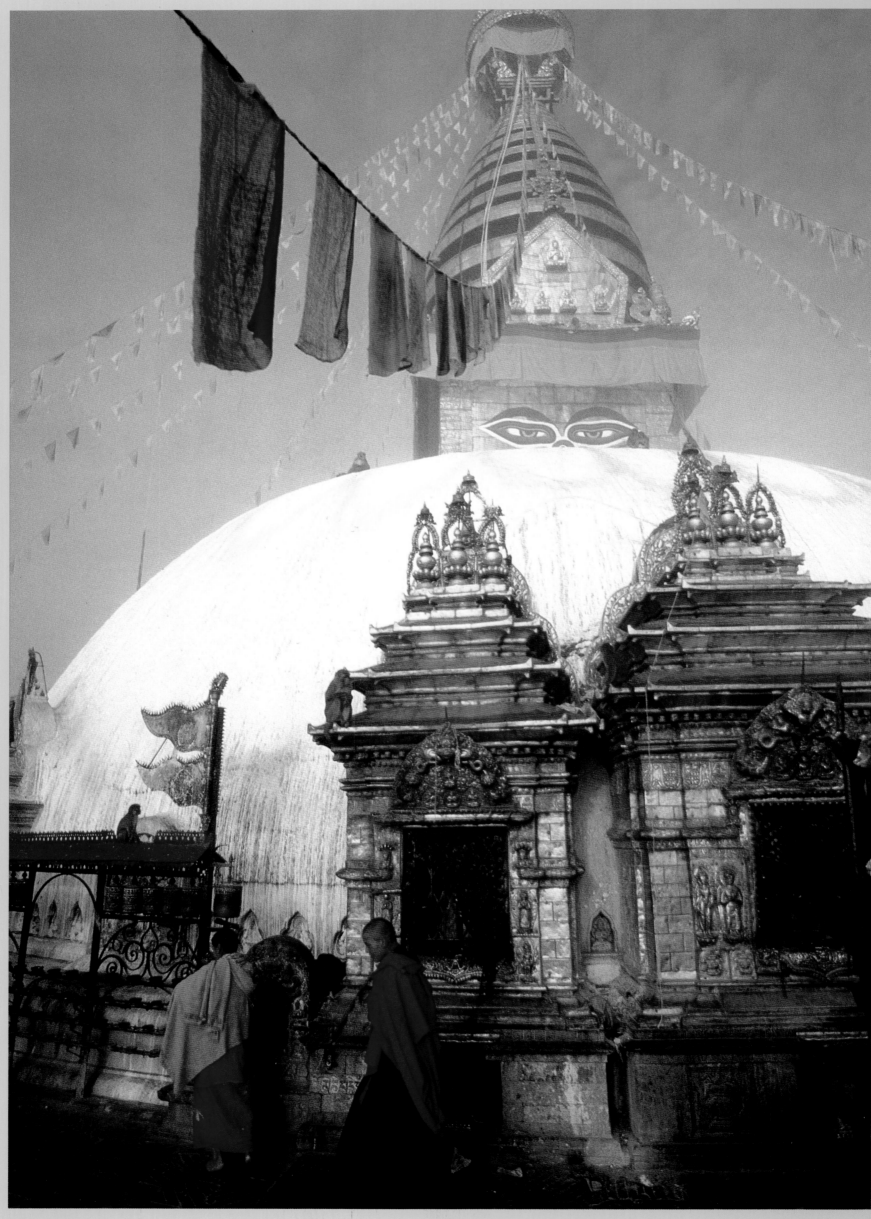

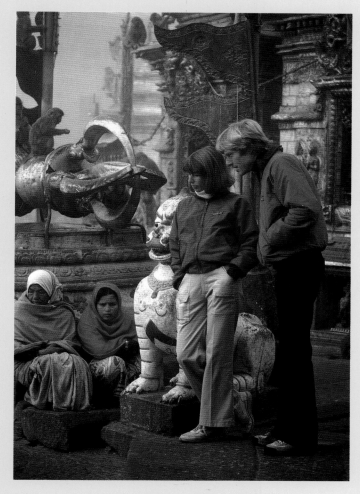

SWAYAMBU TEMPLE IN KATHMANDU

In 1982, Galen and Barbara Rowell traveled with actor Robert

Redford through Nepal. The trip included a trek to

Everest, a journey on elephants through the jungle and this morning

walk through Kathmandu and Swayambu Temple.

Left: The temple emerges from valley fog at dawn while Buddhist

lamas circumambulate the sacred spot.

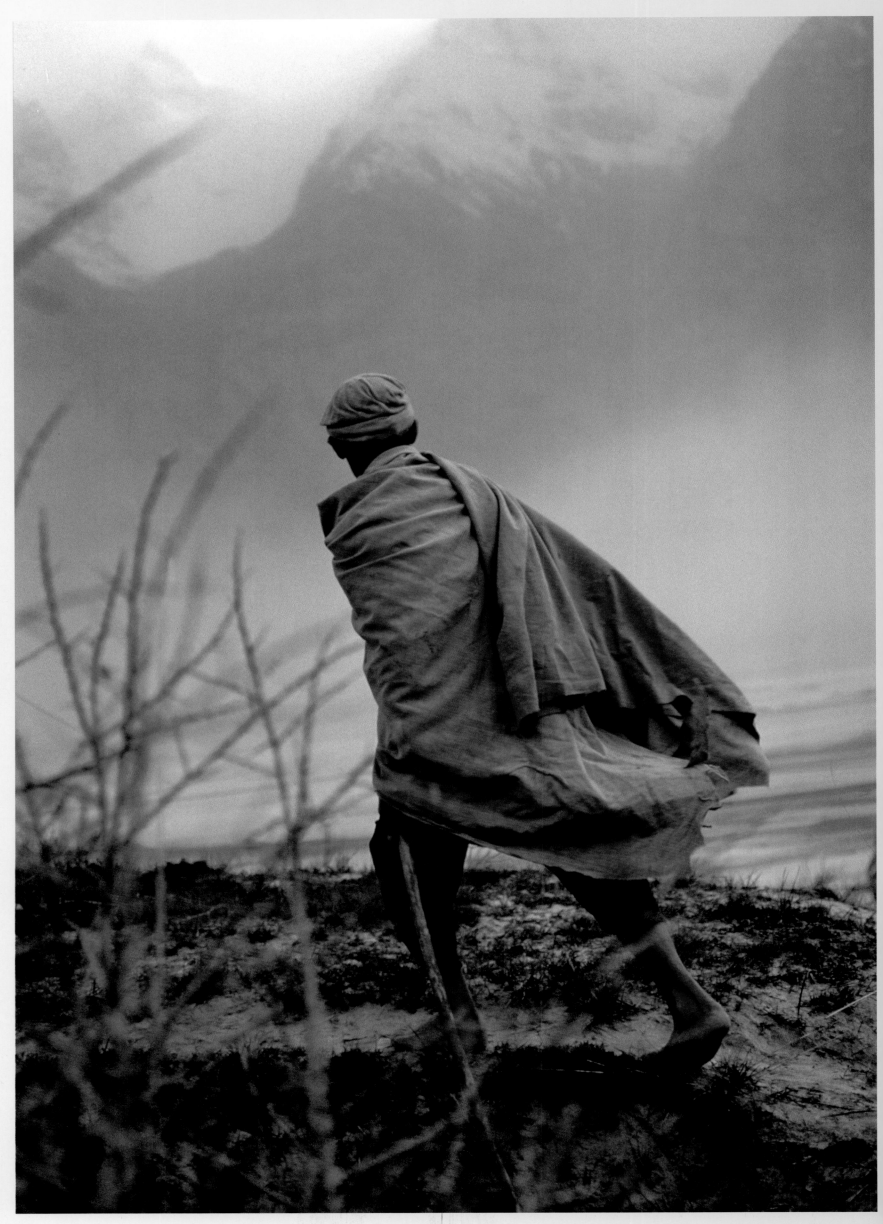

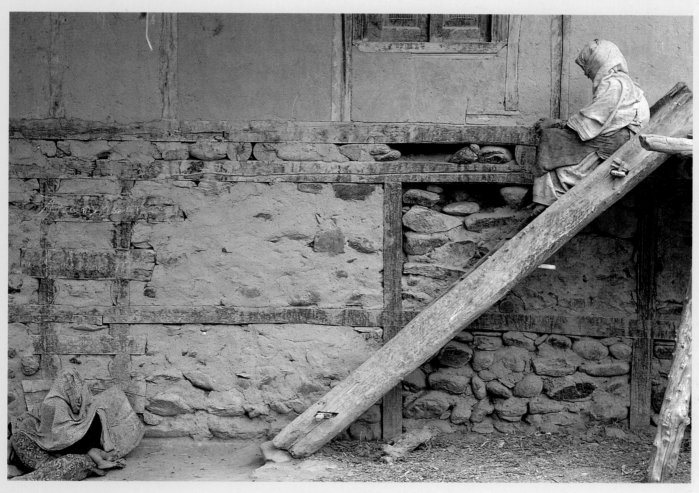

Two Portraits Of Baltistan

Balti women hide from Galen's camera in front of a house
in the village of Shigar. (1984) Left: A barefoot
Balti herder leans into a dust storm in the Shigar Valley of the
Karakoram Himalaya. (1975)

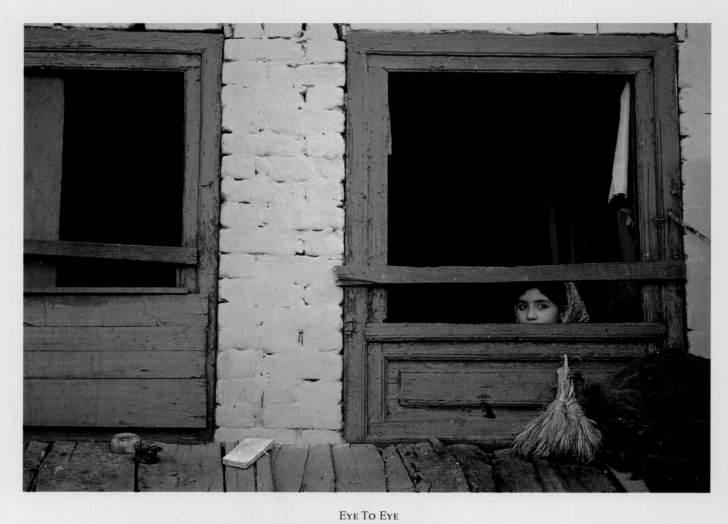

Eye To Eye

Walking down an alley in Srinigar, Kashmir, Galen noticed this girl
staring at him through a window. (1977)
Right: A proud Punjabi merchant in Rawalpindi, Pakistan,
poses for Galen's camera. (1975)

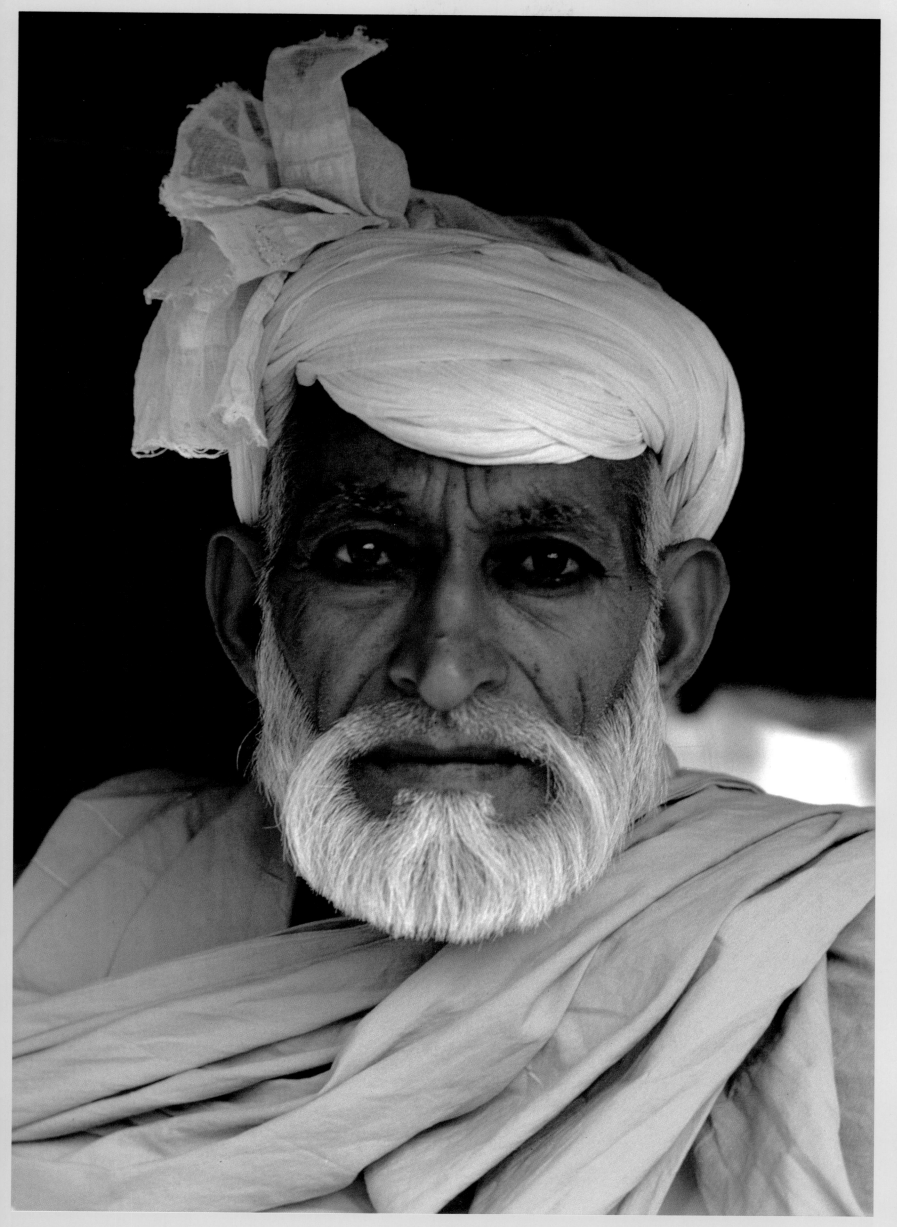

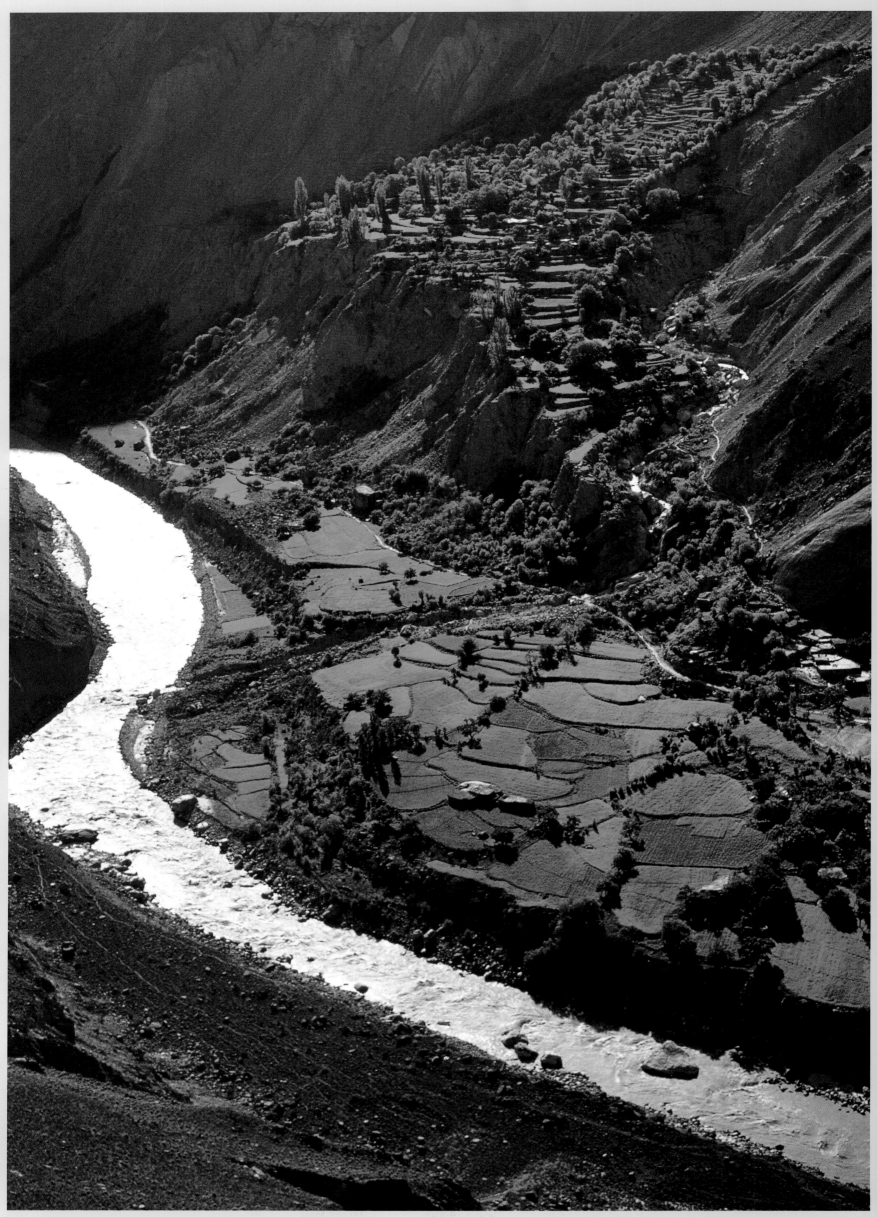

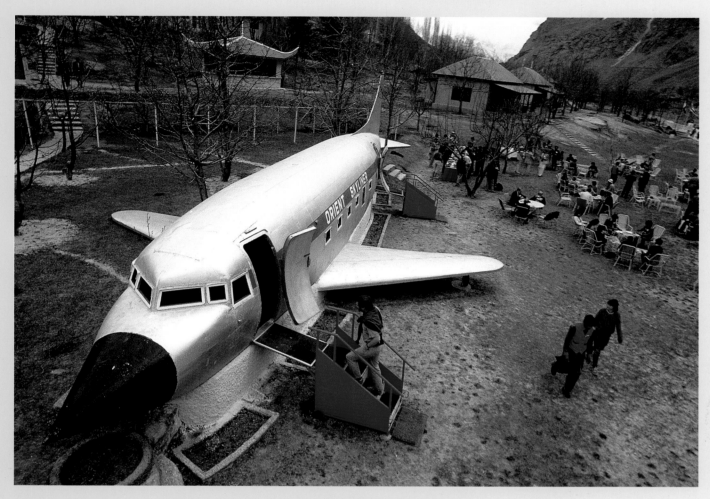

THE SHANGRILA RESORT IN SKARDU VALLEY

echoes the original in James Hilton's 1933 novel, Lost Horizon,

in which a DC-3 crash-lands a group of Westerners in a remote Himalayan

valley. The resort features a honeymoon suite improvised from the

fuselage of a wrecked DC-3. Four hundred Baltis using yak-hair ropes hauled

the plane two miles from the spot where it crashed more than

30 years ago. (1986) Left: Terraced barley fields spill down a wall of the

Braldu Gorge above the tiny shangrila of Oyongo in

Baltistan, Pakistan. (1984)

"The perpetual snow-clad peak of the Holy Kailas,
of hoary antiquity and celebrity, the spotless design of Nature's art,
of most bewitching and overpowering beauty,
has a vibration of the supreme order ... It seems to stand as an
immediate revelation of the Almighty in concrete form,
which makes man bend his knees and lower his head in reverence."
—*Swami Pranavananda, 1949*

For Tibetan Buddhists and all Hindus, Mount Kailas is the center of the universe—the holiest mountain on earth and the snowy parent of the four great rivers, the Brahmaputra, Indus, Karnali and Sutlej. Pilgrims travel thousands of miles to walk the 32-mile holy circle around Kailas.

At 3:00 a.m. on an August morning, Galen Rowell and three Tibetan friends began a one-day holy circle, or parikrama, *around the base of Kailas. Hours later, the sacred peak suddenly revealed itself, lit by waning moonlight and a predawn aurora in the east. The Tibetans bowed to the ground. Galen found himself doing likewise. His first glimpse of Kailas inspired him to make a five-minute time-exposure of the moonlit peak.*

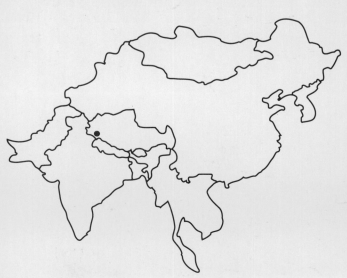

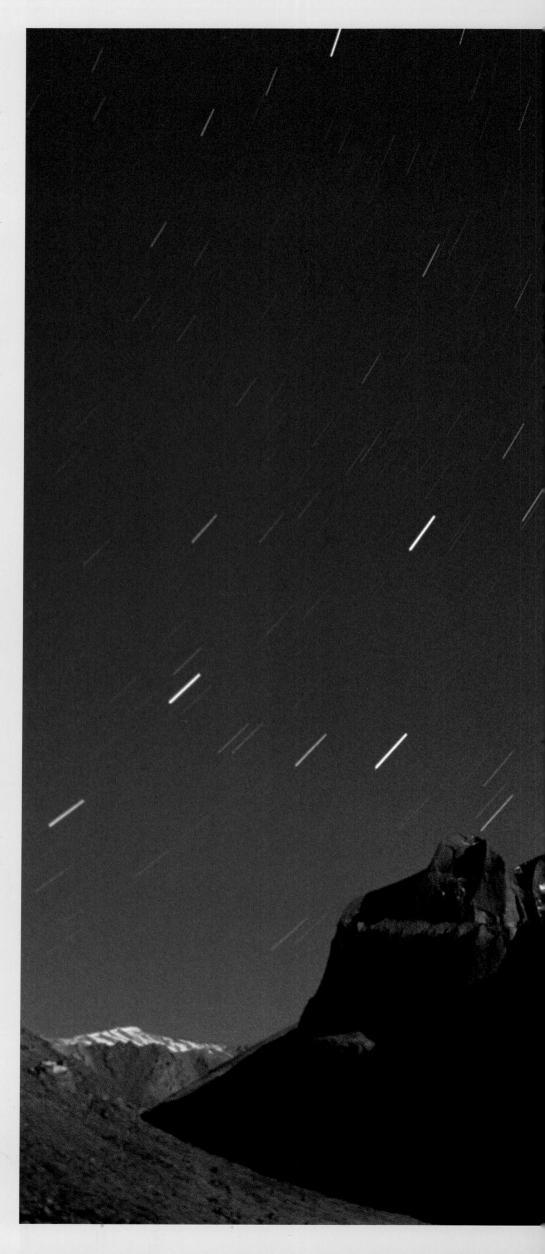

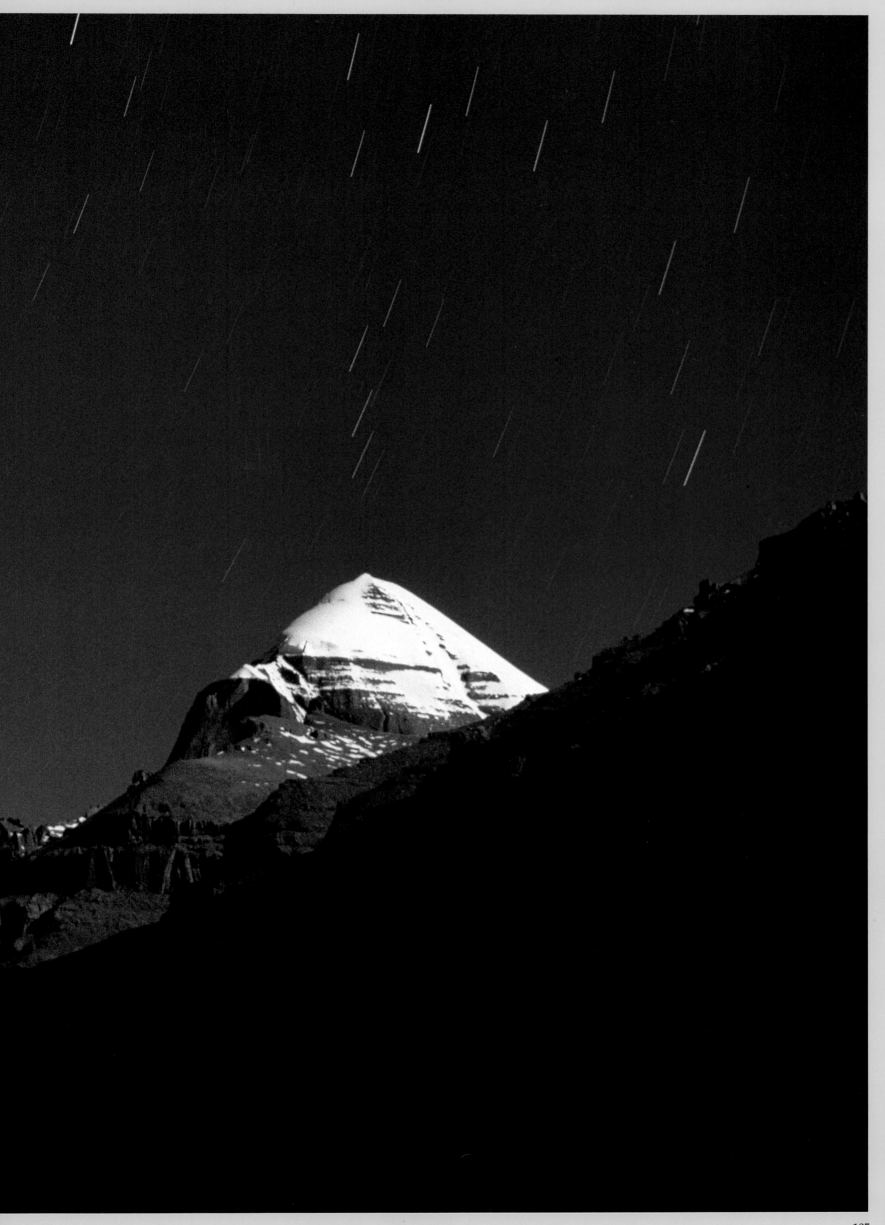

One parikrama around Kailas cleanses the sins of one life; after 108, the pilgrim achieves nirvana. For the supremely pious, there is the grueling sashtanga-danda-pradakshina, a holy circle executed in a continuous series of bodily prostrations so that the length of the body itself draws the circle around Kailas.

The 22,000-foot mountain remains sacred and unclimbed by modern mountaineers. Tibetan Buddhists, however, tell the story of a beloved 11th century saint, Milarepa, who ascended to the summit on a beam of light.

Nearby, Lake Manasarovar (below) is considered the first and holiest lake, worshipped even

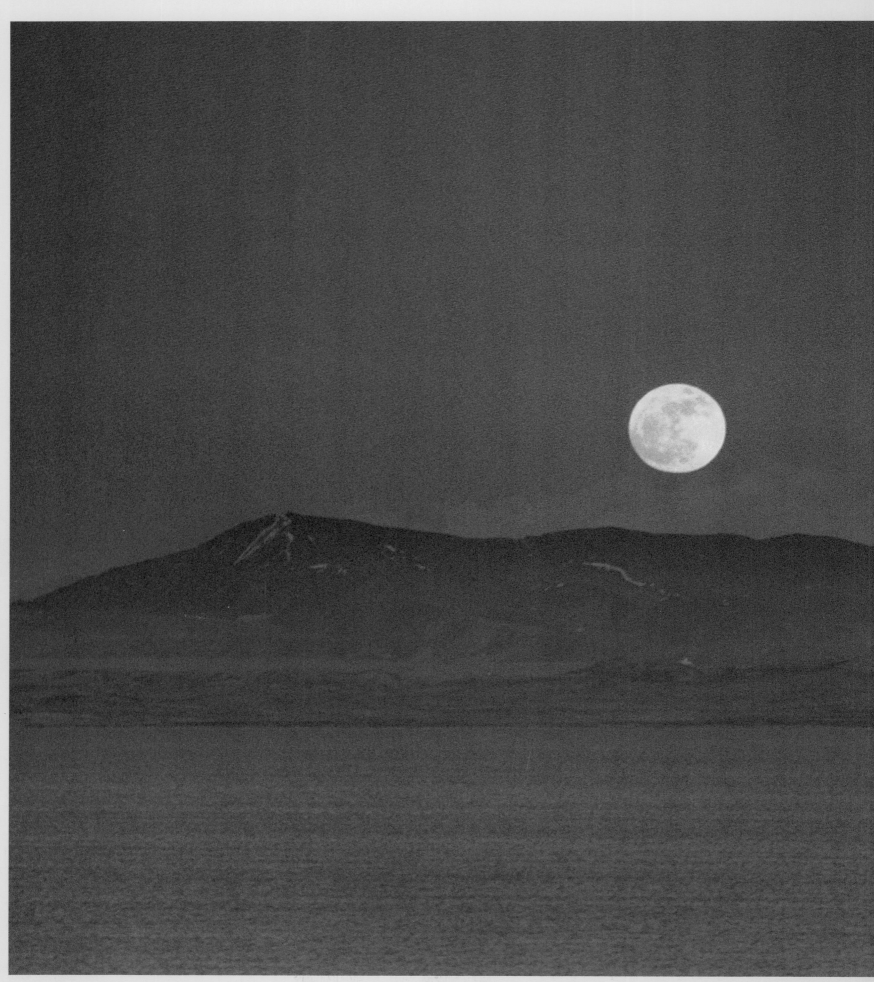

before the dawn of history. Together with Kailas, Manasarovar is the most important Himalayan place of pilgrimage. According to Swami Pranavananda, the spiritual vibrations emanating from the austere landscape "soothe and lull even the most wandering mind into sublime serenity and transport it into involuntary ecstasies."

An entry in Galen's journal recounts his arrival at Kailas: "Near the pass, the land grew ever more austere ...we seemed to be riding on the bones of the earth, elevated above the soft body of the world. It was easy to understand how pilgrims, walking overland for weeks or months, felt they were approaching the center of the universe."

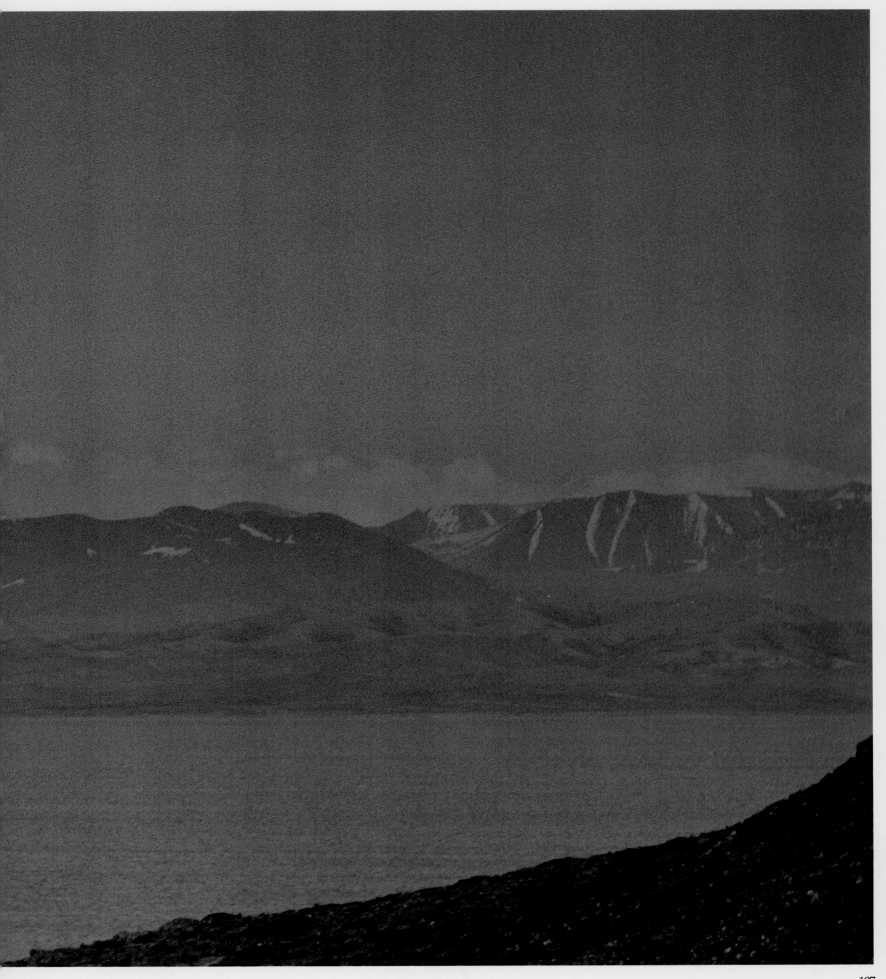

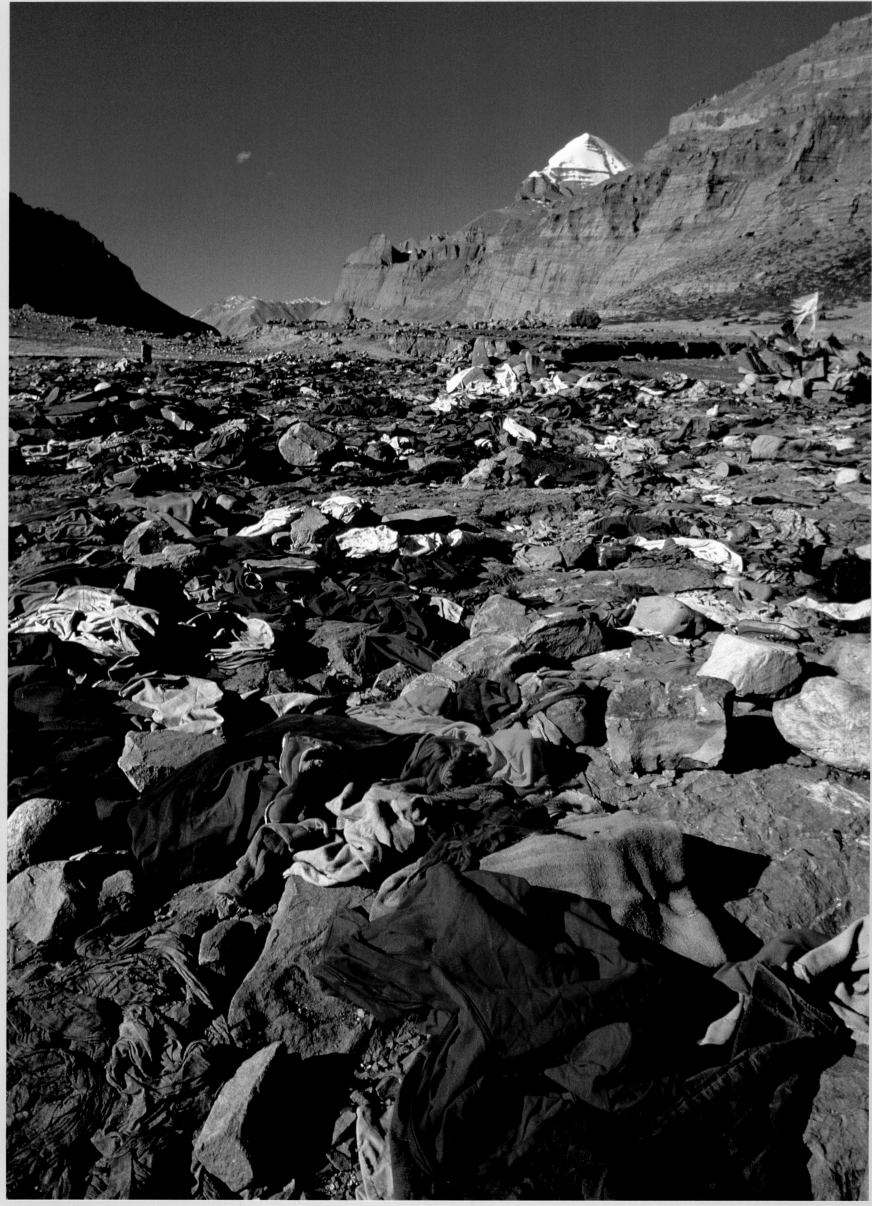

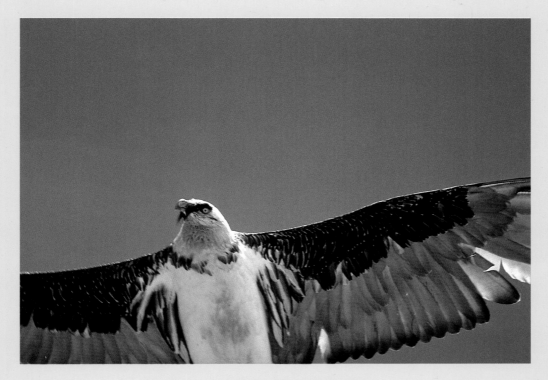

KAILAS PILGRIMS SHED OLD CLOTHES

and possessions as they circle the mountain (left). Abandoning
material goods complements the spiritual cleansing
of the journey. Among the clothing, jewelry and shoes, Galen found a
mummified head and other body parts, the remains of
the sick and elderly who came to die at Kailas. Above: The bodies of
the dead are often cut into pieces for a celestial burial
so that Tibetan vultures, such as this lammergeier, will carry
the pieces to heaven.

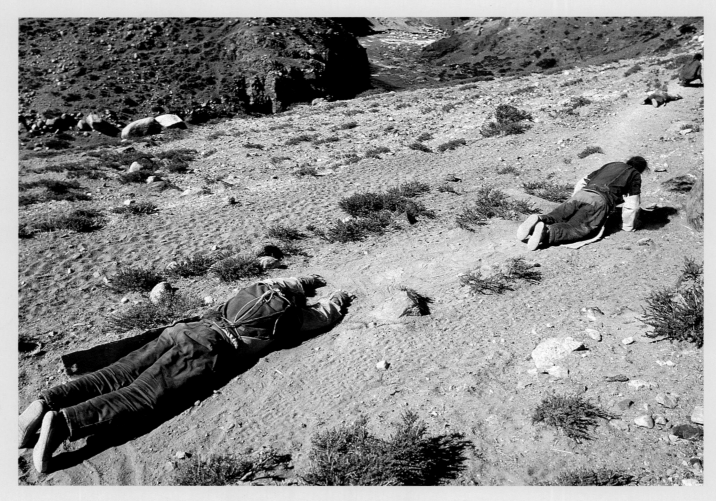

PILGRIMS DEMONSTRATE EXTREME PIETY

by prostrating themselves, standing up, then dropping down
again for the entire 32-mile distance around Kailas. This way of pilgrimage
allows the length of one's body to trace the circle. Wearing
special aprons and sleeves, these Tibetan Buddhists will spend 20 grueling
days in the sand, snow and ice paying homage.
Right: A five-year-old Tibetan girl and her mother cross the highest pass
at 18,600 feet on the Kailas parikrama.

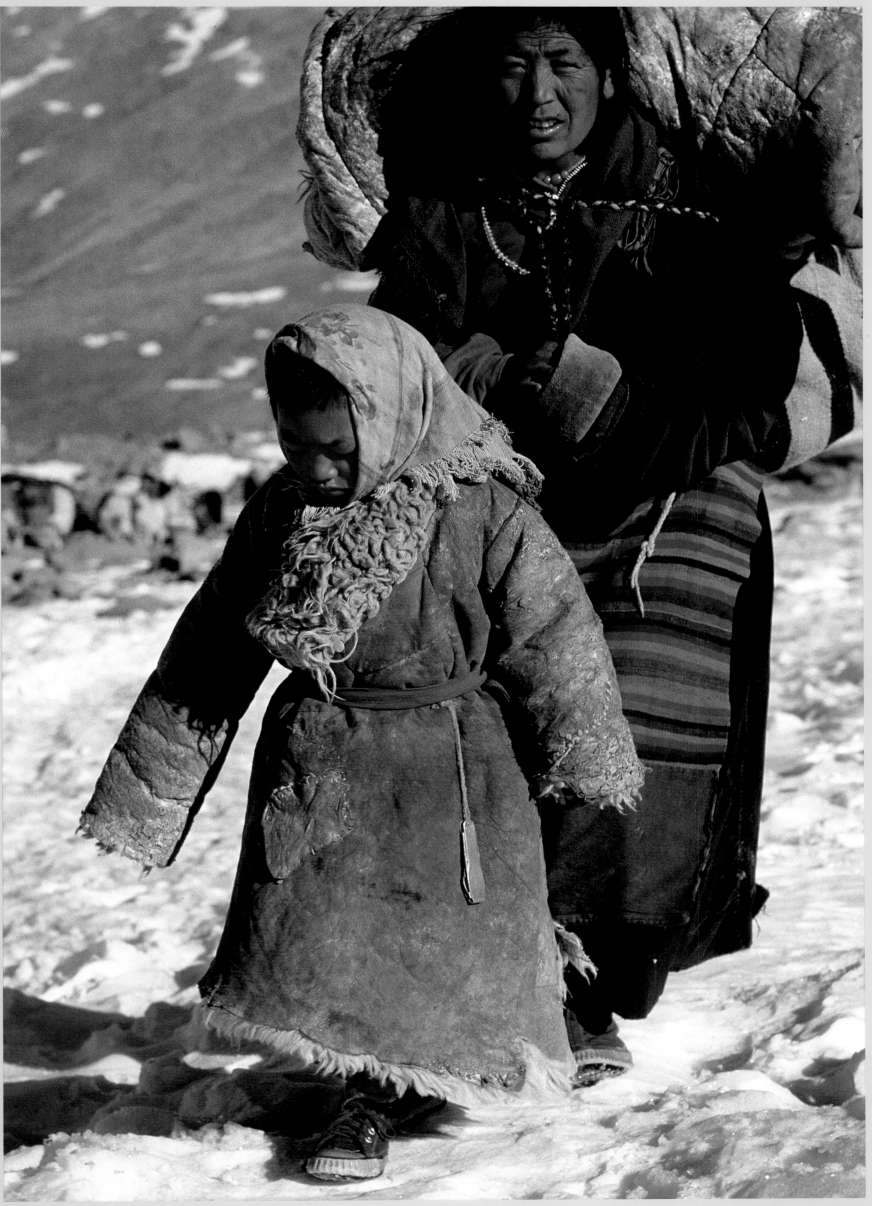

Kailas and Manasarovar Pilgrimage
Western Tibet, 1987

Tsewang Tsambu Traveled 500 Miles
on foot across the Tibetan Plateau to make the Kailas parikrama. *On the*
way, he met Galen and his Tibetan-speaking traveling companions
who drove him to Kailas in their truck. Tsewang circled the holy moun-
tain and washed away the sins of this life, as Galen did. Galen would
meet Tsewang again a year later, in a faraway region of Tibet.

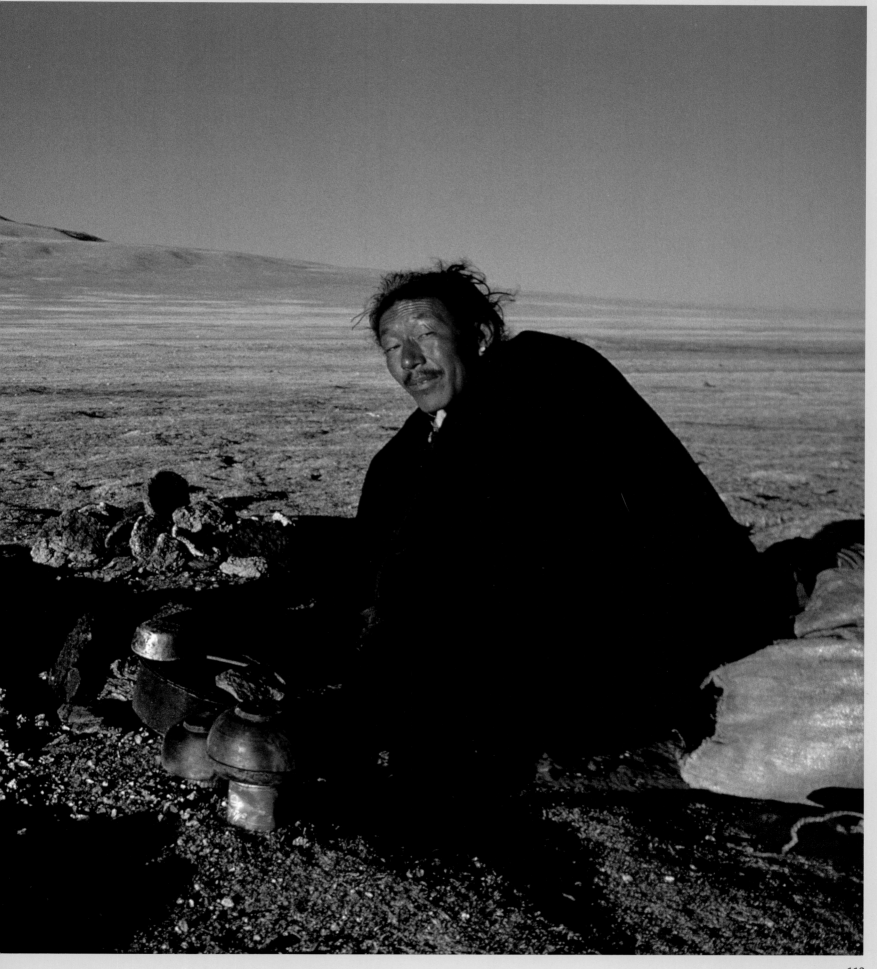

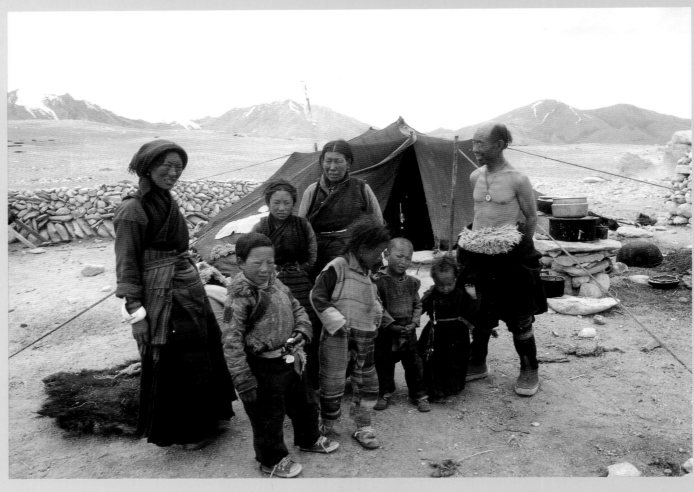

Tsewang Tsambu's Family

greet Galen and his party at their home, a yak-hair tent near the

great lake Pekhu Tso in western Tibet. It had been a

year since Tsewang and Galen shared the sacred pilgrimage around

Mt. Kailas, 500 miles away. Their joyful 1988 reunion was

a surprise to both of them: Galen, Barbara and friends were on a trek in the vicinity

of Xixibangma, the highest peak wholly in Tibet, when they

sought out a native guide. Shepherds led them to a small cluster of nomad tents.

Tsewang, his father, sister and her children stepped out.

While Tsewang's sister nurses her youngest child inside the tent (right),

the child's grandfather holds a picture of the exiled

Dalai Lama to his forehead. (1988)

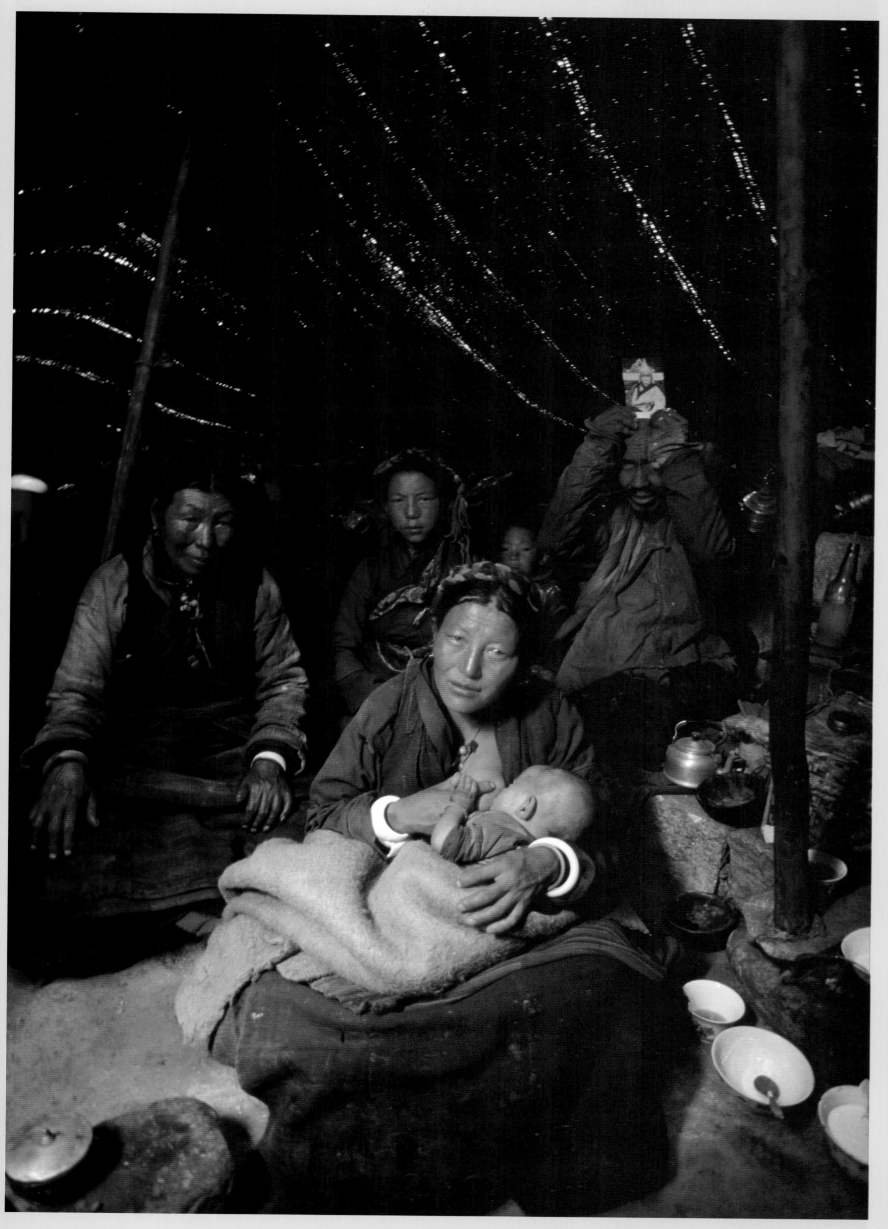

ONCE ALIVE WITH HERDS OF GAZELLE,

*antelope, blue sheep and wild asses, the vast plains of Tibet have
suffered severely under Chinese occupation. Nomadic herds-
men were forced to work on government communes, where production
quotas demanded huge grazing herds. In the competition for
rangelands, domestic cattle won, and the wildlife retreated. Some relief
came in 1983, when nomads were released from the communes,
given back their yak and sheep herds and allowed to resume their sub-
sistent ways. Above: A young nomad rides bareback in the
Pekhu Tso region of western Tibet. Right: Another Tibetan nomad,
tiny beneath Kangbochen, a 23,000-foot peak
near Pekhu Tso. (1988)*

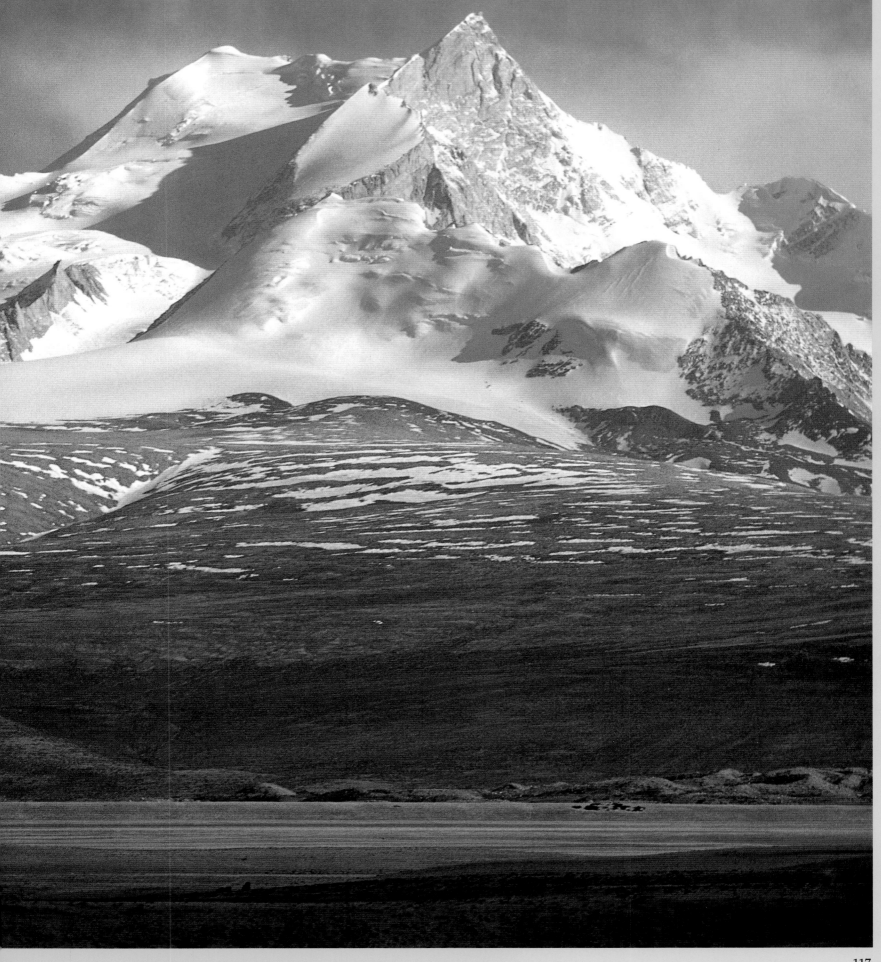

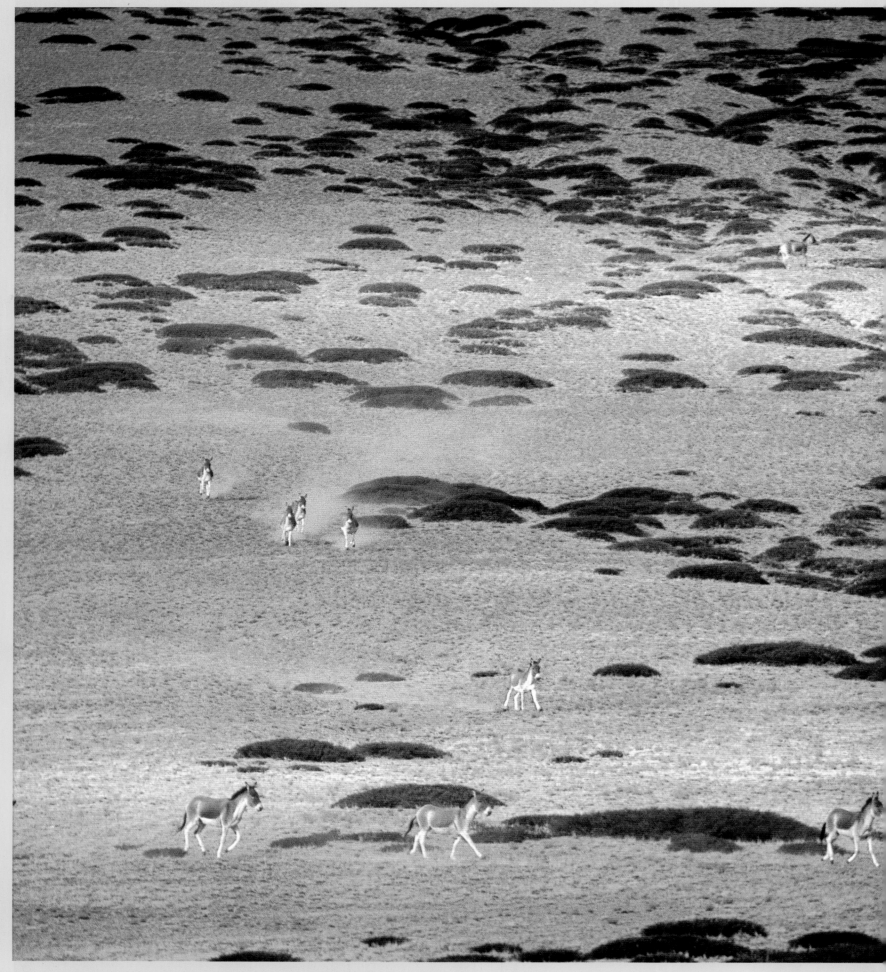

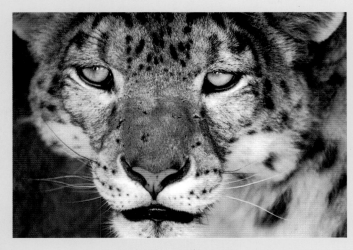

The Vanishing Wildlife Of Tibet

A recently captured snow leopard en route to a zoo in Lanzhou,
China, glowers at Galen's camera. (1981) Left: Colored
like palominos and shaped like mules, the kiang, or Tibetan wild ass,
roams freely in only the most remote regions.
In 1944, German adventurer Heinrich Harrer, an escapee from a
British prison camp in India, wrote about the kiang:
"Since I first saw them, these untamed beautiful beasts have seemed a
symbol of freedom." Harrer eventually found his
way to Lhasa, where he became a tutor to the Dalai Lama until the
arrival of the Communist Chinese. (1987)

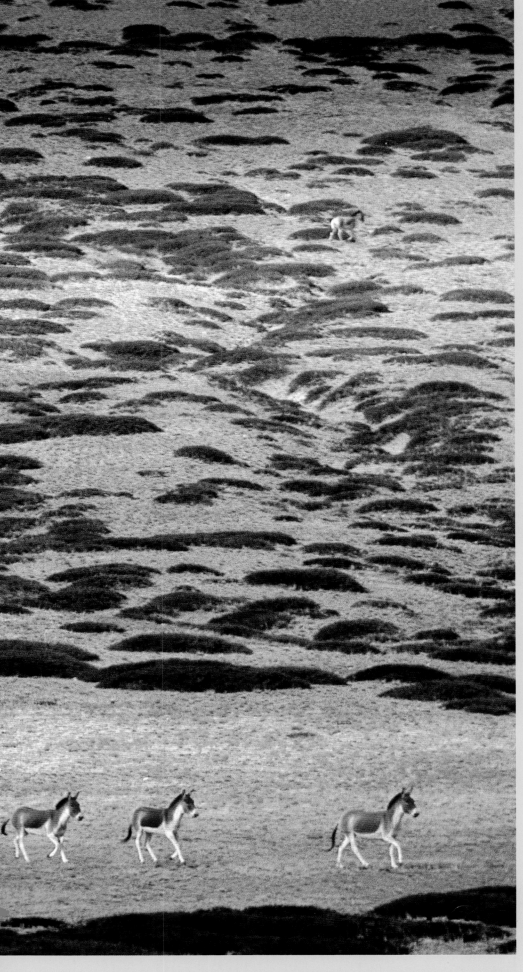

THE XIXABANGMA RANGE

lives up to its name, which means "mountain rising over a grassy plain." Galen camped for four days in this spot near Lake Pekhu Tso in western Tibet. (1988)

◆

RAINBOW OVER THE POTALA PALACE

Following page: A once-in-a-lifetime coincidence of light, weather and subject formed one of Galen Rowell's best-known photographs. This Asian acropolis, traditionally the winter home of the divine Dalai Lama, rises 700 feet above the fabled city of Lhasa, Tibet. (1981)

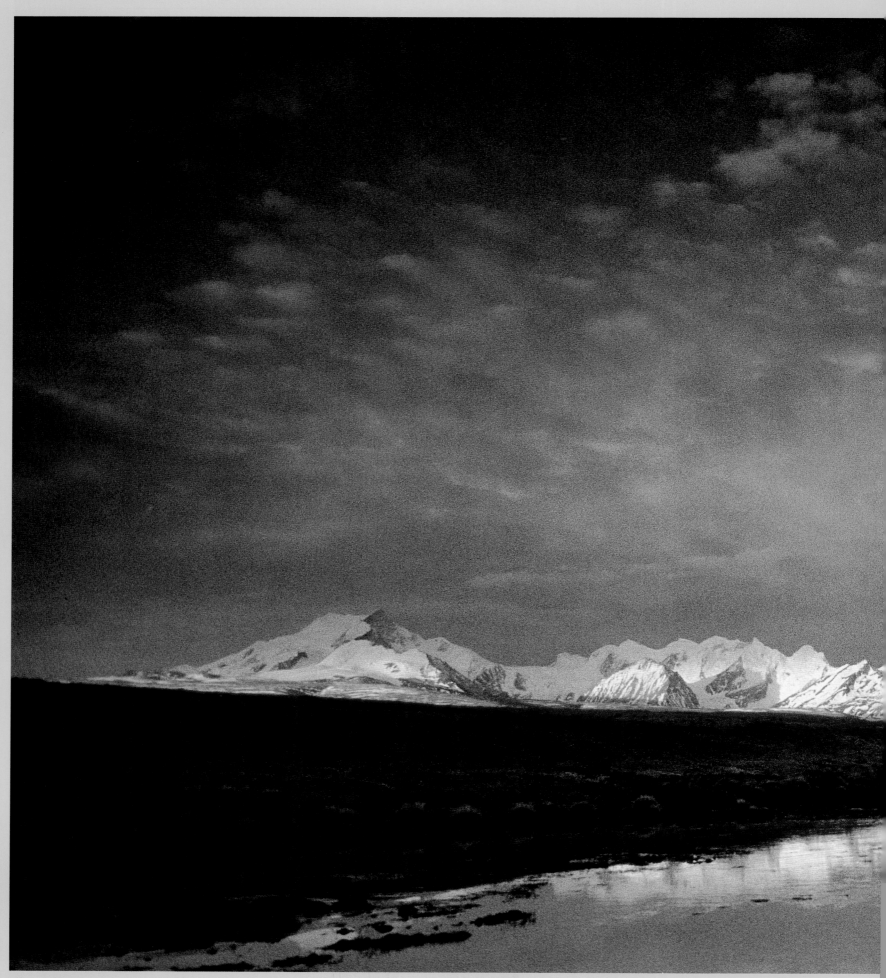

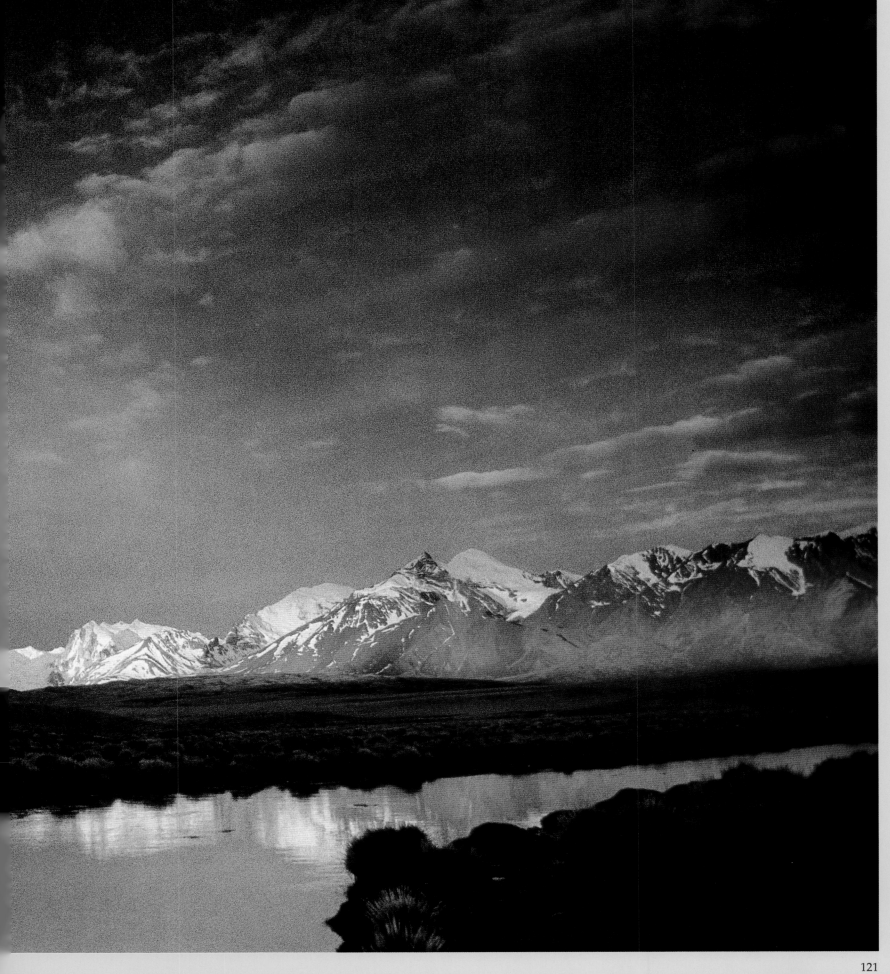

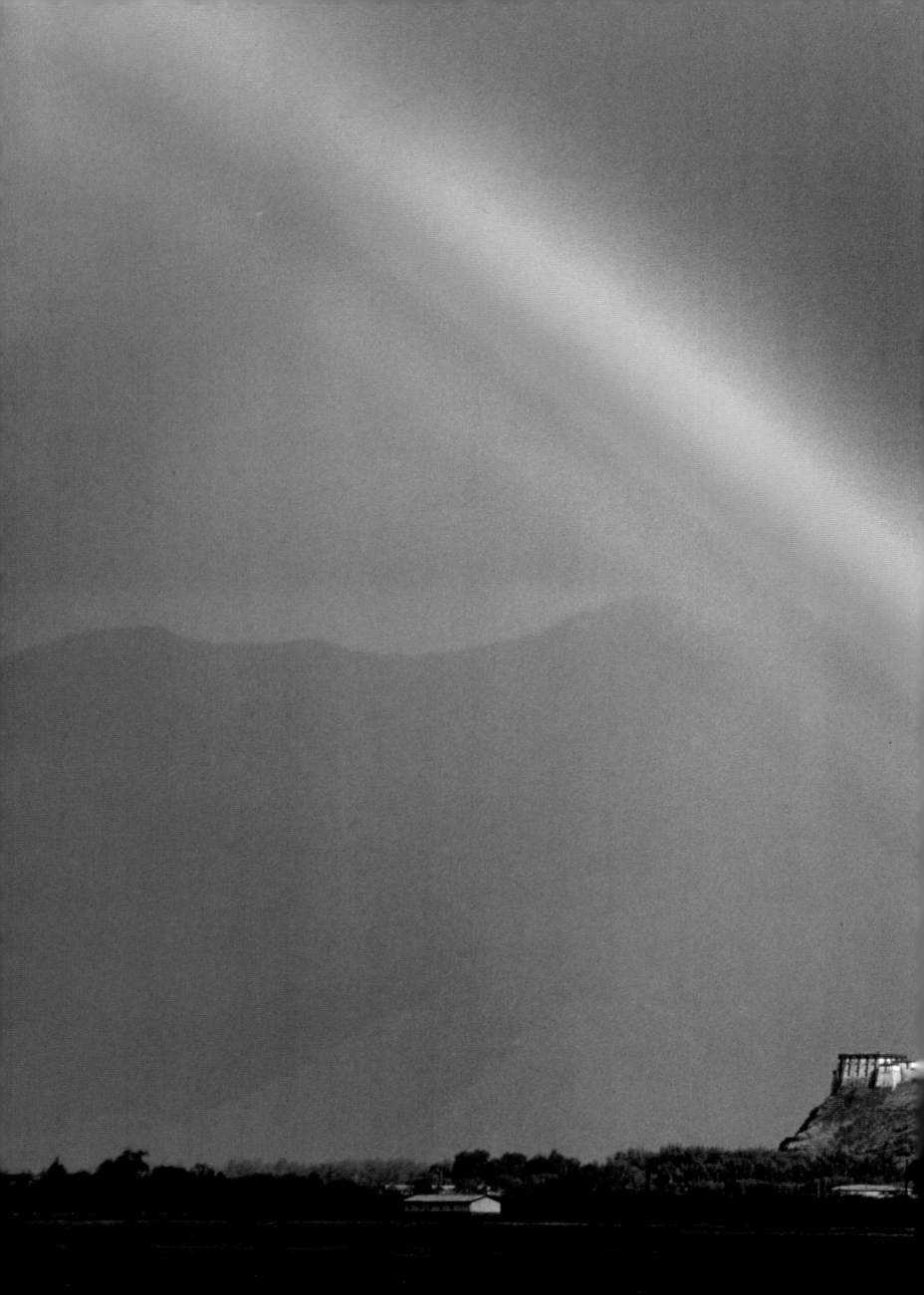

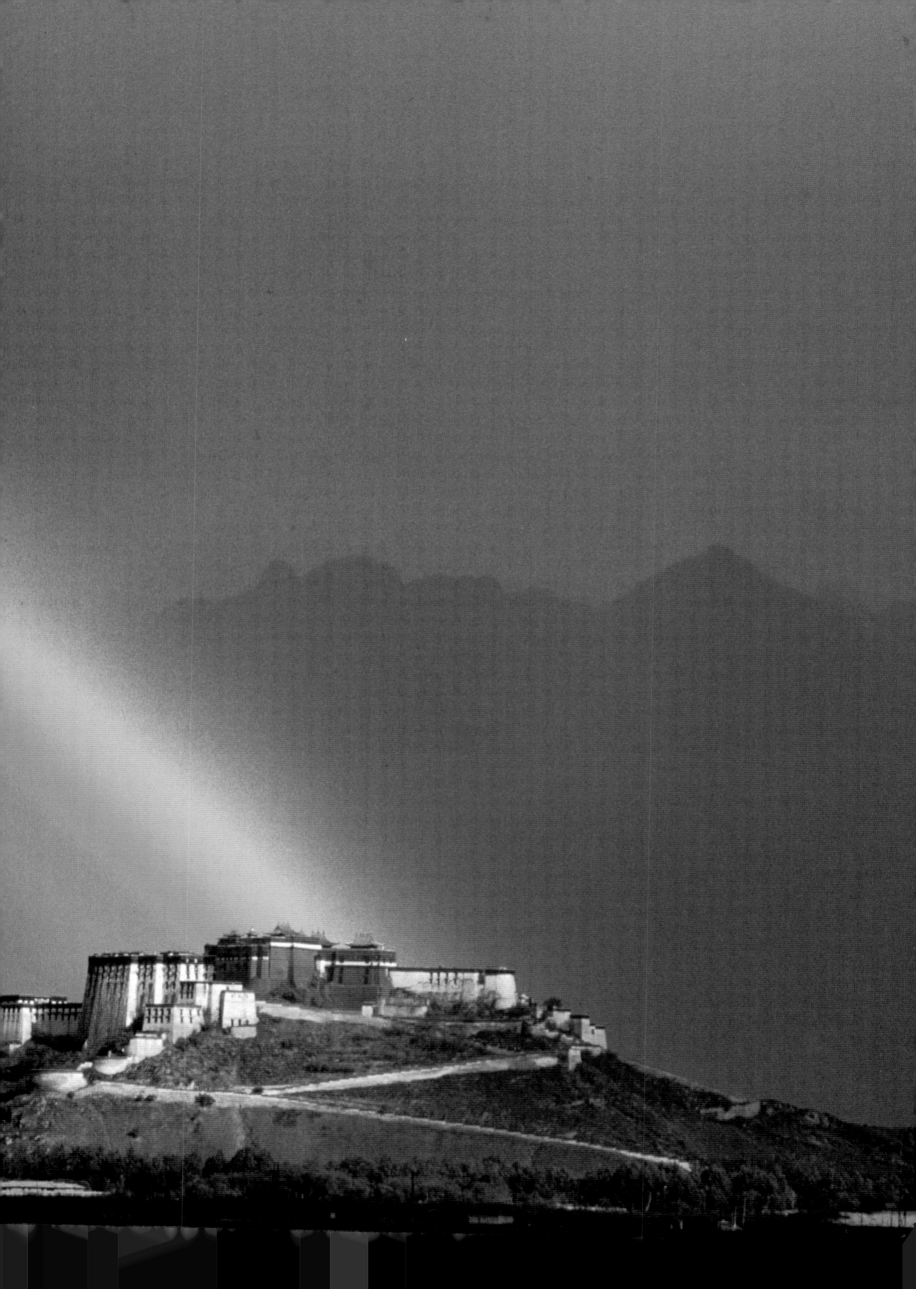

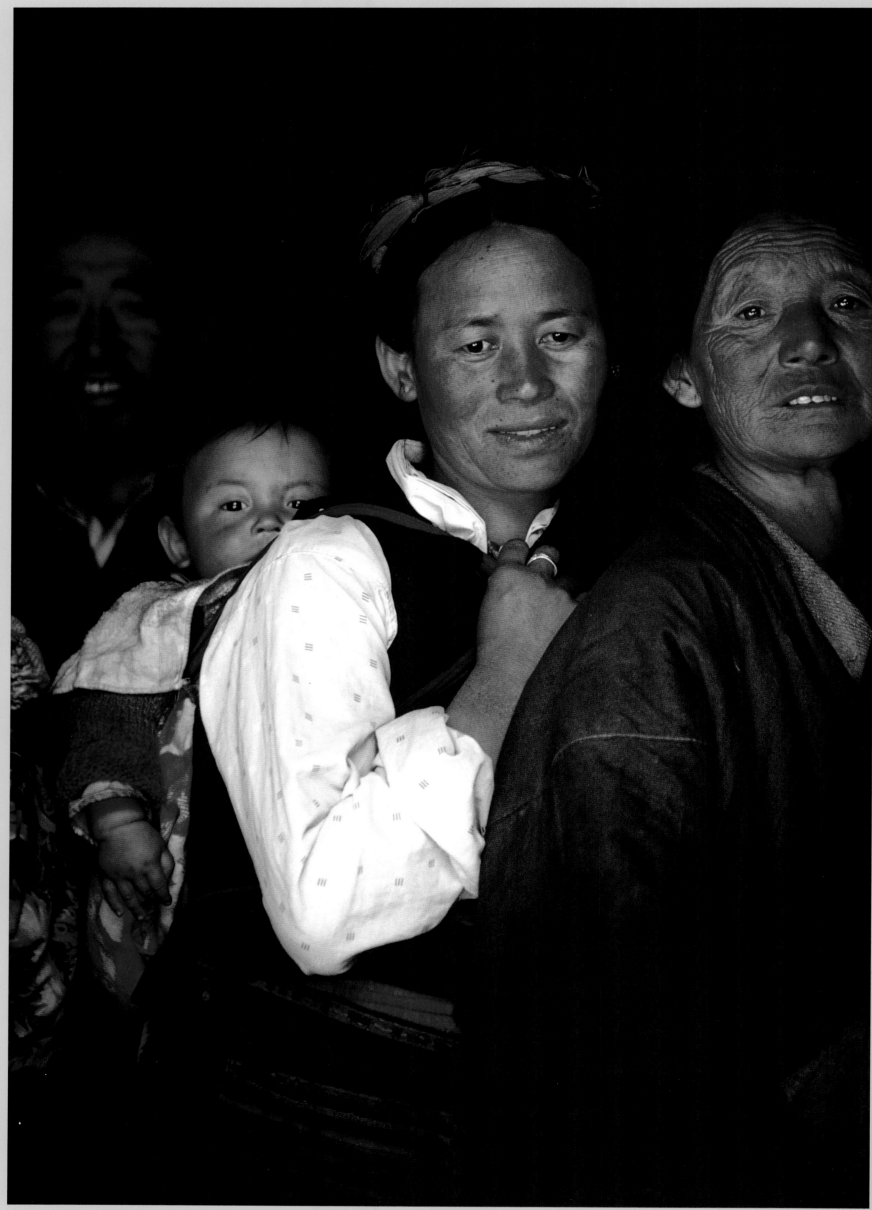

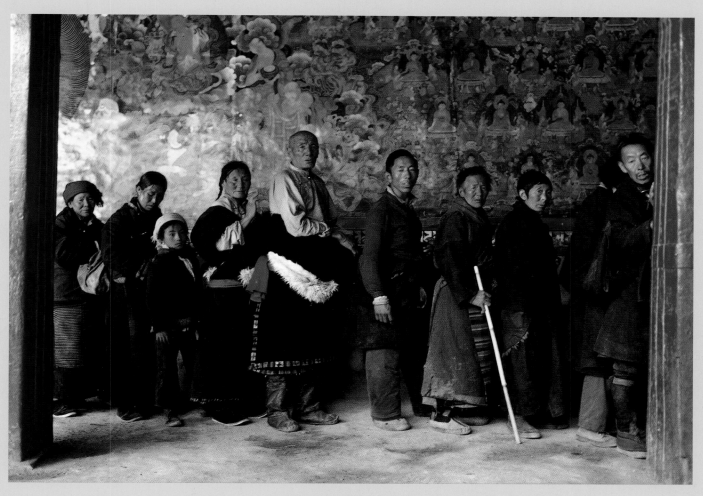

TIBETAN BUDDHISTS LINE UP

to worship in the dark, heavily decorated corridors of Jokhang Temple

in the heart of Lhasa. The low-rise temple, hidden by

surrounding buildings, contains some of Tibet's holiest treasures. It has

become a magnet for thousands of pilgrims since the Chinese

leadership reopened the 7th century shrine in 1981. Left: Mother, daughter and

granddaughter wait to worship in the temple courtyard. The radiant

light in this portrait occurred when high-noon sunlight bounced off the stone

floor of the court and picked up the warm hues of the

temple's red, purple and gold walls. (1981)

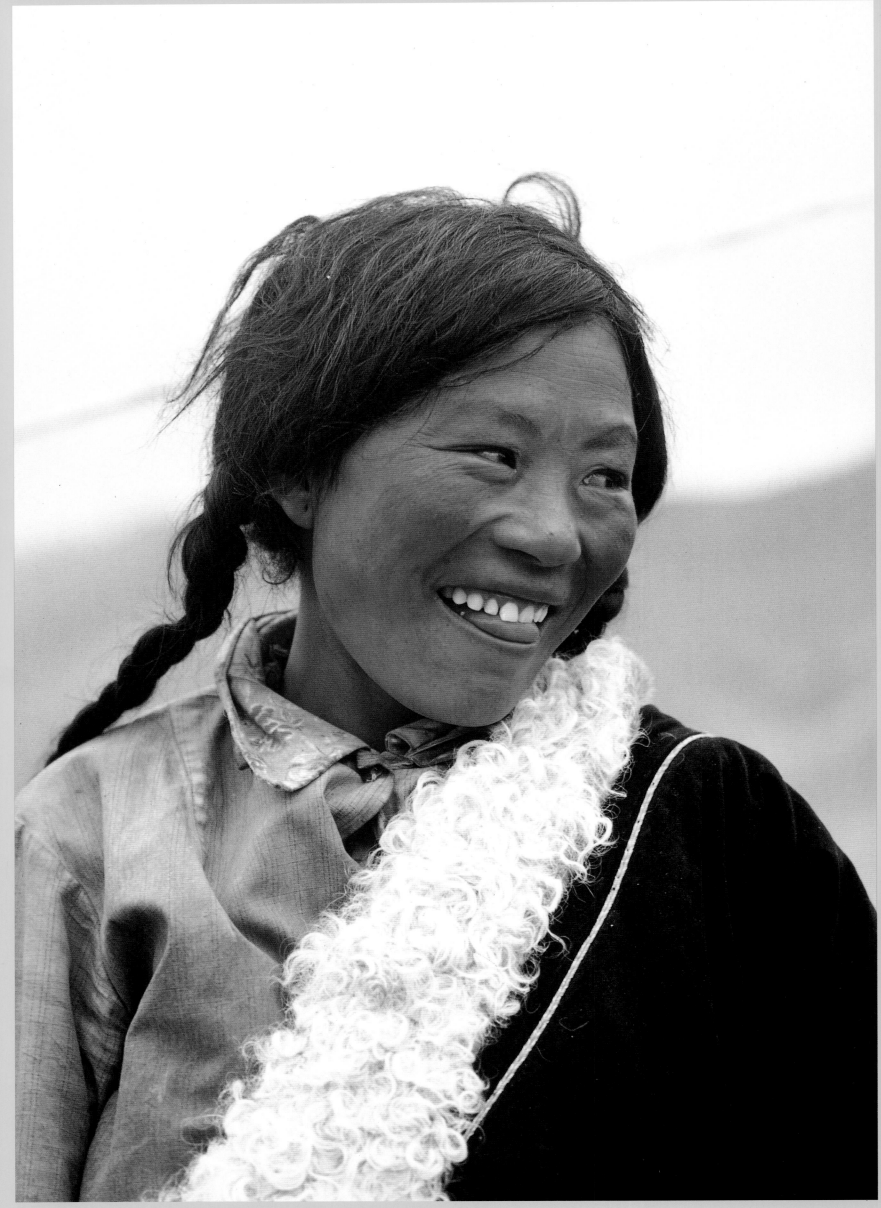

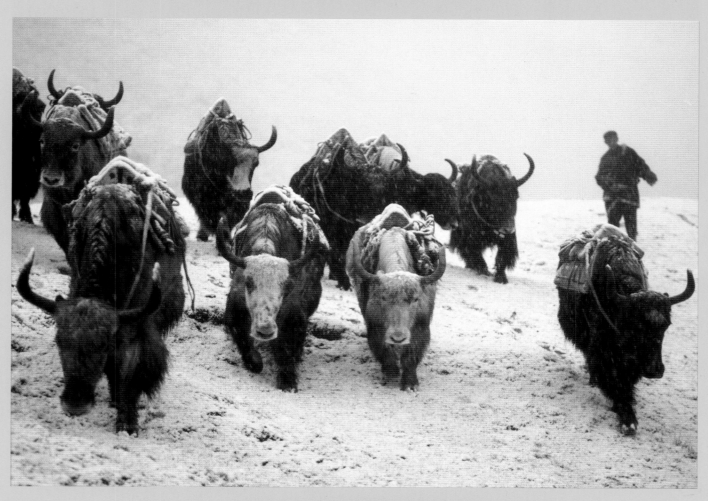

THE MIRACULOUS, ALL-PURPOSE YAK

works like a camel, produces milk like a cow, yields lamp oil like
a whale and offers up its wool like a sheep. Yak dung,
used as a fuel, heats yak-hair tents and roasts yak meat for dinner. It is
understandable, then, why Tibetans put up with this most
cantankerous and unruly beast. (1981)

◆

A GOLOK TIBETAN WOMAN SMILES

and shows her tongue as a sign of greeting. According to Tibetan
legend, a disguised devil once wandered through the land, looking
every inch a human being except that his ears were pointed and his tongue
was black. Thus, early Tibetans exposed their ears and tongues
when they met. In time, the gesture was simplified to a quick display of
the tongue as a sign of friendliness. (1981)

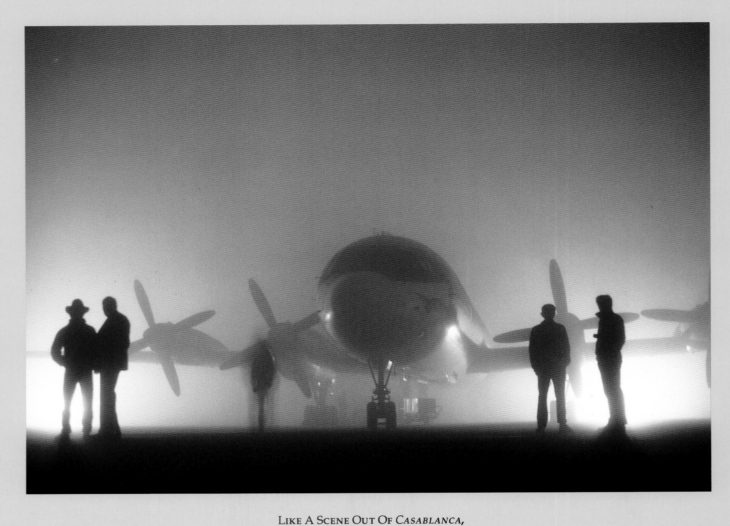

Like A Scene Out Of Casablanca,
a Russian-built Chinese airliner waits out the early-morning fog
at Chengdu airport. Runway lights silhouette four members of Galen's
1983 Everest expedition en route to Lhasa, Tibet.

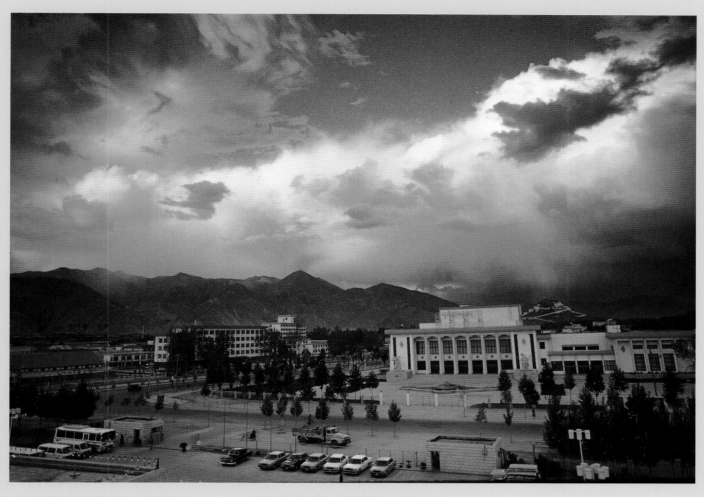

THE VIEW FROM THE LHASA HOTEL

*with Potala Palace barely visible in the background. Galen laments the
sterile new Chinese architecture in the middle of this ancient
holy city and lists other surprising intrusions on the adventurer's dreams
of Lhasa: ubiquitous Chinese soldiers, traffic cops, billboards and
even a place called the Lhasa Disco. (1988)*

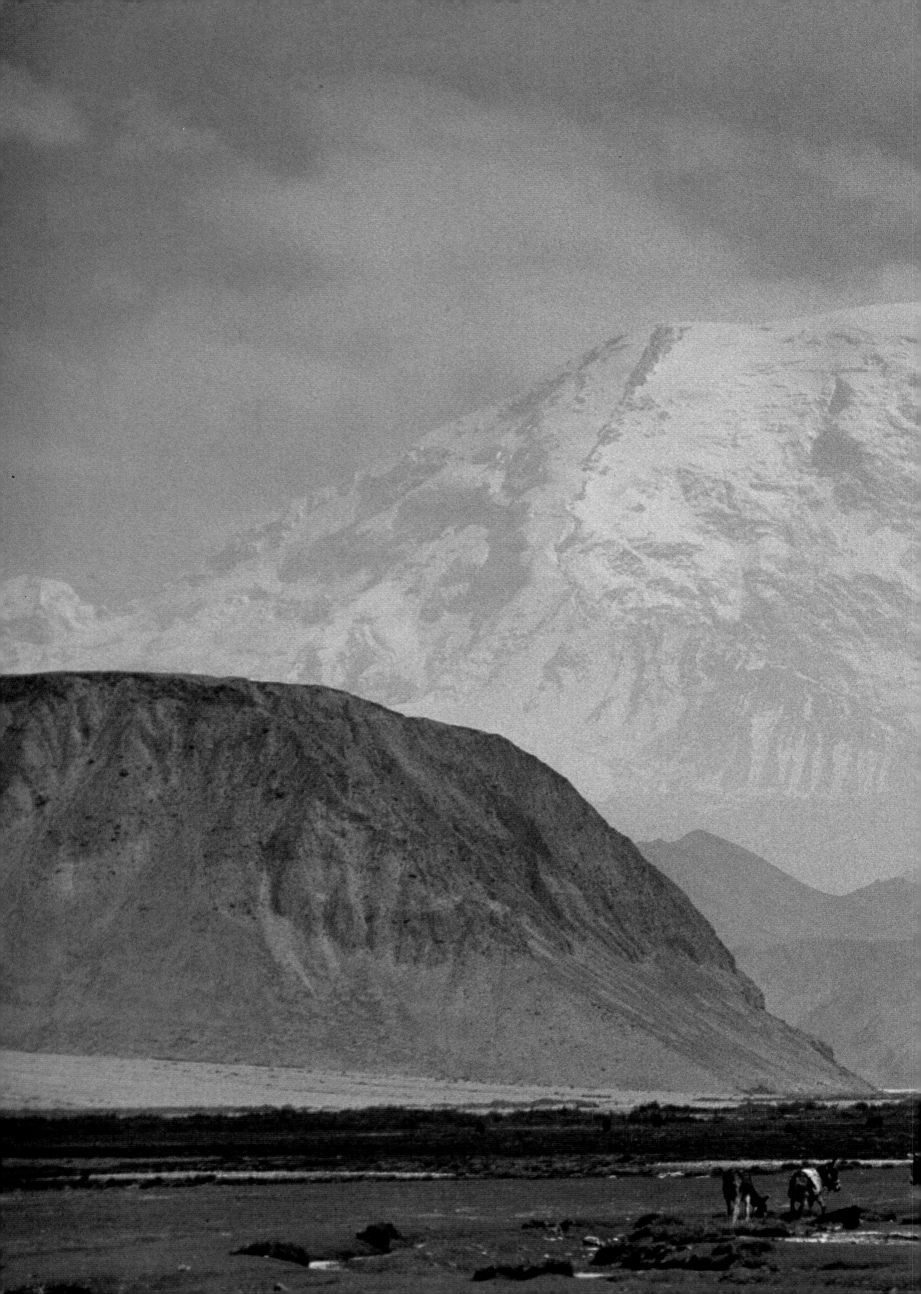

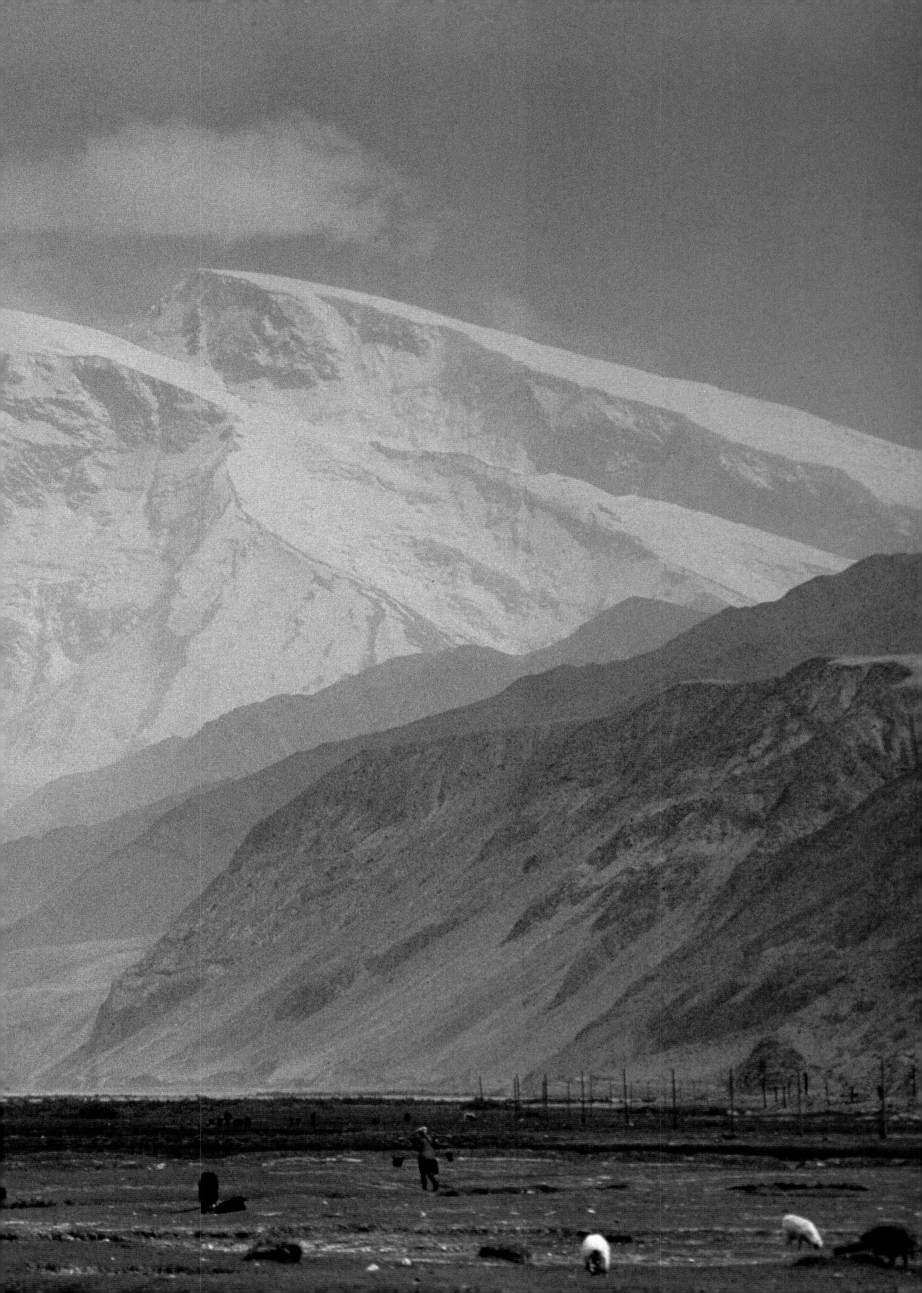

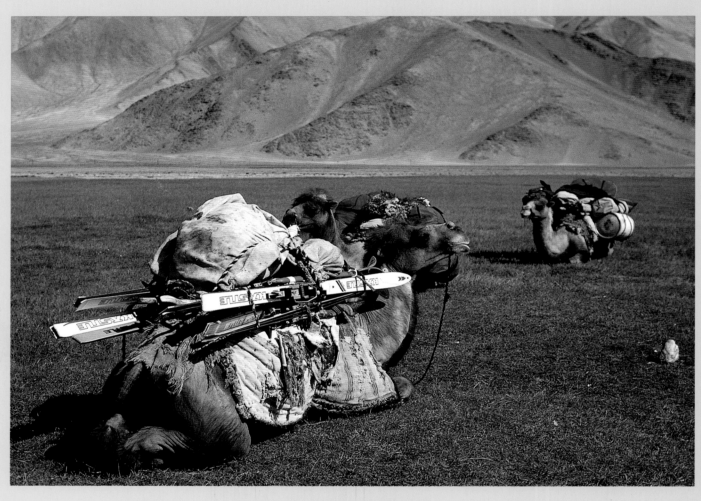

GALEN'S CAMEL CARAVAN RESTS

en route to a 17,000-foot camp on Muztagata. From there, the trekkers
spent three days skiing to the summit with climbing skins
attached to their skis. Right: Jan Reynolds, after reaching the summit and
setting a world altitude record for a woman on skis, enjoys spring
conditions on her way down the mountain. (1980)

◆

ALONG THE SILK ROUTE
Preceding page: Green meadows in western China give way to
the foothills and the two-tiered summit of 24,757-foot
Muztagata, the goal of Galen's 1980 ski expedition. Their route to the
top followed the gentler, snowy slope up the right side
of Muztagata in this photograph.

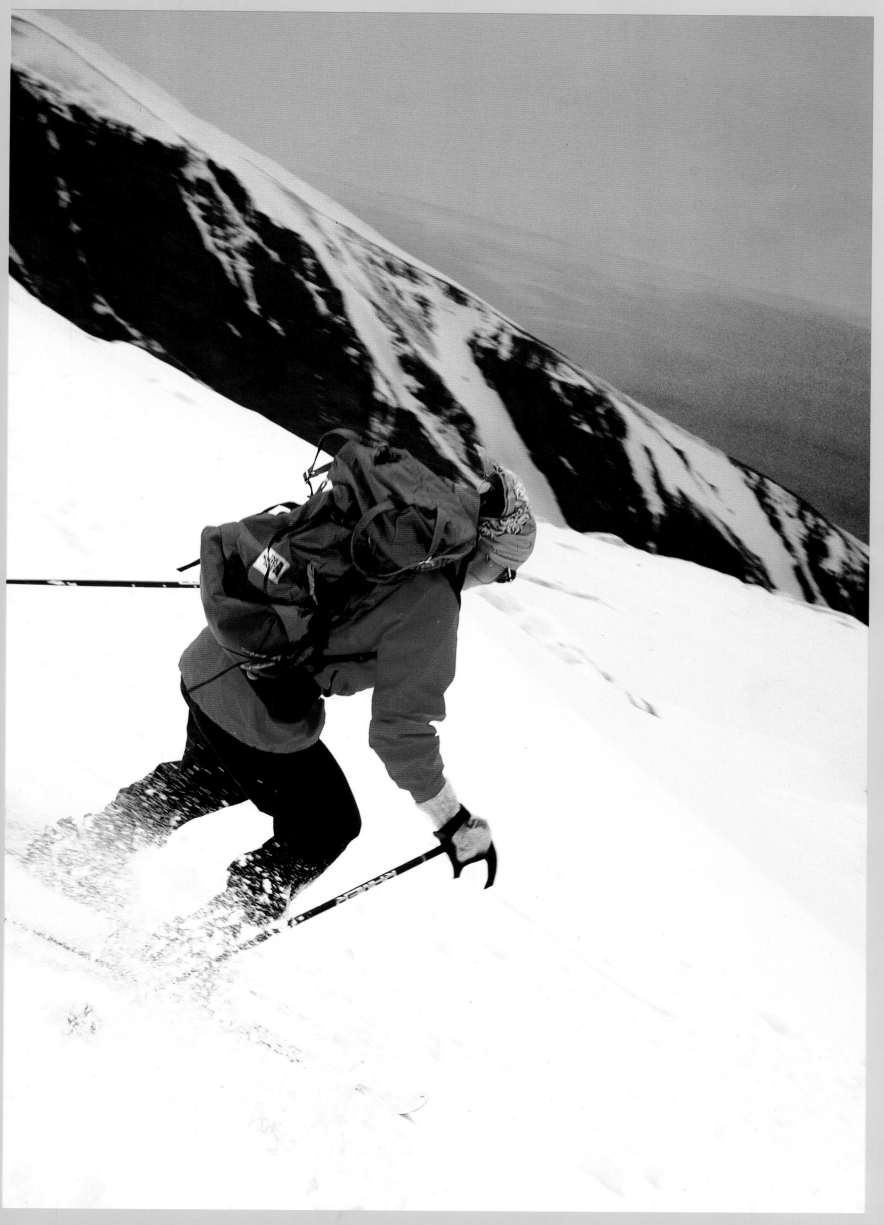

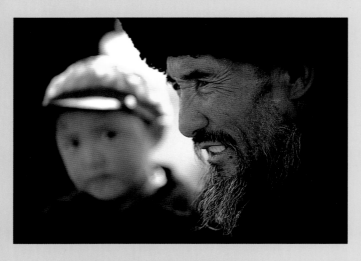

A Kirghiz Father And Son

crossed paths with the peripatetic photographer twice: in
1980 and then again in 1986. The first time, Galen
was en route to Muztagata in Xinjiang province, China. The portrait
above was published in his book Mountains of the Middle
Kingdom. Six years later, he returned to the area. He showed the book
to a man who took one look at the portrait and rushed
into a nearby building. Out came the same Kirghiz father and son—
and their entire family—to greet Galen, and
once again pose for his camera.

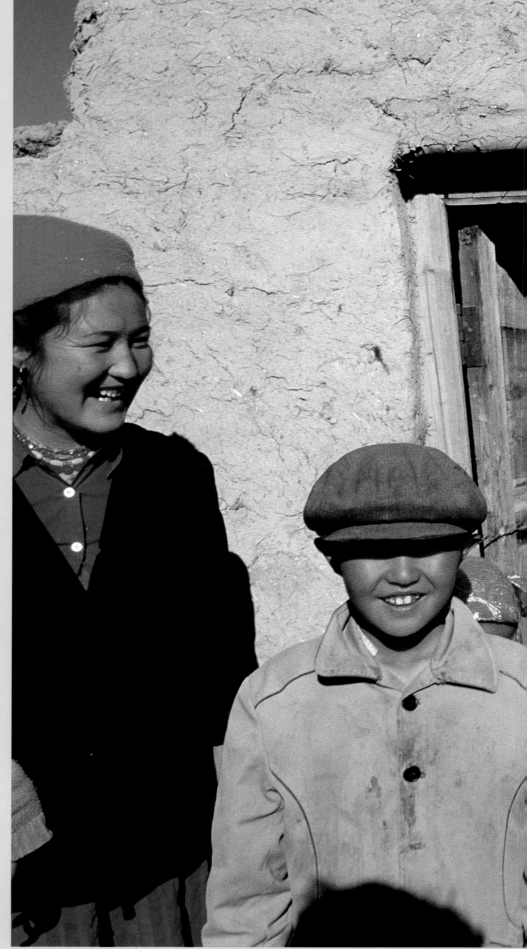

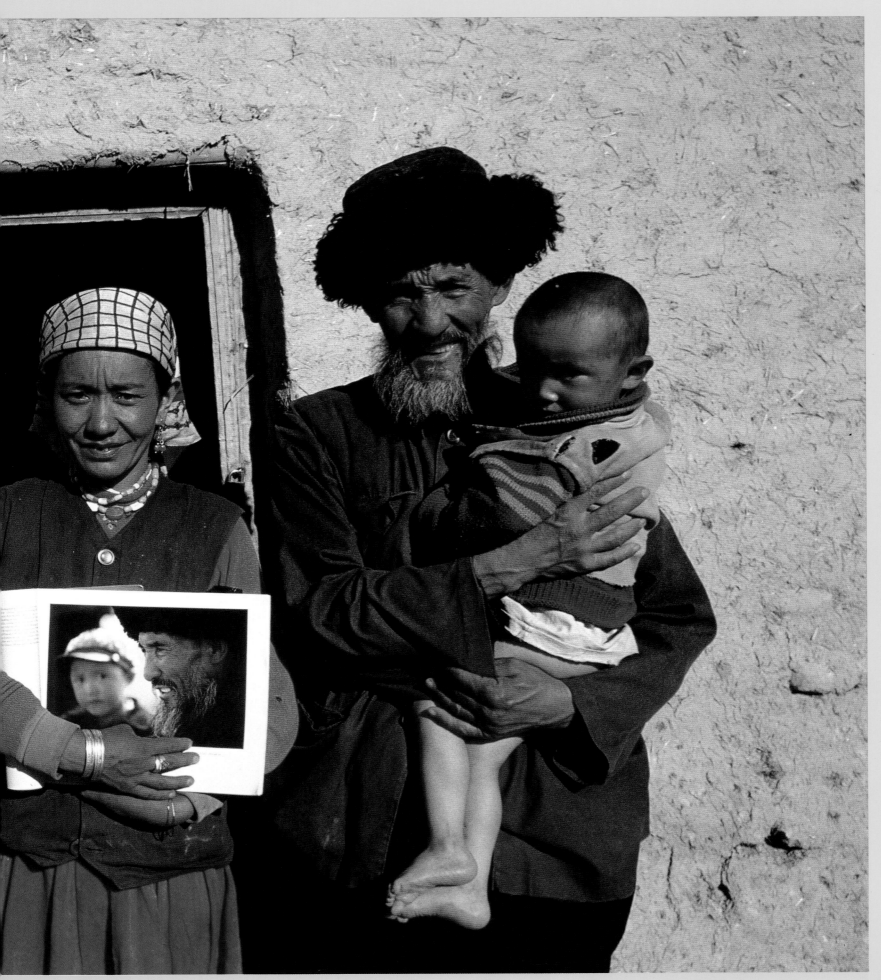

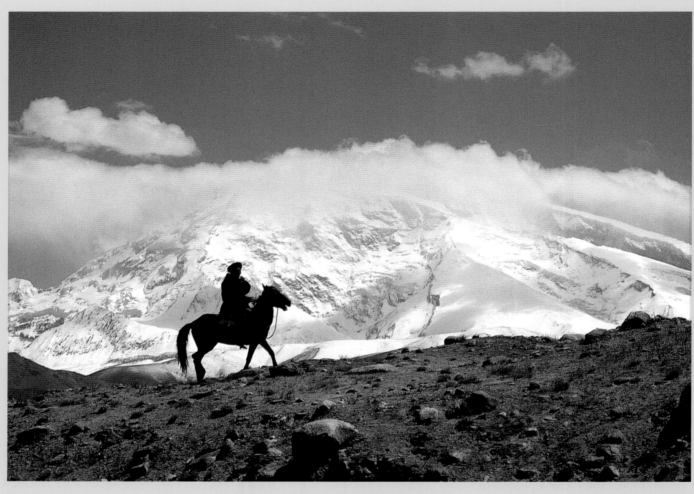

Town And Country In Central Asia

A lone Kirghiz horseman beneath Muztagata contrasts with the traffic

of East Brigade Street in downtown Kashgar, 100 miles away.

In the distance, a monumental statue of Chairman Mao hails the citizens of

this medieval, multiracial trading city. When Galen took

these pictures in 1980, Kashgar and most of western China were

still officially closed to Westerners.

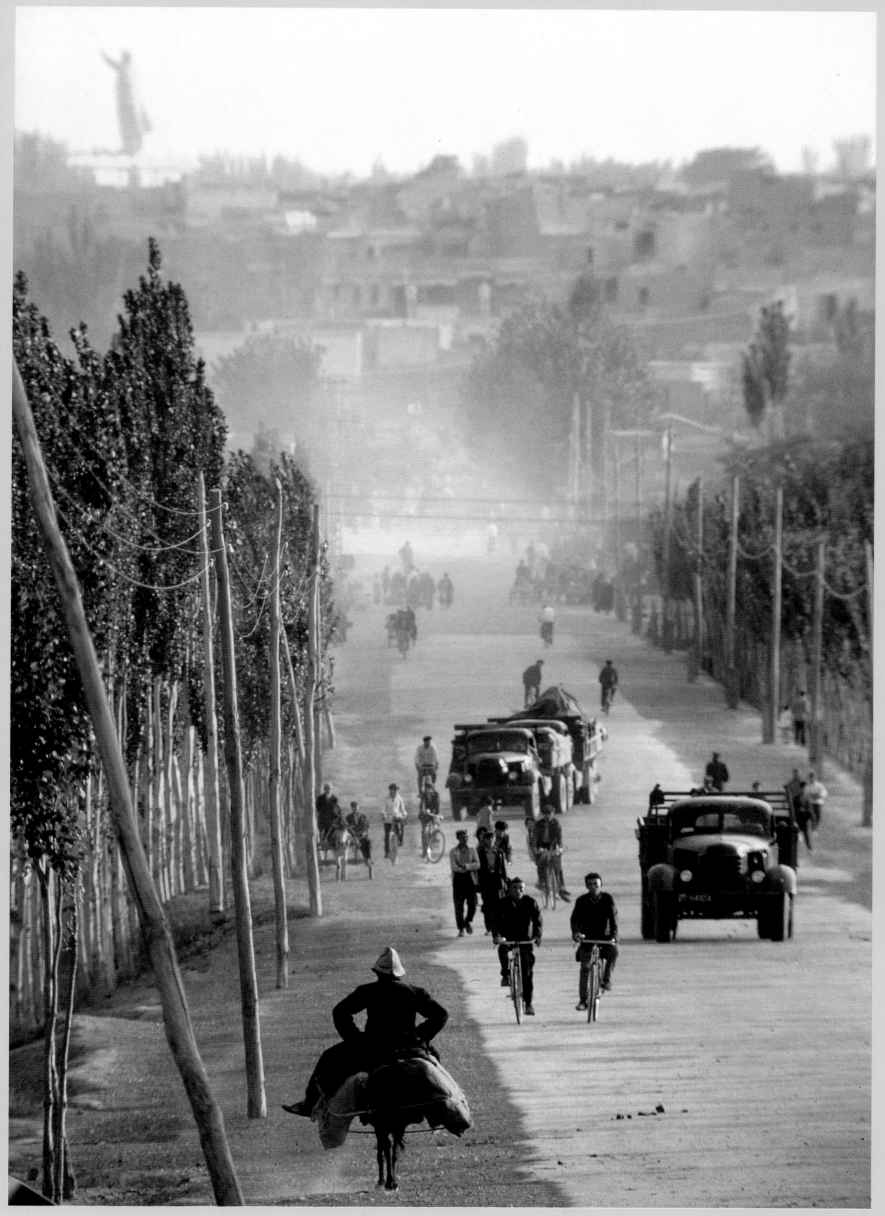

A UYGUR FAMILY HARVESTS WHEAT

on their farm near Kashgar. Uygurs (pronounced **wee-gurs**)
*are a Moslem minority group in western China. They
trace their roots back to Turkish traders of the Ottoman Empire who
traveled parts of the Silk Road. (1986)*

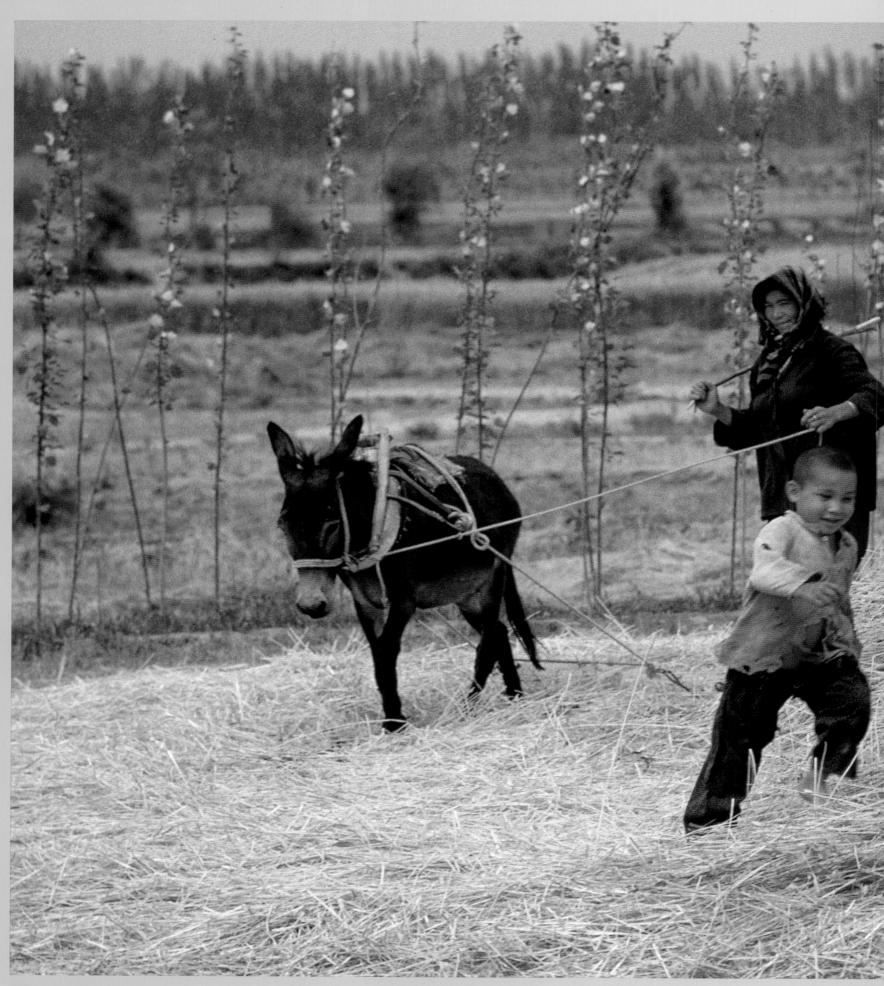

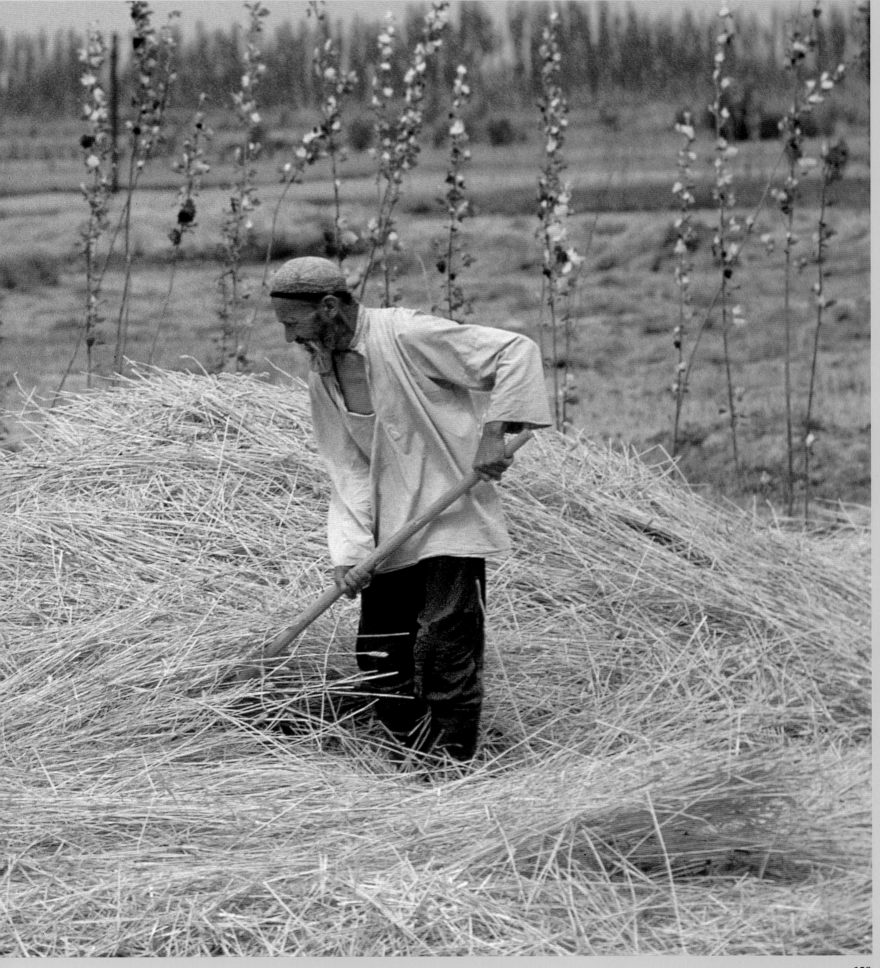

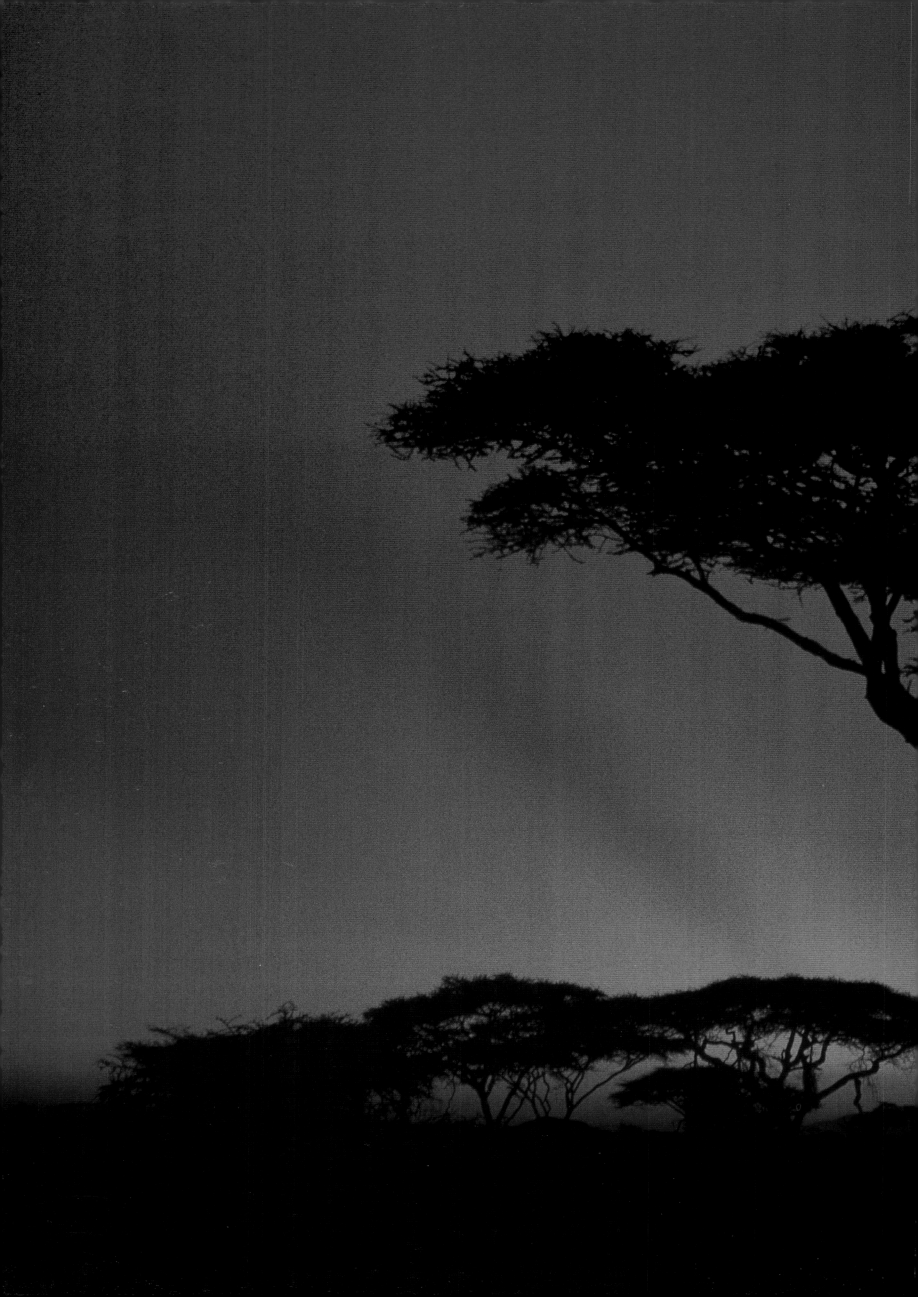

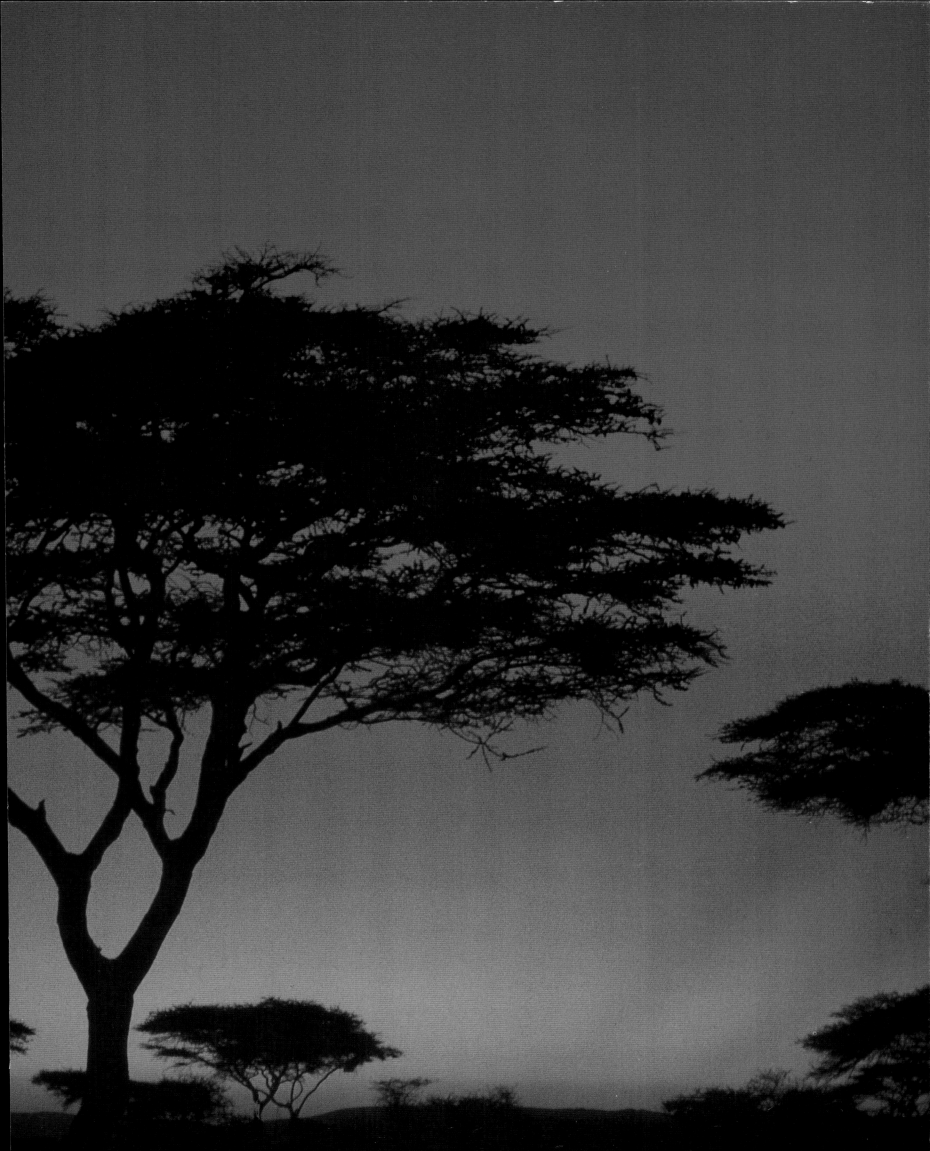

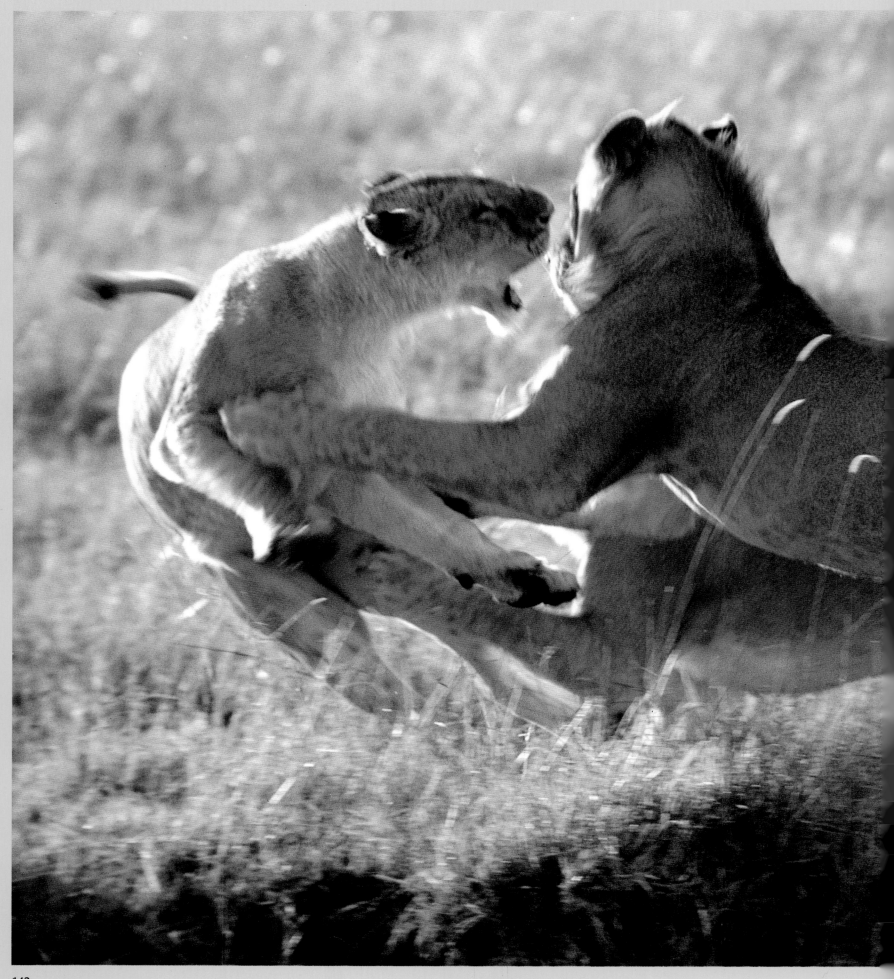

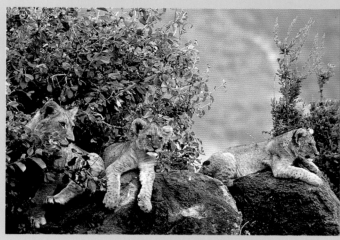

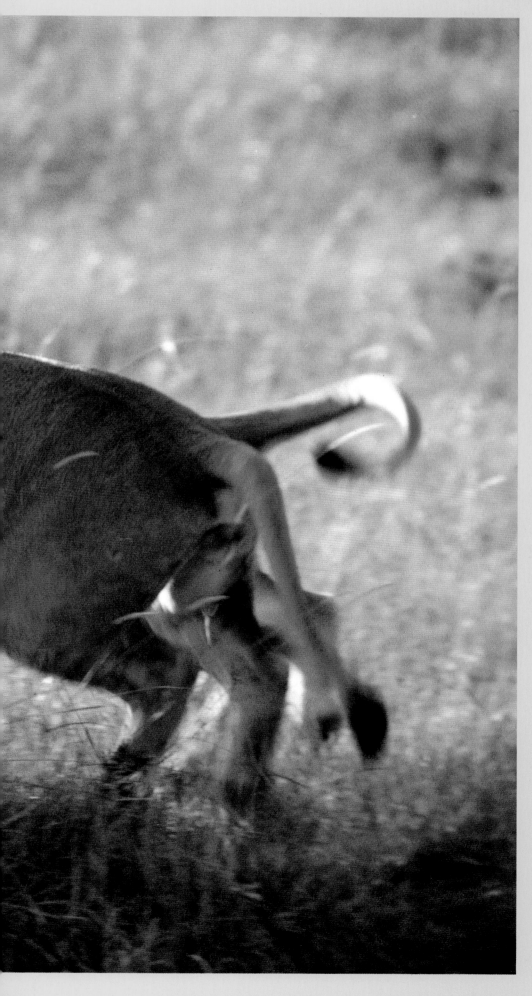

A PASSAGE TO AFRICA

is de rigueur *for any world adventurer, and, in 1982, Galen
and his wife, Barbara, set out for Tanzania and Kenya.
Left: In Masai Mara Reserve they found three young lions roughhous-
ing. Above: In Tanzania's Ngorongoro Crater they found some
even younger cubs lounging on the rocks.*

◆

ACACIA TREES, TANZANIA

*Preceding page: Using a 600mm lens, perfectly clear air, the
canopy of an acacia tree—and no filter—Galen records an African
dawn on the Serengeti Plain. (1982)*

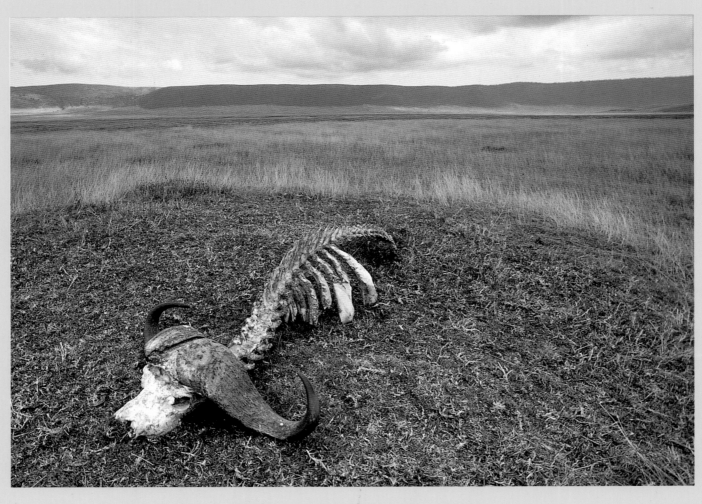

LIFE AND DEATH ON THE AFRICAN PLAIN

A scavenged cape buffalo carcass evokes the primeval feeling
of the grassy Ngorongoro plains. Right: A bull elephant threatens to
charge Galen's Land Rover at Samburu Game Reserve
in northern Kenya. (1982)

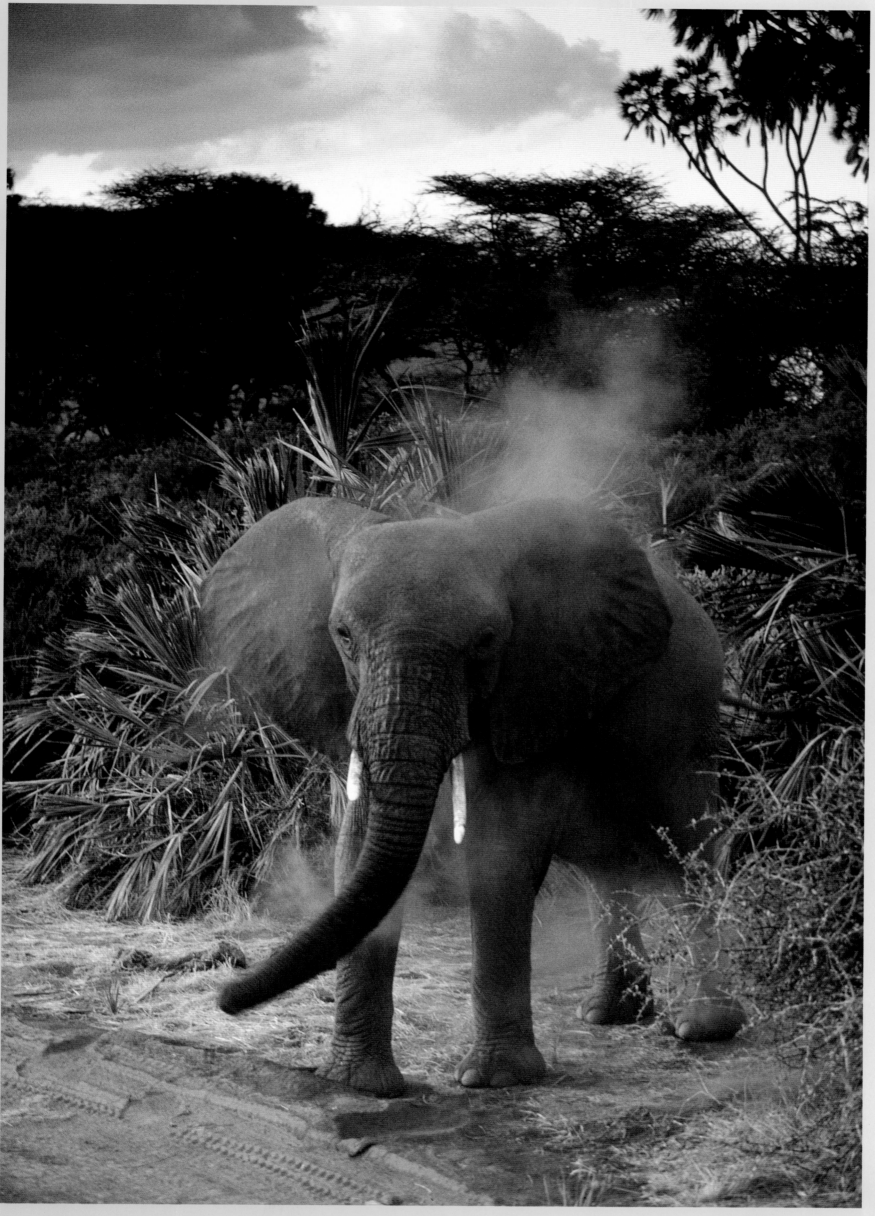

WARY FLAMINGOS

at Ngorongoro Crater shift about nervously to keep a safe
distance while a spotted hyena pretends he's out for
an evening stroll. (1982)

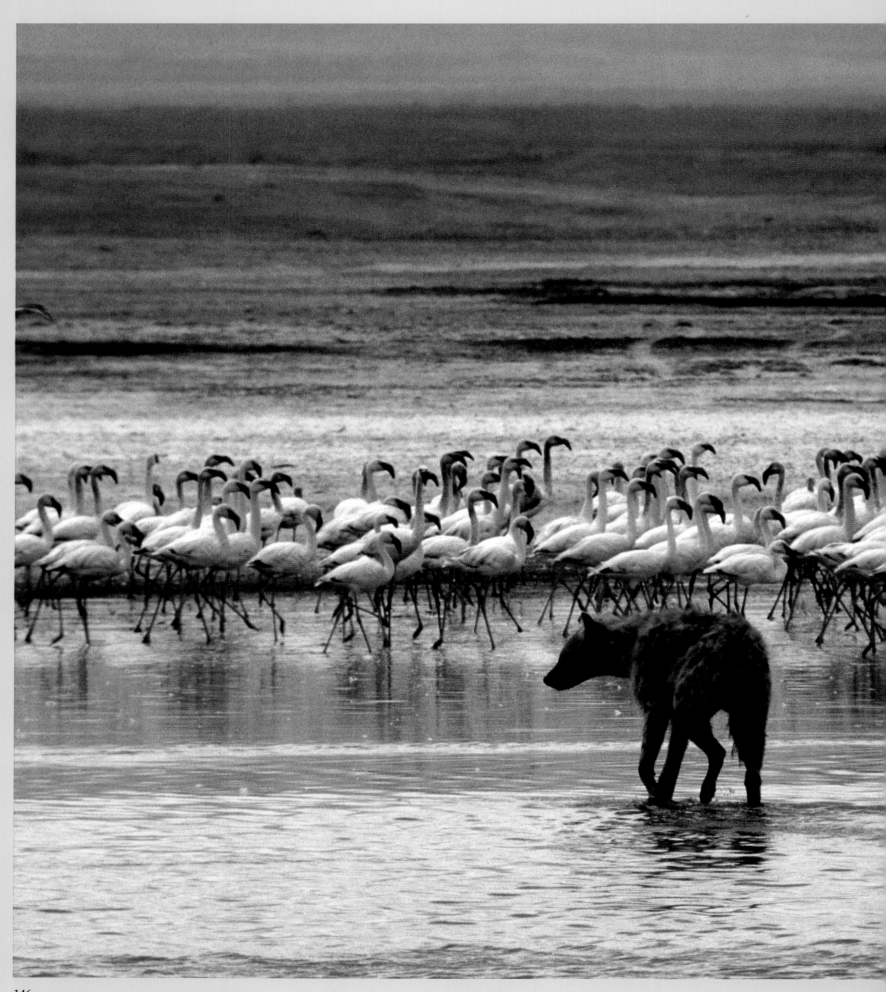

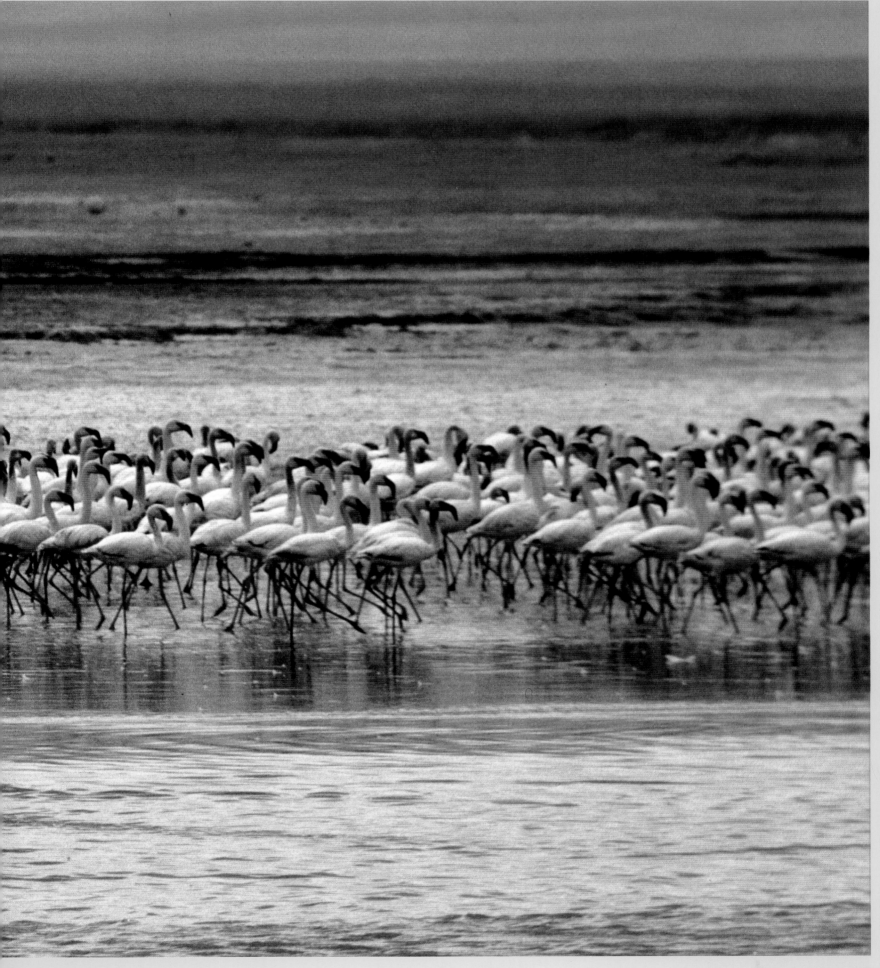

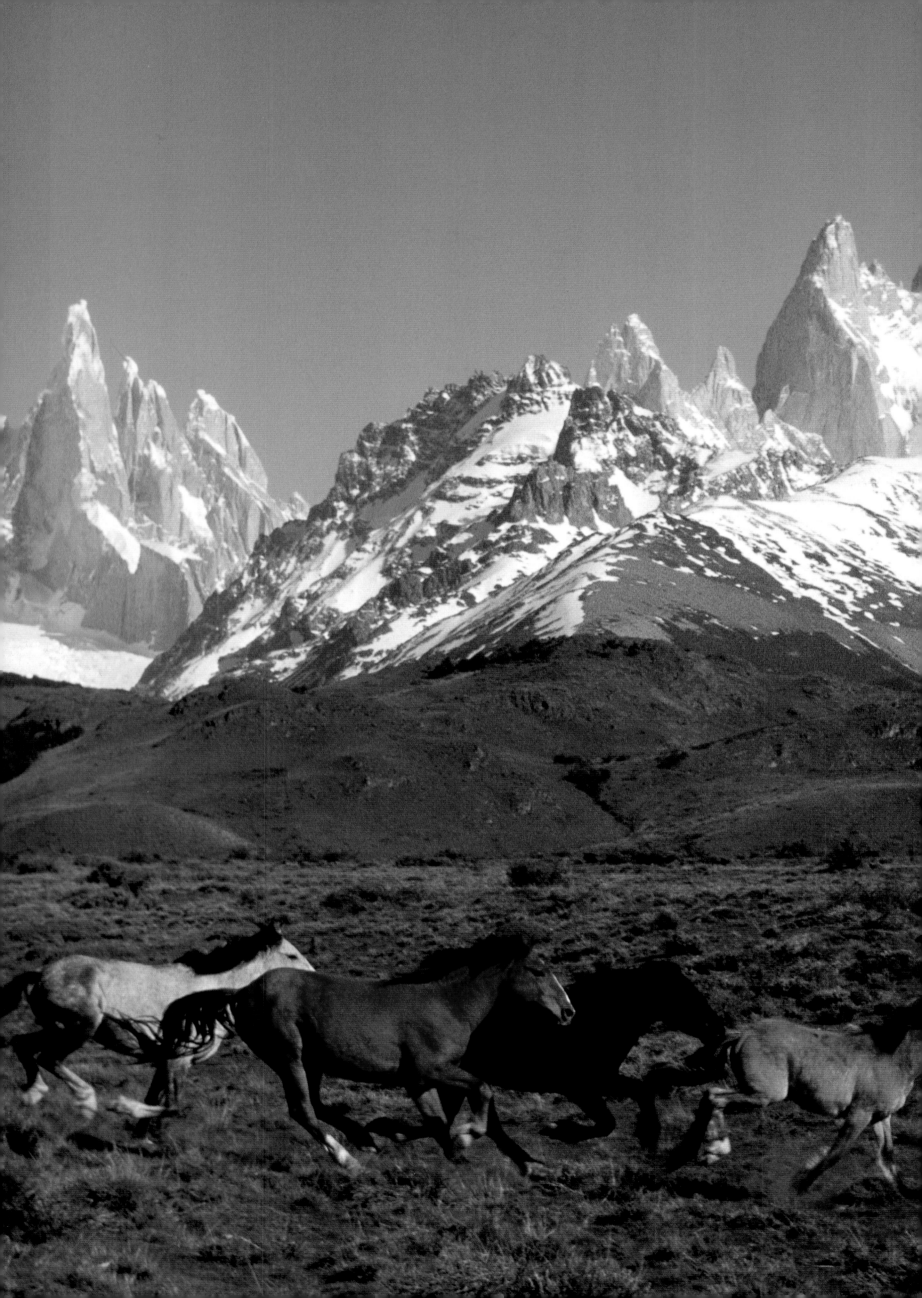

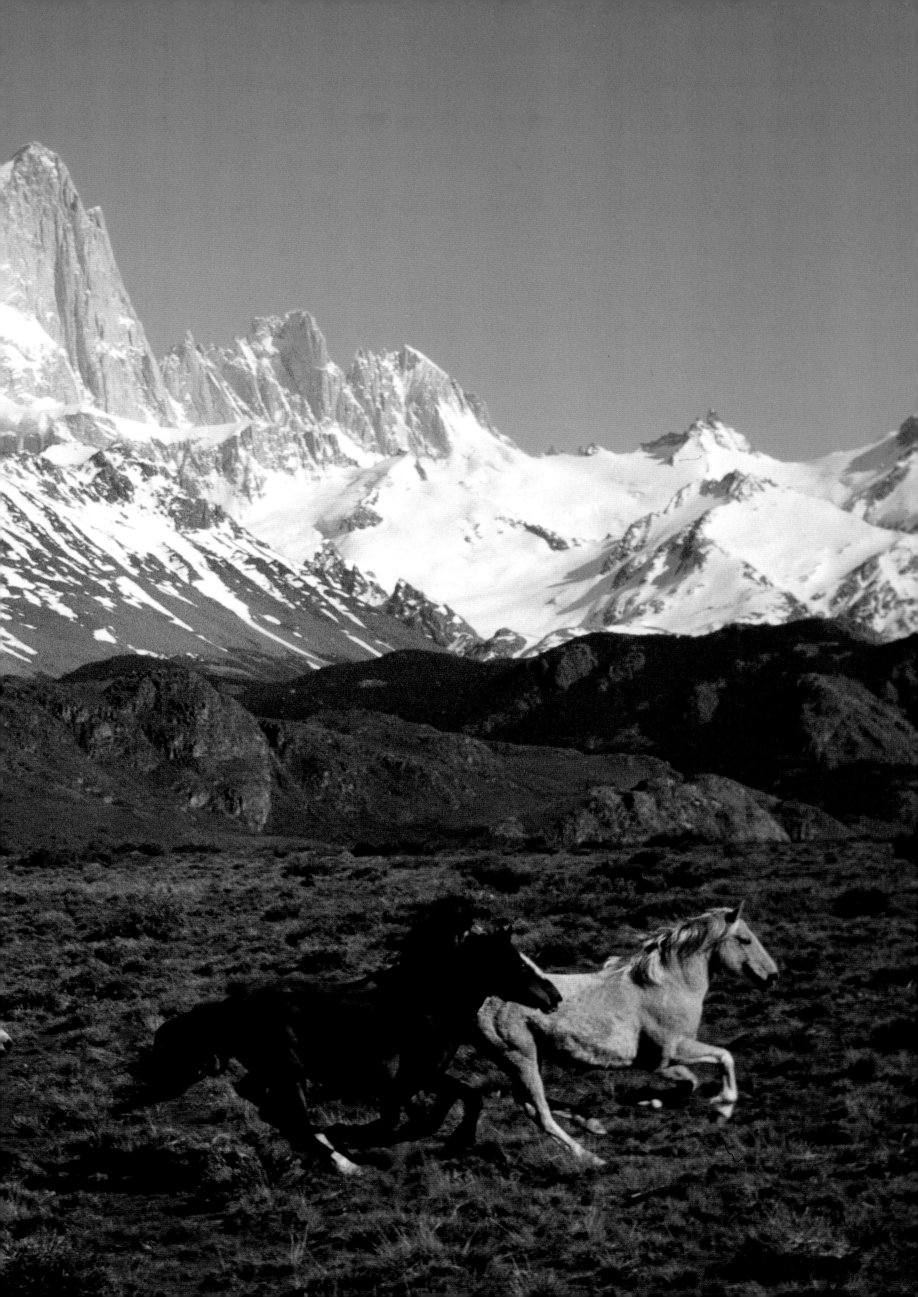

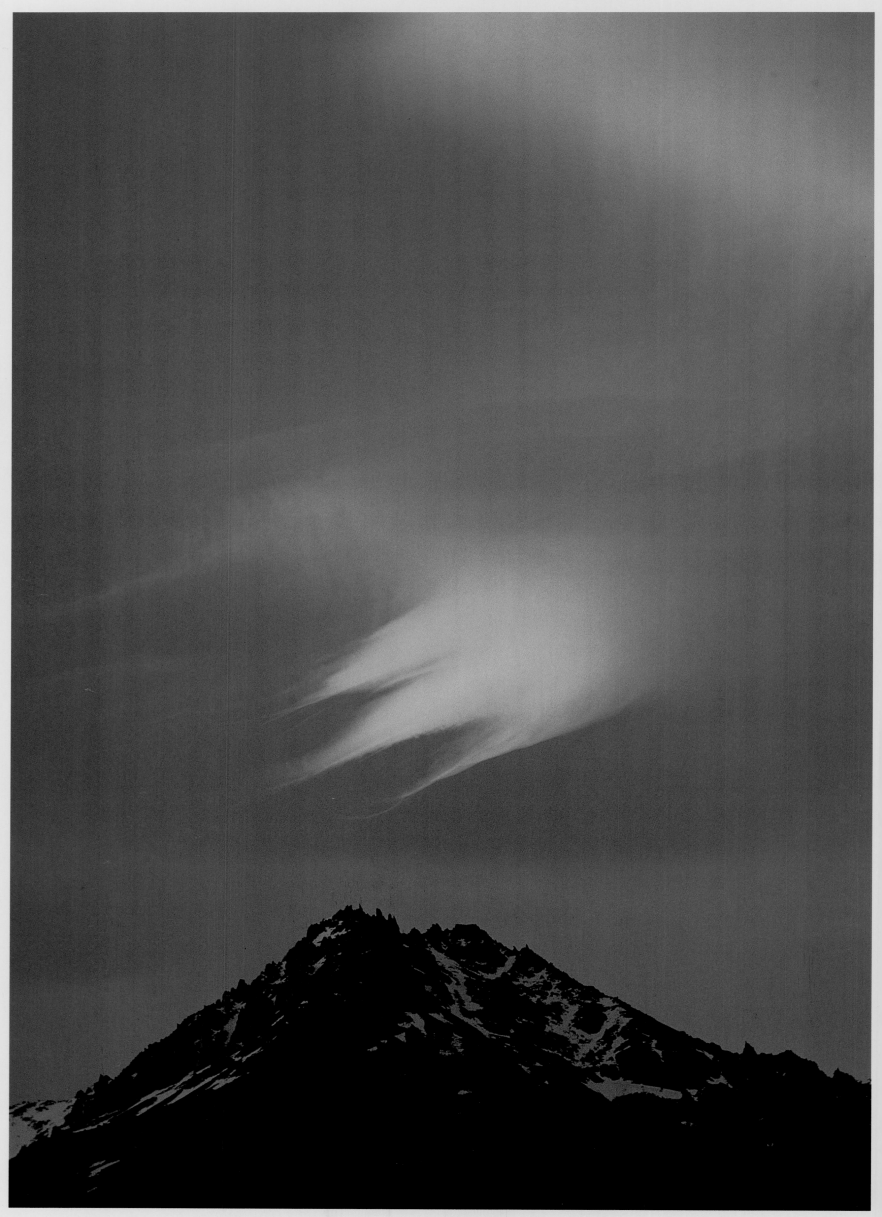

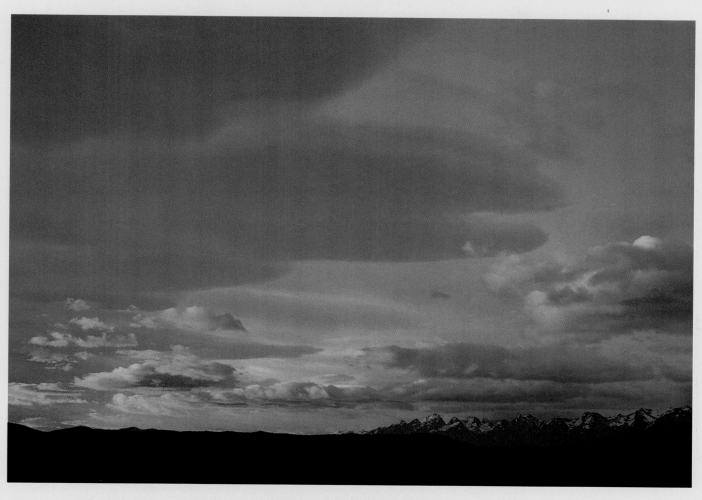

On The Plains Of Patagonia,

a storybook peak called Fitz Roy rises 10,000 feet above a herd

of wild horses (preceding page). Patagonia straddles

Chile and Argentina at the southern, windswept tip of South America.

Like the Karakoram Himalaya, many of

the peaks of the Fitz Roy Range are sheer granite towers draped with ice.

Forbidding and given to vicious weather, Patagonia has enticed adventurers for years.

Butch Cassidy hid-out here, and Charles Darwin gathered

evidence for his theory of evolution. Fitz Roy is named in honor of the captain

of the H.M.S. Beagle which brought Darwin to Patagonia during a

four-year scientific journey around the world.

Above: Storm clouds light up at sunrise above Lago Viedma south of

Fitz Roy. (1985) Left: Snowy patches on a Patagonian peak reflect

the alpenglow from a thundercloud.

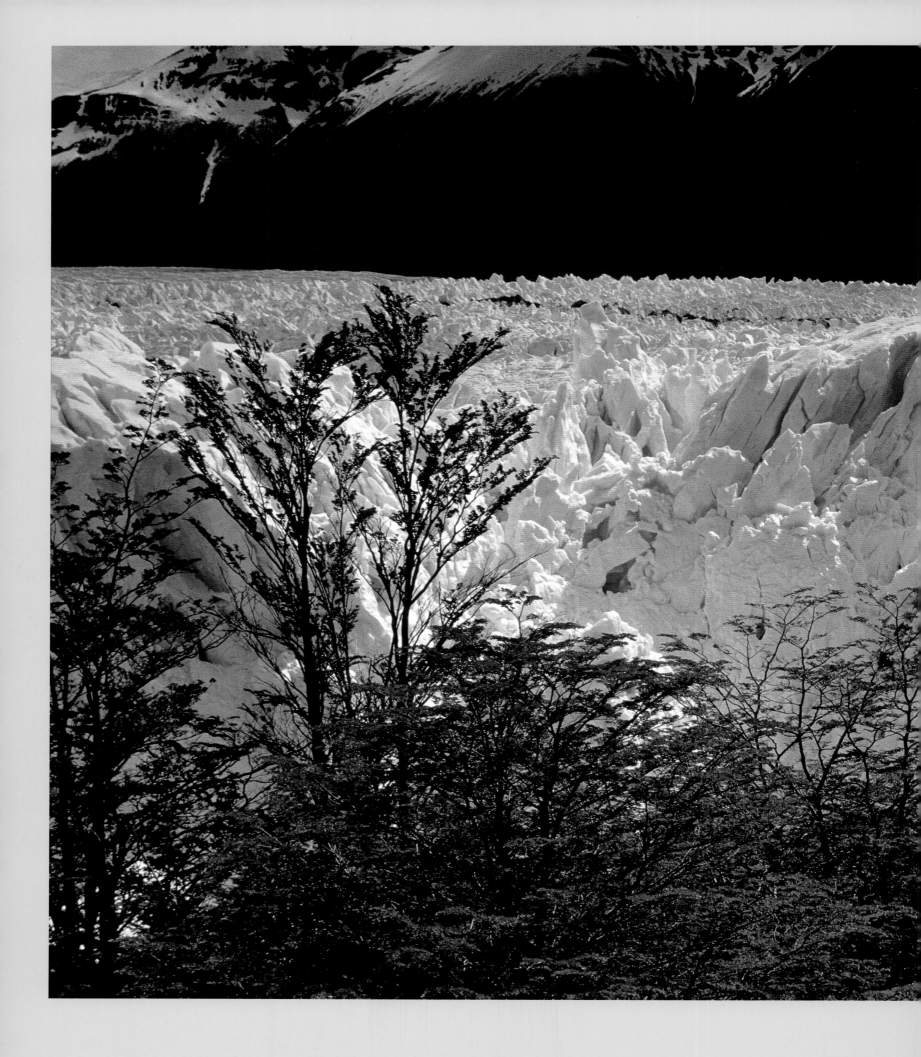

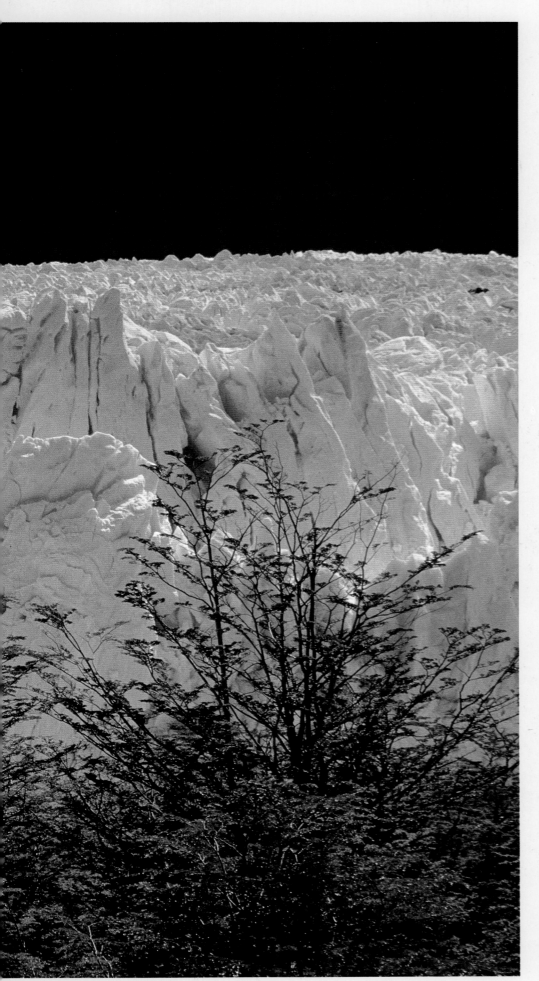

A Filigree Of Beech Trees

seems to hold back the advancing ice wall of the Moreno
Glacier, which closes off a 40-mile arm of Lake Argentina. Every
three years, the backed-up lake overpowers
the glacial dam, setting off a great cataclysm of crashing
icebergs and flooding waters. (1985)

———————◆———————

Little Magellanic Penguins

roost by the millions at Peninsula Valdes on the Atlantic coast
of Patagonia, a teeming metropolis of elephant seals, sea lions, other
sea birds and offshore whales. (1985)

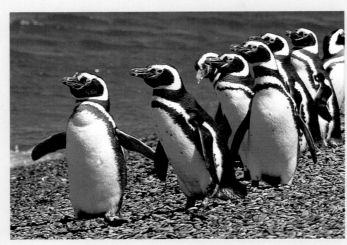

SUNSET SWEEPS THE TREELESS PAMPAS

in Patagonia, backlighting a herd of guanaco, the wild ancestor

of the domestic llama. (1985)

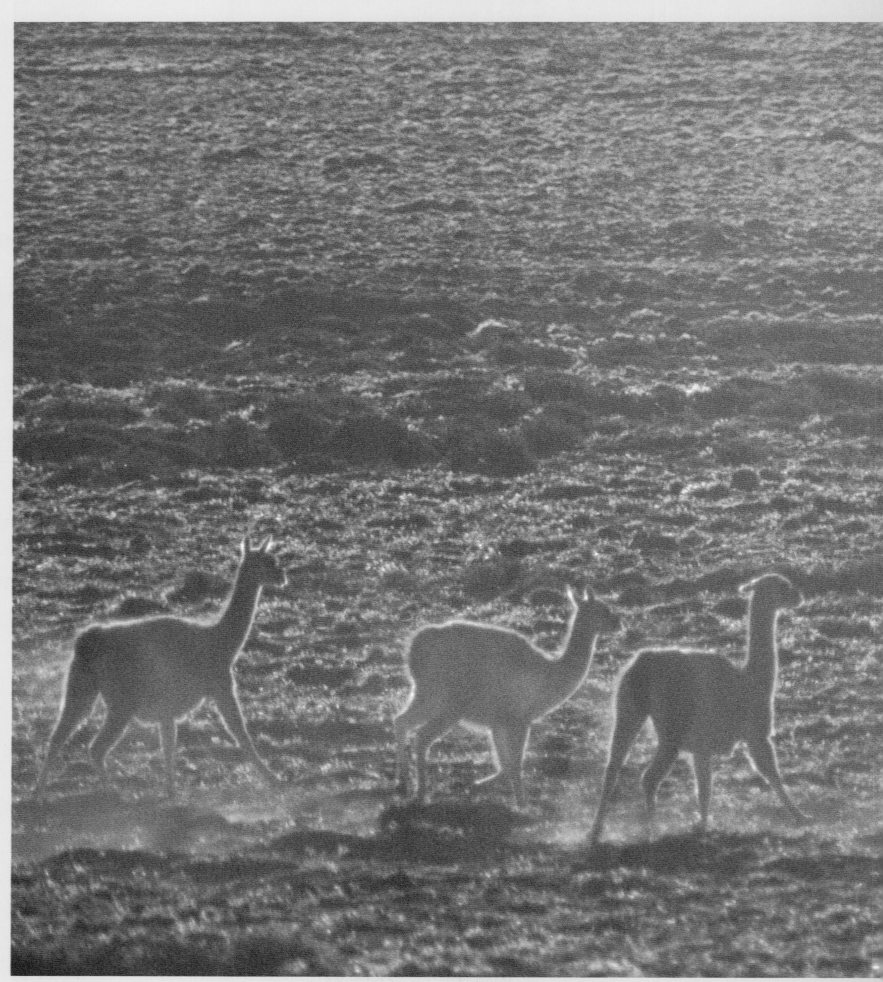

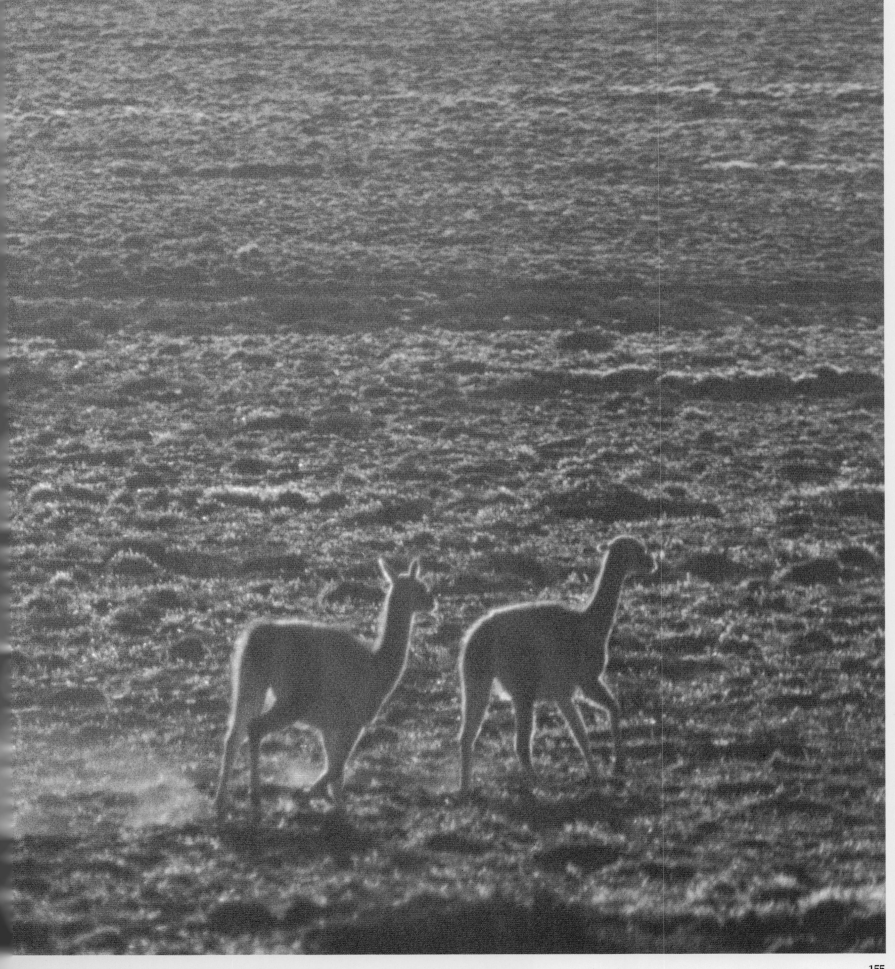

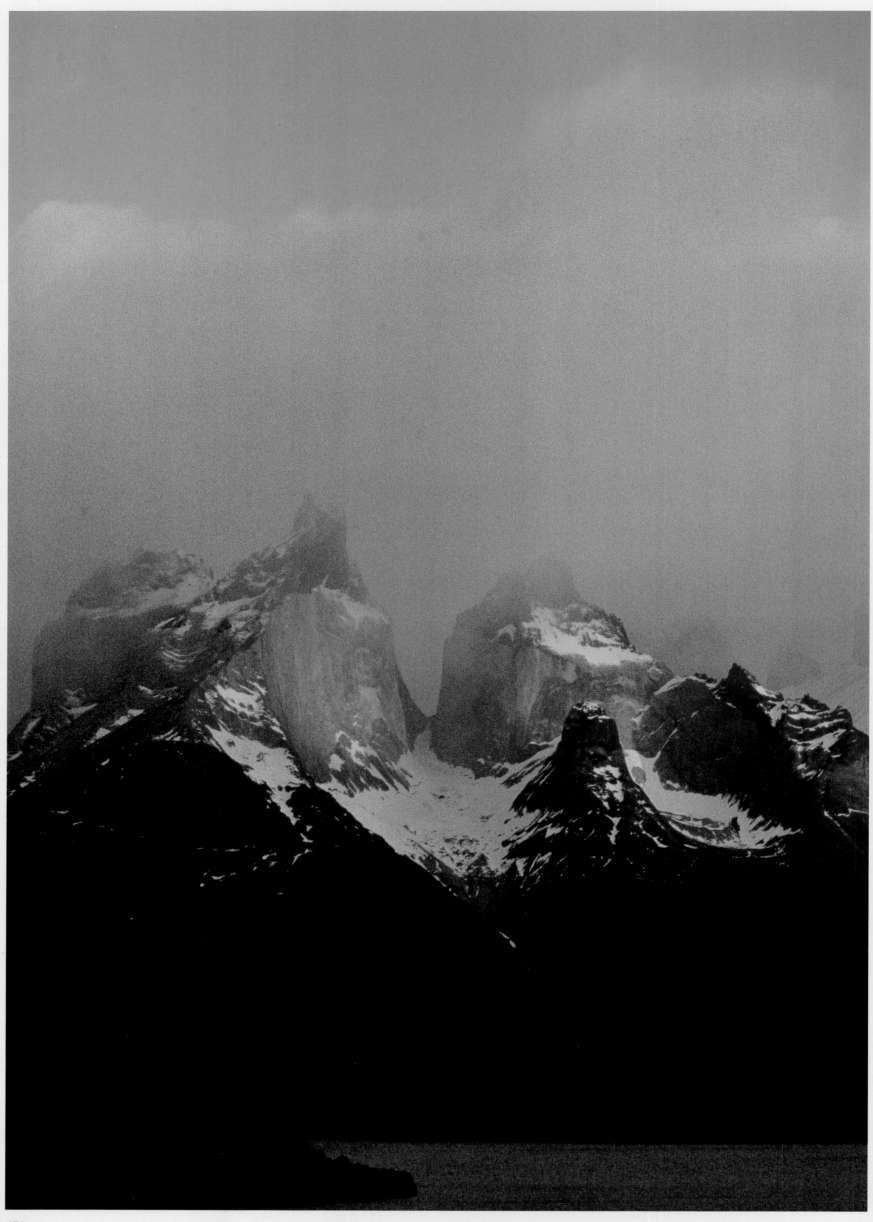

A STORMY SUNRISE

seen through a screen of beech trees at the base camp for Galen's

1985 Fitz Roy expedition. Left: Granite spires called Cuernos, or horns,

in Towers of Paine National Park, Chile.

They tried to make it in only a day, but darkness beat the climbers to the top of Fitz Roy by a few hundred feet. With no tents or sleeping bags, and scarcely room to stand on an ice ledge, Galen Rowell, Michael Graber and David Wilson were forced to stay up all night. They jogged in place to keep warm on their perilous perch as they waited for dawn's first light. The merest breeze chilled them to the bone but their spirits were high: They were close to the top. They sang songs to keep from shivering.

"Tonight we will have no sleep, no warmth, no food, and no liquid," Galen wrote. "We are lacking those basic aspects of human existence, yet we have come to this by our own choosing; for us it is a privilege to stand the night away near Fitz Roy's summit in clarity and stillness."

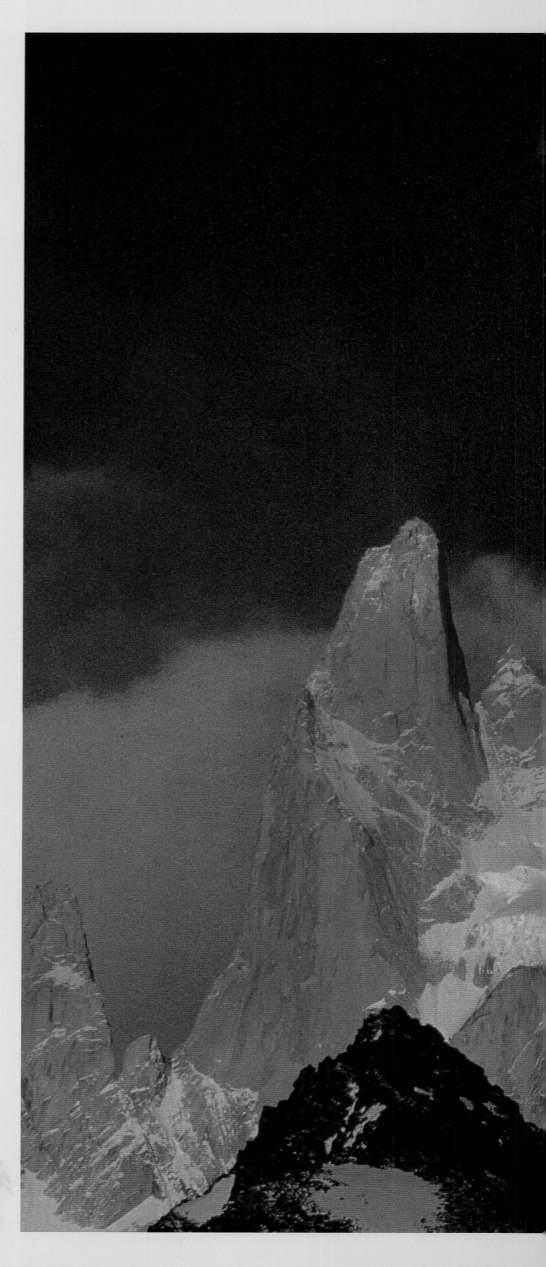

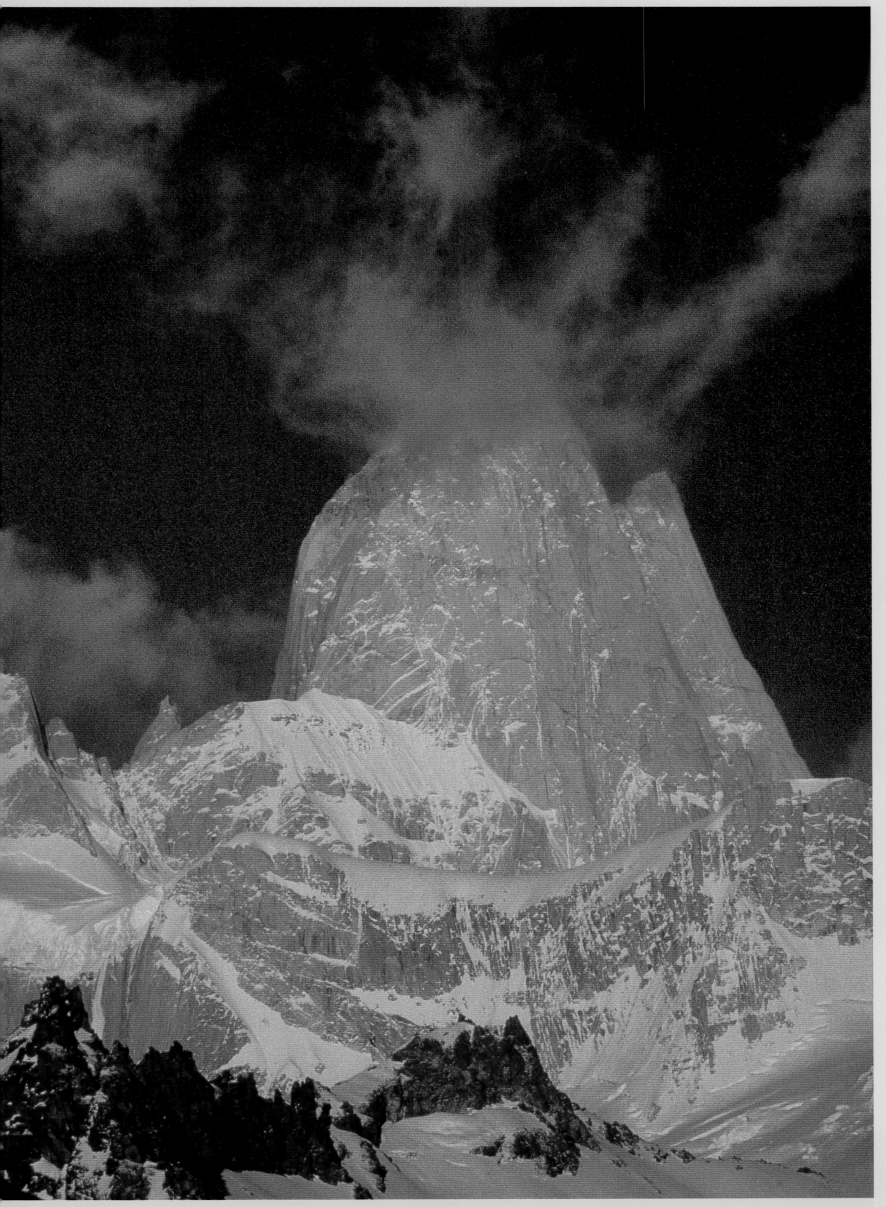

With first light, the three tired and cold climbers began to move to the top. Within minutes they were there, warmed by their effort and the sun's first rays. Below: Galen's view from the summit at dawn. From here, they overlooked the sheer spire of Cerro Torre where legendary Italian mountaineer Toni Egger disappeared in an icy storm in 1959. To the west, they could see the arctic expanse of the Patagonian Icecap stretch for 200 miles.

"The power of the view from Fitz Roy," Galen wrote, "comes from within us. It would not be the same from an airplane, or if we had ridden to the summit in a gondola. Thought and vision

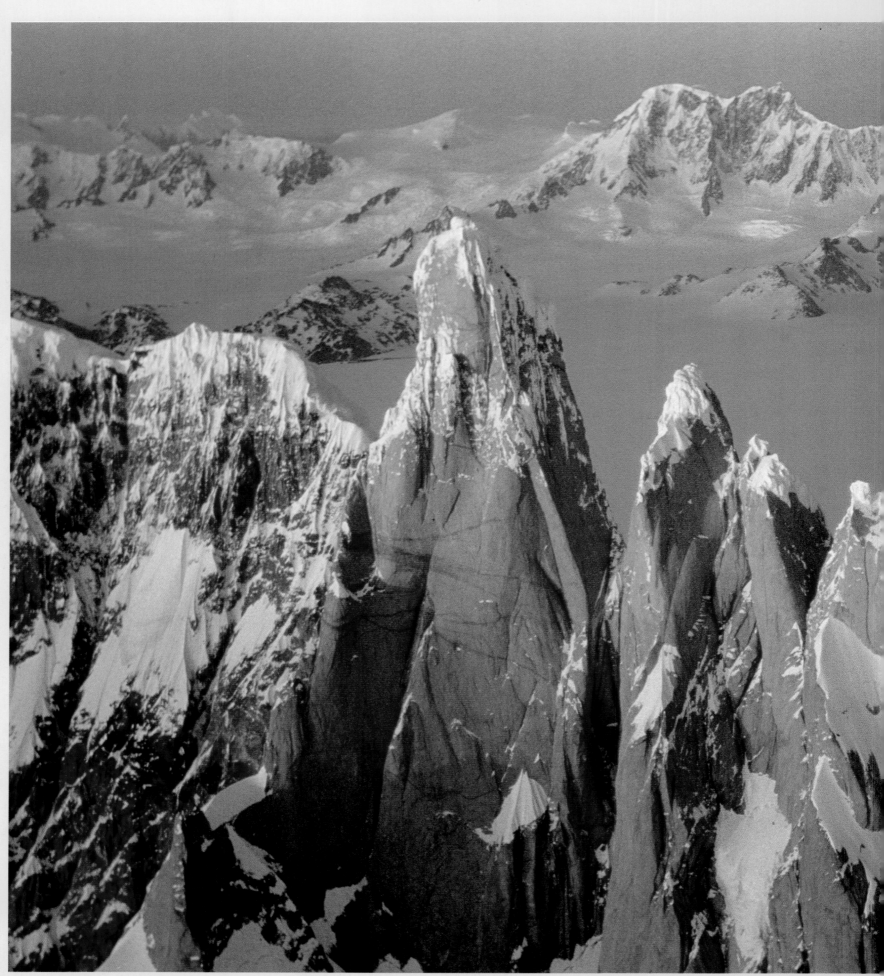

are intertwined ... we feel a strong connection between what is before our eyes and the knowledge of our inner selves that we have gained by pushing the outer limits of our endurance."

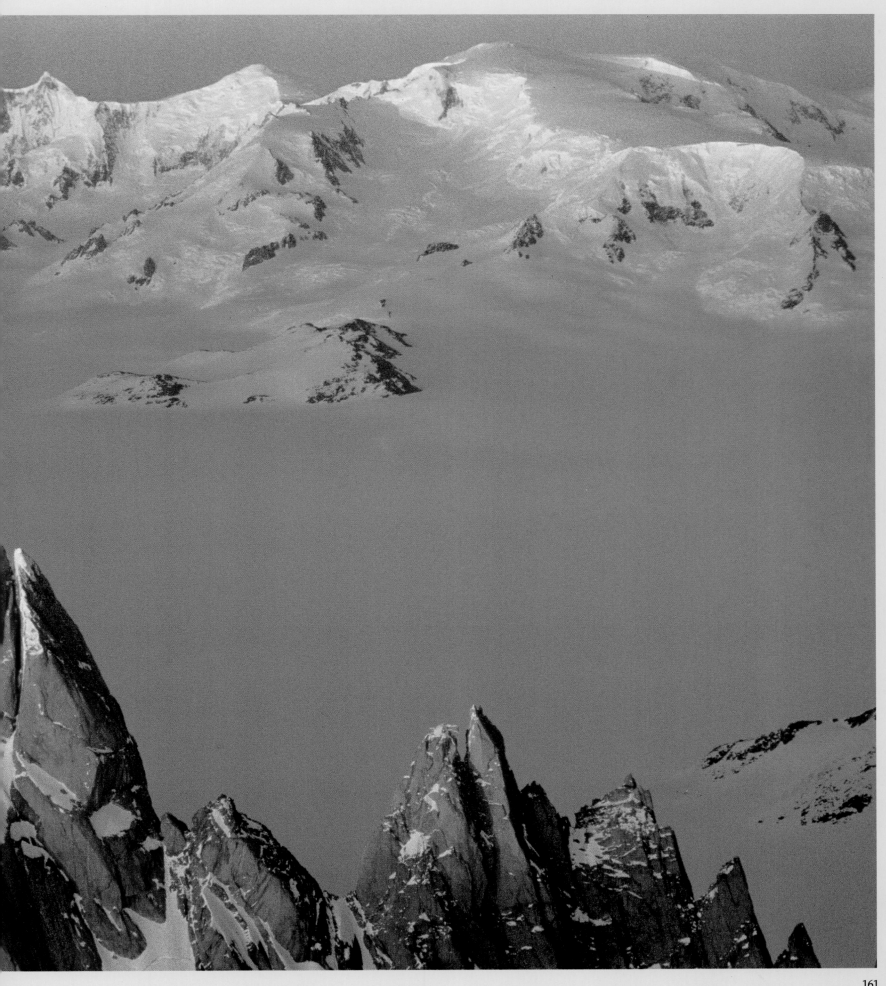

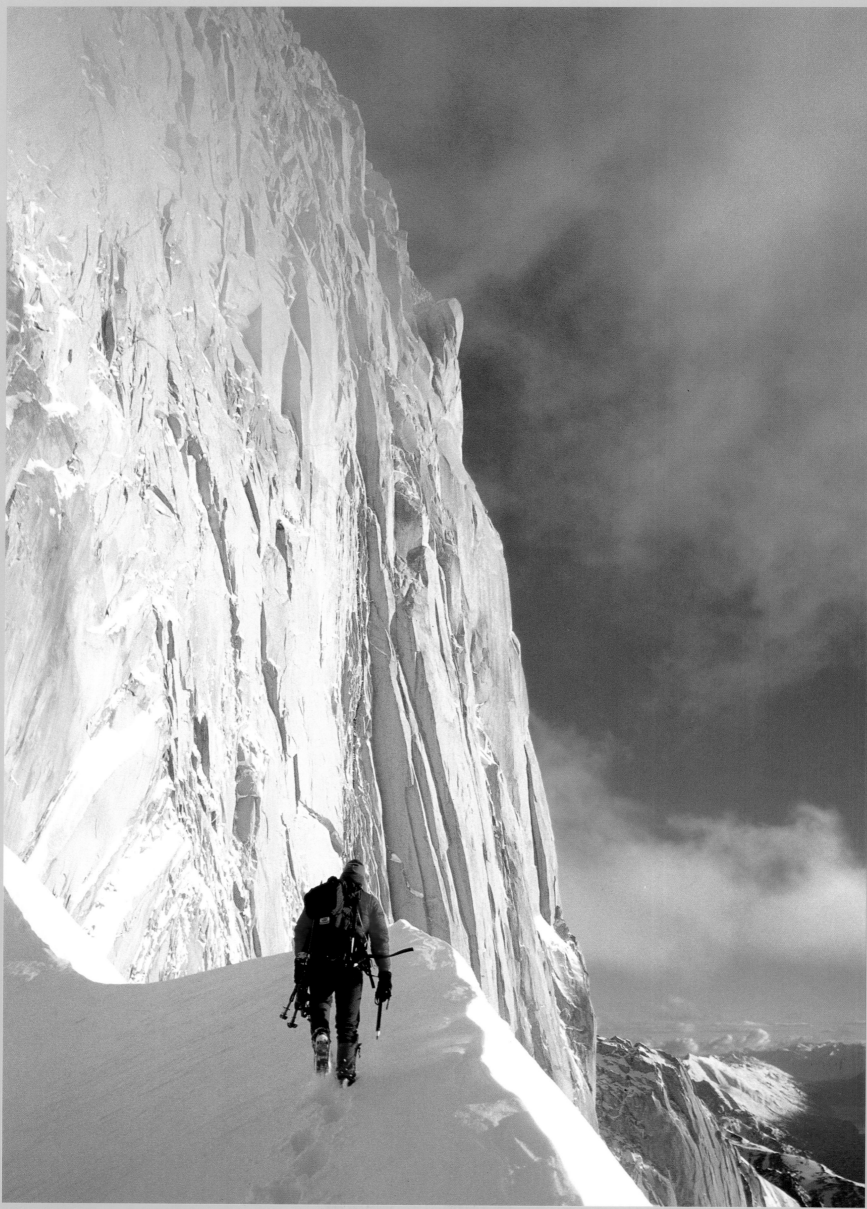

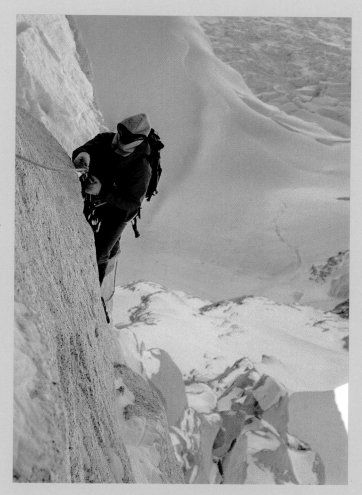

THE ASSAULT ON FITZ ROY

*Just before nightfall, the winds are blessedly light as
David Wilson follows Galen up a sheer wall high on the peak. Fitz
Roy is in the path of the legendary Roaring Forties,
where fierce atmospheric currents circle the globe's subantarctic latitudes,
and blast the Patagonian peaks with hurricane-force winds.
Still, late-winter snow and thick ice clog most of the usable cracks
and ledges, slowing progress and forcing them to spend
the night on an icy ledge. Left: The 2,500-foot final headwall on
Fitz Roy looms above Michael Graber as he leads the
party along a corniced ridge.*

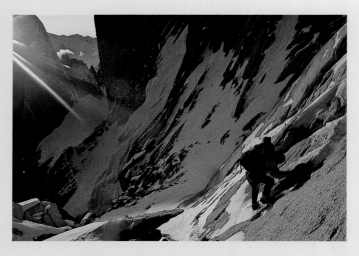

Hitting The Heights Of Adventure

Michael Graber scrambles toward the Italian Col below Fitz Roy's final headwall at sunset. Right: At Fitz Roy's summit Galen's time release shutter records David, Galen and Michael at the high point of their ultimate dream climb. "The time we spent on the summit," Galen wrote, "is locked in our deepest memory, something never to be forgotten."

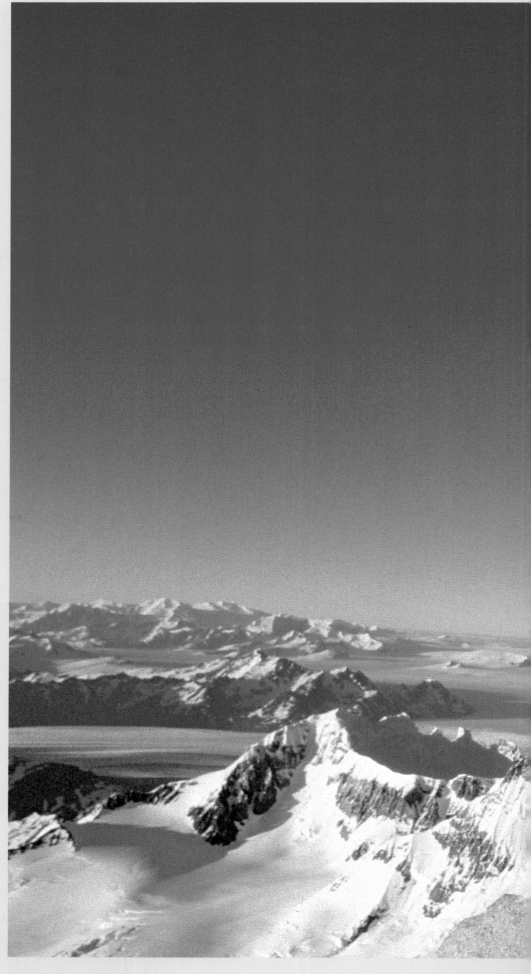

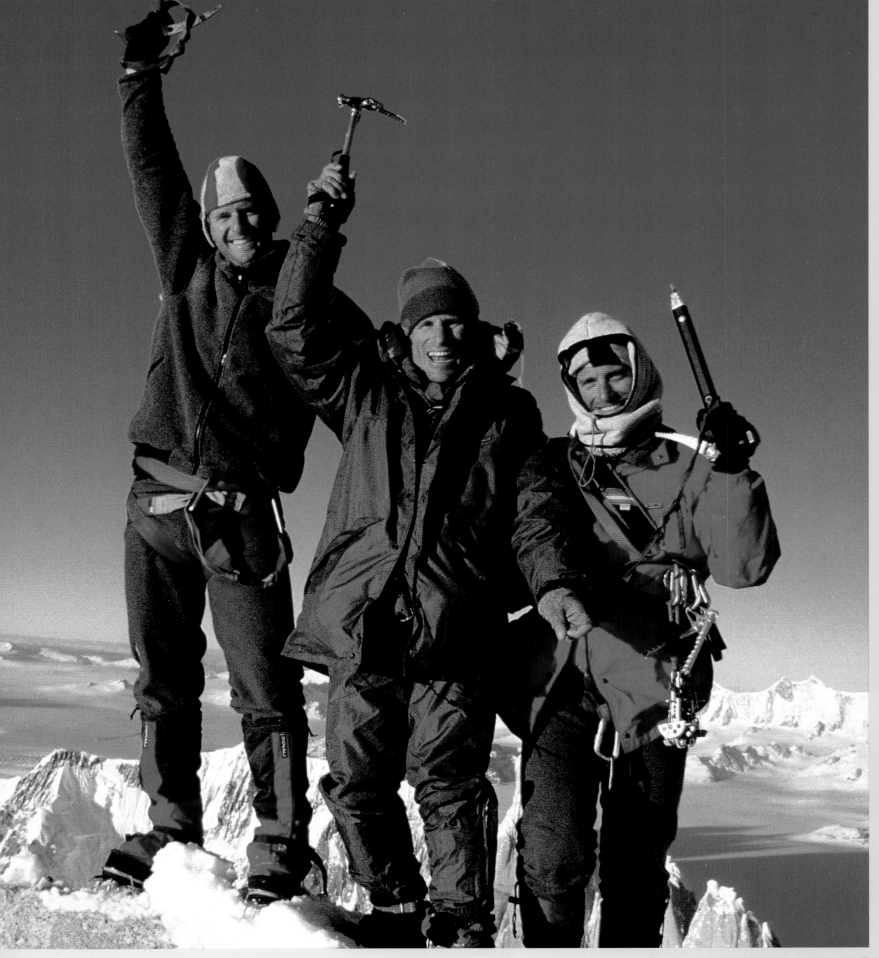

EDITOR
David Cohen

DESIGN DIRECTOR
Jennifer Barry

WRITER
J. Curtis Sanburn

PRODUCTION DIRECTOR
Stephanie Sherman

DESIGN ASSISTANT
Charles Tyrone

PRODUCTION ASSISTANTS
Monica Baltz
Kathryn Yuschenkoff

COPY EDITORS
Amy Wheeler
Mark Rykoff

PUBLICITY
Patti Richards
Kate Kelly

SALES DIRECTOR
Carole Bidnick

MOUNTAIN LIGHT
PHOTOGRAPHY STAFF
Barbara Cushman Rowell
Terri Brown
Justin Lowe
David Sumner
Khumbu

OUR THANKS TO:

Dai Nippon Printing Co., Ltd.

National Geographic Magazine

Repro Images, Inc.

Sports Illustrated Magazine

World Wildlife Fund

PHOTOGRAPHY CREDITS
Page 4: Paul W. Hammond
Page 6, far left: Lou Whittaker

TAKLIMAKAN SHAMO

Kashi
(Kashgar)
Shule
Jiashi
Atux
Kaxgar He
Jor Hu
Bachu

Shu-fu
Yomurga
Serikbuya

Akto
Qianjin Sanchang

Yengisar
Markit

Igiziyar
C H I N

Kosrap
X I N J I A N G

Shache
(Yarkant)
Qarak

Muztagata
Hasalbag
Xaqung
Yecheng
(Karghalik)
Pishan
(Gumal)

Taxkorgan
Kaqung
Koxtag
Muji
Zangguy

Tagarma
Kokyar
Sanju
Jiwa
Moyu

U Y G U R

Akmeqit

Langru

Z I Z H I

Mazar
Xaidulla
Pusa

Aghil Pass
Kangxiwar
Karakax He

K2 (Godwin Austen)
Gasherbrum
Teram Kangri
Dahongliutan
Yangi Davan

SKARDU
Askole
Soda Plains
Chongtash Khitai

Masherbrum
Karakoram Pass
Kizil Jilga

S H A L T I S T A N
Tianshuihai

GANGCHHE
Aksai Chin
Aksayqin Hu

Skardu
Plains of
Khapalu
Tielongtan

Deosai
Chang Chenmo
Lingzi Thang Plains
S. Jilganang Kol

Kharmang
Shyok
Sanzmuling
Changlung La

Marol
Panamik

N O R T H
Nurla
Leh
Pamzal Kwan

K A S H M I R
Tankse
Bankong Co Pt

Srinagar
Pangong Tso

Z A S K A R
Chushul

Padum
Thandhe

R U P S H U

Rutog

UDHAMPUR

UTTAR PRADESH / MADHYA PRADESH region map

RAMPUR
Rampur
Pilibhit
PILIBHIT
BAREILLY
Bareilly
Budaun
BUDAUN
T T A R P R A D E S H
Shahjahanpur
Sitahabad
Sitapur
SITAPUR
BAHRAICH
Bahraich
Fatehgarh
Farrukhabad
Hardoi
HARDOI
GONDA
Gonda
BASTI
Basti
GORAKHPUR
Gorakhpur
Lucknow
BARA BANKI
Faizabad
FAIZABAD
DEOR
Etawah
ETAWAH
Kanpur
KANPUR
Cawnpore
UNNAO
Unnao
Maurawan
Rae Bareli
RAE BARELI
SULTANPUR
Jais Sultanpur
Azamgarh
AZAMGARH
JALAUN
Fatehpur
FATEHPUR
PRATAPGARH
Jaunpur
JAUNPUR
GHAZIPUR
Ghazipur
Hamirpur
HAMIRPUR
JHANSI
Charkhari
Banda
BANDA
Allahabad
ALLAHABAD
Varanasi
VARANASI
Benares
Alipura
Lugasi
CHHATARPUR
Chhatarpur
Ajaigarh
KHAJURAHO
Panna
Bijawar
Mirzapur
MIRZAPUR
Chunar
REWA
Sohawal
Nagod
Jaso
Rewa
PANNA
SATNA
Maihar
SIDHI
Garwa
Damoh
DAMOH
Murwara
Katni
Sihora
SHAHDOL
Shahdol
SURGUJA
Ambikapur
JABALPUR
Jabalpur
Shahpura
RAIGARH
C H O T
MANDLA
Mandla
Maikal Range
SEONI
BILASPUR